D0504238

Die Ausstellung und die Publikation wurden grosszügig unterstützt durch den »Fonds
für künstlerische Aktivitäten im Museum für Gegenwartskunst der Emanuel Hoffmann-Stiftung
und der Christoph Merian Stiftung«.

Generous support for the exhibition and its accompanying publication has
been provided by the "Fonds für künstlerische Aktivitäten im Museum für Gegenwartskunst
der Emanuel Hoffmann-Stiftung und der Christoph Merian Stiftung."

John M Armleder
Scott Burton
Werner Büttner
Miriam Cahn
Francesco Clemente
James Coleman
Walter Dahn
Helmut Federle
Eric Fischl
Peter Fischli David Weiss
Günther Förg
Katharina Fritsch
Robert Gober
Jack Goldstein
Group Material
Peter Halley
Georg Herold
Jenny Holzer
Ilya Kabakov
Mike Kelley
Martin Kippenberger
Jeff Koons
Louise Lawler
Sherrie Levine
Robert Longo
Robert Mapplethorpe
Allan McCollum
Reinhard Mucha
Cady Noland
Albert Oehlen
Richard Prince
Charles Ray
Tim Rollins + K.O.S.
Thomas Ruff
David Salle
Jean-Frédéric Schnyder
Thomas Schütte
Cindy Sherman
Haim Steinbach
Rosemarie Trockel
Jeff Wall
Franz West
Krzysztof Wodiczko

F L A S H B A C K

Eine Revision der Kunst der 80er Jahre
Revisiting the Art of the 80s

Kunstmuseum Basel,
Museum für Gegenwartskunst

Hatje Cantz Verlag

INHALT

CONTENTS

PREFACE
Bernhard Mendes Bürgi

When the Museum für Gegenwartskunst
opened its doors in Basel in
1980, it was the first venue in the
world to be devoted exclusively
to contemporary art. It became host
primarily to art made after
1960, a collection acquired by the
Öffentlichen Kunstsammlung Basel
and the Emanuel Hoffmann Foundation,
for which there was no longer
enough room in its longtime place of
residence at the Kunstmuseum on
St. Alban-Graben. Regular
acquisitions, especially of the
Emanuel Hoffmann Foundation, focused

VORWORT
Bernhard Mendes Bürgi

1980 wurde in Basel das Museum für
Gegenwartskunst als weltweit erstes Museum
eröffnet, das ausschliesslich der
aktuellen Kunst vorbehalten sein sollte,
insbesondere den Werken ab 1960 der
Öffentlichen Kunstsammlung Basel und der
Emanuel Hoffmann-Stiftung, die am
angestammten Ort ihrer Präsentation, im
Kunstmuseum am St. Alban-Graben, nicht mehr
den nötigen Platz fanden. Immer wieder
um Neuerwerbungen erweitert, gerade was die
Bestände der Emanuel Hoffmann-Stiftung
betrifft, die sich explizit auf das jeweils
neue Kunstschaffen konzentriert, fand
während eines Vierteljahrhunderts rund
um den Nukleus »Joseph Beuys« ein lebendiger
Ausstellungsbetrieb statt, kuratiert
von den Konservatorinnen und Konservatoren
des Kunstmuseums für moderne und zeit-
genössische Kunst, aber auch des Kupfer-
stichkabinetts. So war in Einzelaus-
stellungen – oft erstmals in einem Museum
überhaupt – frühzeitig das Werk bedeutender
Künstlerinnen und Künstler zu sehen.

Angeregt und mit ihrer Familie ermöglicht
hatte damals das neue Haus, das sich
im St. Alban-Tal unweit des Rheins befindet,
Maja Sacher-Stehlin, die Gründerin der
Emanuel Hoffmann-Stiftung, dies in
Partnerschaft mit der Christoph Merian
Stiftung und dem Kanton Basel-Stadt.

2005 feiern wir nicht nur das 25-jährige
Bestehen des Museums für Gegenwartskunst,
sondern auch den Abschluss einer umfassenden
Sanierung und Renovation, getragen von
der Christoph Merian Stiftung und dem Kanton
Basel-Stadt, die dem Haus heute geltende
internationale Standards garantieren, insbe-

sondere in Bezug auf Klima und Sicherheit. In frischer Ausstrahlung und für neue Herausforderungen gerüstet, öffnet das Museum für Gegenwartskunst mit der Ausstellung »Flashback – Eine Revision der Kunst der 80er Jahre« erneut seine Tore, und ich freue mich besonders, dass mit dieser Wiedereröffnung eine 25 Jahre währende und bewährte Partnerschaft zwischen der Emanuel Hoffmann-Stiftung, der Christoph Merian Stiftung und dem Kunstmuseum Basel beziehungsweise dem Kanton Basel-Stadt bekräftigt werden kann.

Mit gutem Grund unternimmt dieses von Philipp Kaiser kuratierte Ausstellungsprojekt eine neue Sichtung und damit auch Wertung der Kunst der 80er Jahre, des ersten zeitlichen Aktionsraums des Museums für Gegenwartskunst – ein ambitiöses und spannendes Unterfangen, das mit einer gesunden Portion Subjektivität und Radikalität angegangen werden muss. Im Zentrum auch hier Werke der Emanuel Hoffmann-Stiftung und des Kunstmuseums Basel, ergänzt um wichtige Leihgaben aus anderen Museums- und Privatsammlungen im Sinne auch eines »musée imaginaire«. Und klarzulegen ist, dass es die eine gültige Perspektive nicht geben kann und »Flashback« keineswegs die nostalgische Reinszenierung einer vergangenen Epoche meint. Die Beschäftigung mit den 80er Jahren macht vielmehr deutlich, dass das fokussierte Jahrzehnt keinesfalls ohne die prägenden Erfahrungen der 60er und 70er Jahre denkbar ist, dass noch heute die aktuelle Kunstproduktion sich mit den künstlerischen Errungenschaften dieser Zeit auseinander setzt.

expressly on the work of young practitioners. For a quarter of a century, around the nucleus of Joseph Beuys, the curators of modern and contemporary art at the Kunstmuseum and at the Kupferstichkabinett mounted a steady stream of dynamic, exciting exhibitions, showing the early work of important artists, often exhibited in a museum for the first time.

The new home for the collection on St. Alban-Tal, not far from the Rhine, was initiated by Maja Sacher-Stehlin, the founder of the Emanuel Hoffmann Foundation, and was made possible by her family in partnership with the Christoph Merian Foundation and the Canton of Basel-Stadt.

In 2005 it is our privilege to celebrate not only the twenty-fifth anniversary of the Museum für Gegenwartskunst, but also the completion of extensive refurbishment, funded by the Christoph Merian Foundation and the Canton of Basel-Stadt. The institution now meets the most exacting international standards, especially with respect to climate control and security. Freshly renovated and equipped to accept new challenges, the Museum für Gegenwartskunst is launching the next phase of its existence with the exhibition "Flashback – Revisiting the Art of the 80s." It is especially gratifying that the reopening of the museum offers lively proof of a long and fruitful 25-year partnership between the Emanuel Hoffmann Foundation, the Christoph Merian Foundation, and the Kunstmuseum Basel, the latter funded by the Canton of Basel-Stadt.

It is with good reason that this exhibition project, curated by Philipp Kaiser, revisits and re-

Die Eröffnungsausstellung »Flashback« konnte nur mit der grosszügigen Unterstützung durch den »Fonds für künstlerische Aktivitäten im Museum für Gegenwartskunst der Emanuel Hoffmann-Stiftung und der Christoph Merian Stiftung« realisiert werden. Speziell möchten wir der Emanuel Hoffmann-Stiftung, insbesondere ihrer Präsidentin Maja Oeri, der Christoph Merian Stiftung, insbesondere ihrem Direktor Christian Felber, sowie der Regierung und dem Grossen Rat des Kantons Basel-Stadt für ihr grosses Engagement danken. Unser Dank gebührt auch Theodora Vischer, Direktorin des Schaulagers, den Leihgebern und allen Künstlern, die uns mit Rat und Tat, aber auch mit Leihgaben unterstützt haben.

evaluates the art of the eighties, since that was the first decade in the history of the Museum für Gegenwartskunst. An ambitious and thrilling undertaking, its execution requires a healthy dose of subjectivity and radicalism. The core of the exhibition, consisting of works from the Emanuel Hoffmann Foundation and the Kunstmuseum Basel, is complemented with important loans from other museums and private collections, not least in the sense of a "musée imaginaire." A reassessment of this kind clearly resists confinement to a single binding perspective and Flashback specifically eschews the vantage point of nostalgic reenactment. Study of the art produced in the eighties reveals that it would have been inconceivable without the seminal experiences of the sixties and seventies, while current artistic projects, in turn, continue to reflect and build on the artistic achievements of that decade.

The opening exhibition "Flashback" would not have been possible without the generous support of the "Fonds für künstlerische Aktivitäten im Museum für Gegenwartskunst der Emanuel Hoffmann-Stiftung und der Christoph Merian Stiftung." We wish to extend special thanks to the Emanuel Hoffmann Foundation, in particular its president Maja Oeri; the Christoph Merian Foundation, in particular its director Christian Felber, as well as the government and the Grand Council of the Canton of Basel-Stadt for their great commitment. We also thank Theodora Vischer, director of the Schaulager, the lenders and all the artists for their willingness to stand by us and support us with loans of their work.

LEIHGEBER / LENDERS

Antwerpen
 Museum van Hedendaagse Kunst
 Antwerpen; Bart De Baere

Basel
 Emanuel Hoffmann-Stiftung;
 Maja Oeri
 Galerie STAMPA

Berlin
 Urs Egger
 Galerie Max Hetzler

Bern
 Kunstmuseum Bern;
 Matthias Frehner

Frankfurt am Main
 Galerie Bärbel Grässlin

Genève
 Art & Public – Cabinet P. H.

Graz
 Sammlung Peter Pakesch

Köln
 Sammlung Jörg Johnen
 Sammlung Speck
 Galerie Monika Sprüth / Philomene
 Magers, Köln / München

Le Gue de Langroi
 Sammlung Jean Todt

Lyon
 Collection du Musée d'art
 Contemporain de Lyon; Thierry
 Raspail

München
 Sammlung Goetz; Ingvild Goetz,
 Rainald Schumacher
 Phillips de Pury & Co

Nazareth
 Collection André Goeminne

New York
 Collection Metro Pictures
 B.Z. + Michael Schwartz

Oslo
 Astrup Fearnley Collection;
 Gunnar B. Kvaran

St. Georgen
 Sammlung Grässlin

Torino
 Fondazione Sandretto Re
 Rebaudengo; Patrizia Sandretto
 Re Rebaudengo

Toronto
 Art Gallery of Ontario; Matthew
 Teitelbaum

Zürich
 Thomas Ammann Fine Art;
 Doris Ammann
 Daros Collection; Dieter Beer
 Sammlung Thomas Koerfer
 Mai 36 Galerie
 Sammlung Ringier; Michael Ringier

 Friedrich Christian Flick
 Collection

Die Ausstellung wurde durch das
grosszügige Entgegenkommen
öffentlicher und privater
Leihgeber unterstützt. Allen, die
uns ihre Werke zur Verfügung
stellten, möchten wir herzlich
danken, auch jenen, die es
vorziehen, ungenannt zu bleiben.

This exhibition is generously
supported by public and
private lenders. We would like to
warmly thank all who have
made their works available,
including those who
wish to remain anonymous.

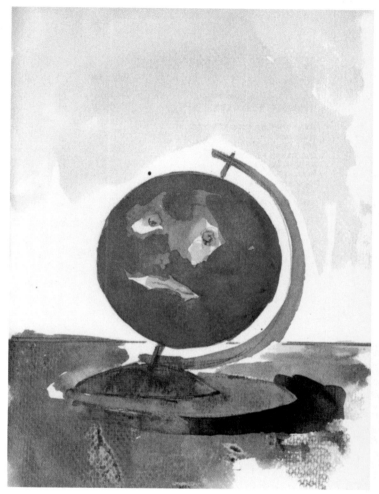

<u>THOMAS SCHÜTTE</u> Total blauer Planet, 1989

EINLEITUNG
Philipp Kaiser

Denken wir zurück an die 80er Jahre, so türmen sich vor unserem inneren Auge unweigerlich apokalyptische Szenarien auf: Bhopal, Schweizerhalle, Tschernobyl, Waldsterben, Ozonloch, Atombomben, Aids, Kalter Krieg, Reagan, Thatcher, Breschnew und Kohl. Das vermeintliche Ende der Geschichte war erreicht, der Abgrund schien nahe. Denken wir an die 80er Jahre, so denken wir ebenso nostalgisch an Madonna, Michael Jackson, Freddy Mercury, Personal Computer und Föhnfrisuren. Denken wir an die Kunst der 80er Jahre, so meinen noch heute viele, die Dekade sei in besonderem Masse durch die Malerei geprägt. Hat sich aber tatsächlich Ende der 70er Jahre ein Paradigmenwechsel ereignet, wie es die mittlerweile in die Jahre geratene Rede der Postmoderne nahe legt, der es legitimieren würde, von einer Kunst der 80er Jahre zu sprechen?

Die präglobalisierte Kunstszene der 80er Jahre agierte, trotz Schlagwörter wie der »neuen Übersichtlichkeit«, in einem vergleichsweise überschaubaren Feld und spiegelte in erster Linie die geopolitische Nachkriegsordnung wider, wobei sich der Kunstmarkt auf die USA und Westeuropa konzentrierte – das heisst auf New York und Köln –, respektive Deutschland, Italien, England und Frankreich sowie die Niederlanden und die Schweiz. Noch einige Jahre zuvor, in den 60er und 70er Jahren, dominierten, so das gängige Erklärungs- modell, Pop Art, Minimal Art und Konzeptkunst. Es erscheint aus heutiger Sicht aufschlussreich, dass sich in Westeuropa gerade innerhalb dieser Formation

INTRODUCTION
Philipp Kaiser

When we think back to the 1980s, a series of apocalyptic scenes unavoidably passes before our mind's eye: Bhopal, Schweizerhalle (the devastating explosion at the Sandoz AG chemical plant in 1986), Chernobyl, moribund forests, ozone hole, nuclear bombs, AIDS, Cold War, Reagan and Thatcher, Breshnev and Kohl. Back then the end of history seemed imminent; the abyss yawned. Yet thinking of the

eines konventionalisierten »International Style« der Kunst eine mediale und stadtgeografische Ausdifferenzierung ereignet hat. Die Künstler kamen nun aus Westberlin, Hamburg, Köln oder Düsseldorf, und auch hierzulande fand die Kunst dieser Jahre erst als eigene nationale »Szene« zu ihrem Selbstverständnis. Dieser subkutan wohl realpolitisch motivierte Emanzipationsversuch, innerhalb der engen Grenzen des Westens der Nachkriegsordnung zu entkommen, hat jedoch manches Missverständnis mit sich gebracht und den Glauben an den Paradigmenwechsel der 80er Jahre noch bekräftigt.

Die Ausstellung »Flashback – Eine Revision der Kunst der 80er Jahre« versteht sich als essayistische, offene Versuchsanordnung und will einen kritischen Blick zurückwerfen, um ein Bild der 80er Jahre zu zeichnen, das in einem gewissen Sinne repräsentativ für die Kunst dieser Zeit ist, ohne dabei einem unmotivierten Pluralismus des »anything goes« anheim zu fallen. Zweifellos kann und muss eine solche Sicht fragmentarisch und subjektiv bleiben, will sie nicht enzyklopädisch argumentieren. In diesem Sinne bedeutet eine Revision zweierlei: Die Kunst der 80er Jahre wird einerseits erneut gesichtet, andererseits werden Korrekturen vorgenommen und Schwerpunkte verschoben. Als Kurator und Moderator der Roundtable-Diskussion muss ich spätestens hier einräumen, dass ich während der 80er Jahre im Unterschied zu allen anderen Gesprächsteilnehmern nicht Akteur war. Umso wichtiger ist es mir, für diese Dekade die Figur der Rückblende, den Flashback, in Anspruch zu nehmen. Die filmische Montagetechnik der Rückblende

1980s also brings back nostalgic memories of Madonna, Michael Jackson, Freddy Mercury, the novelty of personal computers, and big hair. Looking back on the art of that decade, many people still believe it was largely determined by painting. But did a paradigm shift really occur at the end of the 1970s, as the by now somewhat stale postmodernist rhetoric would have it, a change that would justify speaking of 1980s art?

Despite buzzwords like the "new ludicity," the pre-globalized art scene of the 1980s functioned within a comparatively limited field and largely reflected postwar geopolitical realities. The art market was concentrated in the United States and Western Europe—that is, in New York and Cologne, in West Germany, Italy, England, and France, along with the Netherlands and Switzerland. Just a few years earlier, in the 1960s and 1970s, the dominant streams, according to the conventional wisdom, were Pop Art, minimal art, and conceptual art.

In hindsight, it would seem revealing that the emergence of this conventionalized "international style" went hand in hand in Western Europe with a differentiation in terms of media and city geography. German artists, for instance, began to come from West Berlin, Hamburg, Cologne, or Düsseldorf, and there was a coinciding emergent independent Swiss national art scene as well. This attempt at emancipation from the postwar order within the constricting frontiers of the Western world, probably subliminally politically motivated, has led to many misunderstandings and further bolstered the belief that a change of paradigms had occurred.

formuliert einen Standpunkt im Hier und Jetzt und fragt gleichzeitig nach ihren künstlerischen Einflusssphären. Dies ist nicht zuletzt einer der Gründe, weshalb eine Ausstellung zur Kunst der 80er Jahre zum heutigen Zeitpunkt sinnvoll erscheint, zumal die Wirkmacht der Mechanismen, der Kunst und ihres Betriebssystems, zum Guten wie zum Schlechten immer noch überaus präsent ist. Zum anderen wäre das 25-jährige Jubiläum des Museums für Gegenwartskunst Basel, das 1980 seine Tore geöffnet hat, eigentlich Anlass genug, eine Ausstellung zur Kunst seines ersten Jahrzehnts, quasi avant la lettre, zu konzipieren. Erstaunlicherweise konzentrierte sich die Auseinandersetzung mit den 80er Jahren in den letzten Jahren aber vor allem auf die USA.[1]

Kunst lässt sich nicht in Dekaden ordnen, und so will »Flashback«, unter Mitberücksichtigung der lokalen Perspektive, in erster Linie eine konzise Bestandsaufnahme einer damals neuen Künstlergeneration sein, auf keinen Fall aber die Behauptung eines autistisch autonomen Zeitkosmos. Es kommt hinzu, dass nicht alleine die 25- bis 28-Jährigen ein Jahrzehnt ausmachen können, wie es Kasper König im Gespräch formuliert hat. Vielmehr müsste der Versuch einer Historisierung das Wirken unterschiedlichster diskursiver Konstellationen mitsamt ihren Generationsüberschneidungen berücksichtigen. Die Ausstellung »Flashback« möchte indes eine Re-Perspektivierung vornehmen. So muss zuallererst die vielfach kolportierte und zu Beginn kurz umrissene Lagebestimmung zugleich radikal infrage gestellt werden, denn gab es tatsächlich eine nennenswerte und

The exhibition "Flashback—Revisiting the Art of the 80s" is conceived as an essaylike, open experimental setup. Its purpose is to take a critical look backward in time, to draw a picture of the 1980s that is in a certain sense representative of the period's art while avoiding the unmotivated pluralism of "anything goes." Doubtless such an overview must remain fragmentary and subjective if its argument is not to expand to encyclopedic proportions. In this context, a revision implies two things: first, yet another attempt to review of the art of the 1980s, and second, a correction of definitions and a shifting of emphases.

As curator and moderator of the roundtable discussion, I must admit at this point that I was the only participant not to have been a protagonist during the 1980s. So in approaching this decade, I found it all the more important to refer to it as a "flashback." A cinematic montage technique, the flashback implies a vantage point in the here and now, from which an inquiry into the artistic influences takes place. This is one of the key reasons why an exhibition of 1980s art seems particularly meaningful right now, especially as the power of the mechanisms of art and its distribution system is still very real and present today, for good or evil.

On the other hand, the twenty-fifth anniversary of the Museum für Gegenwartskunst in Basel, which opened its doors in 1980, seemed sufficient reason to conceive an exhibition of the art of its first decade, avant la lettre. Yet astonishingly, involvement with the 1980s in recent years has concentrated on the U.S. above all.[1]

Art, of course, cannot be categorized in terms of decades. So

"Flashback," while taking the local perspective into account, focuses principally on a concise stocktaking of a then-new generation of artists, and is far from positing the existence of any artistically autonomous time cosmos. Moreover, as Kasper König pointed out in our discussions, it is not only the twenty-five- to twenty-eight-year-olds who put their stamp on a decade. Rather, any attempt at historicization must consider the most diverse discursive constellations, including generational overlappings. The exhibition "Flashback" is a re-view of this time.

First of all, the much-touted initial situation briefly referred to above is questionable in the extreme. Did the hegemony of conceptual art worthy of the name truly exist in Western Europe in the late 1970s, against which a new movement like Transavanguardia and Neue Wilde had to be marshalled?[2] The phenomenon of figurative painting, which caused waves first in Italy, then in Berlin, Cologne, and Hamburg (not to mention Basel), was in many cases not long-lived. Yet the myth of a subject-centered, anticonceptual gut-level painting still tenaciously persists in many people's minds. In the opposite camp stood a coterie of American critics whose revulsion at "regressive painting" could not have been greater. As a result, the binary formula of neo-expressionists versus conceptualists came to determine the discourse, despite the fact that this very dichotomy accorded figurative painting a power that in hindsight seems difficult to understand. This likely explains why the polemics peaked at that point, making all painting, whether neo-expressive, figurative, or abstract, seem suspect.

hegemoniale Konzeptkunst im Westeuropa der späten 70er Jahre, gegen die man eine neue Bewegung wie die Transavanguardia und die Neuen Wilden aus der Taufe heben musste?[2] Das Phänomen der figurativen Malerei, die erst in Italien, dann in Berlin, Köln und Hamburg, aber auch in Basel für Aufsehen sorgte, hielt in vielen Fällen nicht allzu lange an. Der Mythos der Vorherrschaft einer subjektzentrierten, antikonzeptuellen Bauchmalerei hält sich dennoch bis heute hartnäckig im Bewusstsein vieler. Auf der gegnerischen Seite steht ein Heer amerikanischer Kritiker, deren Abscheu gegenüber einer als regressiv empfundenen Malerei nicht grösser sein könnte. So wurde die binäre Formel Neoexpressionisten versus Konzeptualisten diskursprägend, wenngleich durch eben diese Dichotomie der figurativen Malerei eine aus heutiger Sicht unverständliche Macht eingeräumt wurde. Wohl deshalb erreichte die Polemik damals ihren Höhepunkt, sodass ausnahmslos alle Malerei, ob neoexpressiv, figurativ oder abstrakt, suspekt erschien. Douglas Crimps mittlerweile legendäre Ausstellung im alternativen Artists Space 1977 in New York benannte mit der »Pictures«-Generation das Gegenmodell.[3] Diese Künstlerinnen und Künstler bedienten sich zumeist der Fotografie, um mittels Aneignungen, Rahmungen und Inszenierungen unterschiedlichste Schichten massenmedialer, stereotypisierter Repräsentationsmuster freizulegen und damit einen kritischen Umgang mit der eigenen Lebenswirklichkeit zu formulieren. Es gibt demnach kein Bild ohne ein Vor-Bild. Ist es ein Sakrileg zu fragen, ob das vielleicht etwas einfache Verlangen des Neoexpressionismus, nie gesehene, ja

Douglas Crimp's now legendary 1977 exhibition in the alternative Artists Space in New York launched an alternative model, known as the "pictures" generation.[3] Most of these artists employed photography, using appropriations, excerpts, and stagings to reveal the diverse levels of stereotyped mass-media patterns of representation, reflecting a critical involvement with their own life reality. In terms of this approach, there could be no image without a pre-existing image. Is it sacrilegious to ask whether the perhaps somewhat simple-minded urge of the neo-expressionists to create unprecedented, even "personal" images might not have been motivated by interests analogous to those behind the attempts of New York artists to deconstruct mass-media imagery? No matter how dissimilar their artistic strategies and motivations may appear, the two approaches seem to be two sides of the same coin. The binary formula is overly simple, suggesting the existence of national, even local phenomena, and pitting New York, virtually the only American art center even today, against Western Europe.

Seen in this light, "Flashback" argues for thinking of conceptualism without the foil of the heroically expressive, and for respecting both the decade break at the end of the 1970s and the ambiguities, blurrings, and continuities of art.[4] As this implies, conceptualism, like Pop, was never abandoned in the U.S. or in Western Europe, but was continually reformulated from the 1970s through the 1980s and on into the 1990s. So it is high time, as Stephan Schmidt-Wulffen says, to finally bid farewell to the legend of the regressiveness of the 1980s.[5]

»eigene« Bilder zu schaffen, und die Bestrebungen einiger New Yorker Künstlerinnen und Künstler, massenmediale Bildwelten zu dekonstruieren, nicht aus einem ähnlichen Interesse hervorgingen? Auch wenn die beiden künstlerischen Strategien und Motivationen noch so weit auseinander liegen, scheinen sie doch die beiden Seiten ein und derselben Medaille zu bezeichnen. Die binäre Formel greift zu kurz, suggeriert nationale, gar lokale Phänomene und setzt New York, als bis heute einziges Kunstzentrum der USA, Westeuropa entgegen. In diesem Sinne plädiert die Ausstellung »Flashback« dafür, das Konzeptuelle ohne das heroisch Expressive zu denken und sowohl den Dekadenbruch Ende der 70er Jahre als auch die Uneindeutigkeiten, Unschärfen und Kontinuitäten der Kunst zu respektieren.[4] Dies bedeutet, dass Konzeptualität, aber ebenso Pop, in den USA wie auch in Westeuropa nie aufgegeben, sondern vielmehr von den 70ern über die 80er bis in die 90er Jahre umformuliert wurden, sodass es, um Stephan Schmidt-Wulffen zu zitieren, Zeit geworden ist, von der Legende der Rückwärtsgewandtheit der 80er endlich Abschied zu nehmen.[5] In diesem Sinne lässt sich medienunspezifischer argumentieren, denn Konzeptualität knüpft sich kaum alleine an einzelne künstlerische Medien. Die Kunst in den 80er Jahren war denn auch vielfältig, denke man nur an die aufkommende Becher-Schule, an Neo-Geo, Simulationismus, an aktionistische und feministische Strategien, die so genannten Modellbauer und wie die zahlreichen künstlerischen Haltungen sonst noch benannt wurden. Es fällt auf, dass eben diese Diversifizierung, die nicht zuletzt ein einflussreicher Markt erforderlich gemacht

hatte, mit der Einführung vieler Kunstlabels korrespondiert. Die Ausstellung »Flashback« reinszeniert jedoch keine unverbindliche Vielheit, sondern versucht im Gegenteil, vielstimmig eine Fokussierung auf heute noch virulente und relevante künstlerische Positionen vorzunehmen. Das Roundtable-Gesprächs, das gewissermassen als Leitlinie fungiert, wurde von den beteiligten Künstlerinnen und Künstlern mit Kommentaren und Statements bereichert, um sich der ephemeren Wirklichkeit eines Jahrzehnts in irgendeiner Art und Weise zu nähern.

This permits us to argue in less media-specific terms, because conceptualism is hardly linked with any one artistic medium. The art of the 1980s was accordingly manifold in character. One need only recall the emergent Becher School, Neo-Geo, Simulationism and feminist and actionistic strategies, the so-called "model builders," and whatever other names were attached to the numerous approaches of the day. Interestingly, this very diversification, prompted not least by the demands of an influential market, went hand in hand with the introduction of a plethora of labels.

Whatever the case, "Flashback" does not set out to reconstruct any arbitrary variety. On the contrary, it attempts to bring into focus a diversity of artistic positions that have remained vital and relevant to this day. The roundtable discussion that formed the kernel of our consideration has been supplemented and enriched by comments and statements by the participating artists to shed further light on the ephemeral character of a decade.

1 Vgl. insbesondere folgende Ausstellungskataloge:
 »Culture and Commentary. An Eighties Perspective«, Hirshhorn
 Museum, Washington 1990; »The Decade Show. Frameworks of
 Identity in the 1980s«, The Museum of Contemporary Hispanic
 Art, New Museum of Contemporary Art, The Studio Museum Harlem,
 New York 1990; »Devil on the Stairs. Looking Back on
 the Eighties«, Institute of Contemporary Art, Philadelphia
 1991; »Around 1984«, P.S.1 Contemporary Art Center,
 New York 2000, sowie »East Village USA«, New Museum of
 Contemporary Art, New York 2005.
 Vgl. ebenso: »Artforum International«, März und April, 2003,
 sowie Alison Pearlman, »Unpackaging Art of the 1980s«,
 Chicago 2003.

2 Diedrich Diederichsen, ›Im Kino onanierend‹, in: »Obsessive
 Malerei: Ein Rückblick auf die Neuen Wilden«,
 Ausst.-Kat. Museum für Neue Kunst ZKM, Karlsruhe 2003, S. 170.

3 Douglas Crimp, ›Pictures‹, in: »Image – images: Positionen zur
 zeitgenössischen Fotografie«, hrsg. von Tamara Horakova,
 Ewald Maurer u. a., Wien 2001, S. 120-138. Vgl. ebenso Claudia
 Gould und Valerie Smith (Hrsg.), »5000 Artists Return to the
 Artists Space: 25 Years«, New York 1998.

4 Vgl. Anne Rorimer, ›Photography – Language – Context: Prelude
 to the 1980s‹, in: »A Forest of Signs. Art in the Crisis
 of Representation«, Ausst.-Kat. Museum of Contemporary Art,
 Los Angeles 1989.

5 Stephan Schmidt-Wulffen, ›Abschied von Echternach‹, in:
 »Obsessive Malerei«, a. a. O., S. 75.

1 See especially the following exhibition
 catalogues: "Culture and Commentary.
 An Eighties Perspective," Hirshhorn
 Museum (Washington, D.C., 1990);
 "The Decade Show. Frameworks of Identity
 in the 1980s," The Museum of
 Contemporary Hispanic Art, New Museum of
 Contemporary Art, The Studio Museum
 Harlem (New York, 1990); "Devil on the
 Stairs. Looking Back on the Eighties,"
 Institute of Contemporary Art
 (Philadelphia, 1991); "Around 1984,"
 P.S.1 Contemporary Art Center (New York,
 2000); and "East Village USA,"
 New Museum of Contemporary Art
 (New York, 2005).
 See also the March and April 2003 issues
 of Artforum International, and Alison
 Pearlman, "Unpackaging Art of the 1980s"
 (Chicago, 2003).

2 Diedrich Diederichsen, "Im Kino
 onanierend," exh. cat. "Obsessive
 Malerei: Ein Rückblick auf die
 Neuen Wilden," Museum für Neue Kunst ZKM
 (Karlsruhe, 2003), p. 170.

3 Douglas Crimp, "Pictures," October 8
 (spring 1979), pp. 75-88; and
 "5000 Artists Return to the Artists
 Space: 25 Years," ed. Claudia Gould and
 Valerie Smith (New York, 1998).

4 See Anne Rorimer, "Photography–
 Language–Context: Prelude to the 1980s,"
 exh. cat. "A Forest of Signs.
 Art in the Crisis of Representation,"
 Museum of Contemporary Art (Los Angeles,
 1989).

5 Stephan Schmidt-Wulffen, "Abschied von
 Echternach," in: "Obsessive Malerei"
 (as in note 2), p. 75.

DIE 80ER JAHRE SIND UNTER UNS

Roundtable-Gespräch
Basel, 18. Juni 2005

Mit John M Armleder, Benjamin H. D. Buchloh,
Werner Büttner, Isabelle Graw,
Kasper König, Jutta Koether und Thomas Ruff.
Moderiert von Philipp Kaiser

PHILIPP KAISER: Wann genau beginnen
 eigentlich die 80er Jahre in der Kunst,
 und welche Anzeichen von Veränderung
 waren damals spürbar?
BENJAMIN H. D. BUCHLOH: Die 80er begannen
 mit dem Ende der konzeptuellen Kunst,
 die sich bis in die Mitte der 70er Jahre
 gerettet hat und institutionalisiert
 wurde. Im Gegenzug zur konzeptuellen
 Kunst – und der Gegenzug war natürlich
 vielfältig und kompliziert – kann man von
 einer Formation der 80er sprechen.
 Diese reicht von den Künstlern, die so-
 wohl in Europa als auch in den USA
 mit fotografischen Bildwelten umgegangen
 sind, bis hin zu den Wiederentdeckern
 der Malerei, die sich als Gegenpol
 zur konzeptuellen Kunst positioniert
 haben. Konzeptuelle Kunst erschien vielen
 als Sackgasse oder als Entleerung,
 die vermutlich mit einer neuen Plénitude,
 einem neuen Reichtum von sinnlicher
 Erfahrung, kompensiert werden sollte. Das
 ist für mich der Anfang.
ISABELLE GRAW: Könnte man nicht sagen, dass
 der Blick zurück und der Kult der 80er
 Jahre – mit dem wir uns in der Mode sowie
 in der bildenden Kunst konfrontiert
 sehen – immer auch Produkte einer retros-
 pektiven Verklärung sind?

THE 80s ARE IN OUR MIDST

Roundtable Discussion
Basel, June 18, 2005

With John M Armleder, Benjamin H. D.
Buchloh, Werner Büttner,
Isabelle Graw, Kasper König, Jutta
Koether, and Thomas Ruff.
Moderated by Philipp Kaiser

PHILIPP KAISER: When precisely do
 you locate the beginning of the
 eighties in art, and what
 signs of change were noticeable
 at that time?
BENJAMIN H. D. BUCHLOH: The eighties
 began with the end of conceptual
 art that survived into the
 middle of the seventies and had
 become institutionalized. One
 could say that a countermove to
 conceptual art—and the
 countermove was of course
 multifaceted and complex—was one

formation of the eighties. This
ranges from when those
artists who both in Europe and
the U.S. started dealing with
photographic visual worlds to the
rediscoverers of painting who
positioned themselves as a
counterpole to conceptual art. To
many, conceptual art seemed
to be a dead end or a depletion,
which they probably wanted to
compensate with a new
"plenitude," a new richness of
sensual experience. For me,
that's the beginning.

ISABELLE GRAW: Might we not say that
looking back and the cult of the
eighties—something we are
confronted with both in art and
in fashion—are always also
products of a retrospective
idealization? This thinking in
decades may be helpful for
organizing material, but at the
same time it is falsely
disambiguating, because breaks
are posited and continuities
are overlooked. After all, there
were also conceptual practices in
the eighties. Maybe we could
agree to speak of a new
constellation: we are dealing
neither with an absolute paradigm
shift nor with mere continuity,
but rather a specific
constellation that needs to be
analyzed, where we can't
assume that anything has come to
an end or something new started.
I doubt that we'll make much
progress by thinking in decades
and positing a break if we
want to do justice to both the
simultaneities and non-
simultaneities.

JUTTA KOETHER: There are definitely
certain starting points we can
name. I would put the
beginning at the end of the
1970s, with Douglas Crimp's 1977
exhibition "Pictures," the

22

Das Dekadendenken ist zwar einerseits hilfreich, um Material zu organisieren, andererseits aber falsch verein-deutigend, weil Brüche postuliert und Kontinuitäten übersehen werden. Auch in den 80ern hat es schliesslich konzep-tuelle Praktiken gegeben. Vielleicht könnte man sich darauf einigen, von einer neuen Konstellation zu sprechen: Man hat es weder mit einem absoluten Paradigmenwechsel noch mit blosser Kontinuität zu tun, sondern mit einer spezifischen Konstellation, die es zu analysieren gilt und bei der man nicht davon ausgehen kann, dass irgendetwas zu einem Ende gekommen sei oder neu anfangen würde. Ich bezweifle, dass wir mit dem Dekadendenken und der Behauptung eines Bruches weiterkommen und den Gleichzeitigkeiten und Ungleich-zeitigkeiten tatsächlich gerecht werden.

JUTTA KOETHER: Es gibt sicher bestimmte Anfangspunkte, die benannt werden können. Ich würde den Beginn Ende der 70er Jahre ansetzen, bei Douglas Crimps Aus-stellung »Pictures« von 1977, der Transavanguardia und den Neuen Wilden. Aber auch in anderen kulturellen Bereichen änderte sich einiges, so in der Musik: Reggae tauchte auf und kurz davor Punk Rock, der gewissermassen eben-falls eine expressionistische Äusserungs-form darstellt. Es ist der Versuch, sich anders als vorher zu artikulieren.

BENJAMIN H. D. BUCHLOH: Aber es handelt sich auch um die Konstellation einer neuen Generation und eine sich neu entwickelnde Art der Subjektivitätsstruktur. Künstlerinnen wie Sherrie Levine, Jenny Holzer, Barbara Kruger und Louise Lawler haben sich von Anfang an auf Transavanguardia and the Neue Wilde. But in other cultural areas as well quite a bit was changing: in music, for example, reggae appeared, and shortly before that punk rock, which also in a way represents an expressionist form of articulation. It is the attempt to express oneself differently than before.

BENJAMIN H. D. BUCHLOH: But it is also the constellation of a new generation and a newly developing kind of subjectivity structure. Artists like Sherrie Levine, Jenny Holzer, Barbara Kruger, and Louise Lawler referred back to conceptual art from the very start. Their counterposition was decisively influenced by feminist thinking, Pop Art, and institutional critique. They introduced a completely new position to distance themselves as a generation or to detach themselves from the heritage of Pop Art, and to set up something to counter conceptual art. This is not a problem of decades, but a group or generational formation.

WERNER BÜTTNER: It's a coincidence that this corresponds to the decade of the 1980s, even if it started already in the 1970s. There was a generation of 25-, 26-, 27-year-olds who were rebellious and wanted and needed to set themselves apart from the old guys. And if up to then everything had been white, straight, and angular, from then on it had to be colorful, bent, and terrible. This is how generational changes are, or how generations deal with each other: differentiating themselves from each other.

ISABELLE GRAW: Is it appropriate to

reproduce the historiography up to now and to assume a polarization of conceptual art and so-called neo-expressionism? Especially since there were indeed conceptual approaches among the supposedly "wild" painters.

BENJAMIN H. D. BUCHLOH: Really?

JUTTA KOETHER: Yes, absolutely.

BENJAMIN H. D. BUCHLOH: Where?

ISABELLE GRAW: Just as there are artists in the concept- and appropriation-line in whose works there are remnants of an expressive subjectivity, one could characterize the approaches of Martin Kippenberger or Albert Oehlen as critical appropriation or a special form of institutional critique.

JOHN M ARMLEDER: I'm a pragmatic person. If you ask me when the 1980s started, I say at the end of 1979. All the diseases and crises of the 1980s had already been there before. But what are we talking about? When we discuss the 1980s, we speak about politics and economics, which at that time in the Western world were changing radically and gave everything a different direction. It was a profound change that led to dramatic shifts in all sorts of areas. We are not concerned with ideology and with evaluating what was better or worse.

KASPER KÖNIG: If we speak of politics, we must mention Margaret Thatcher, Ronald Reagan, and Helmut Kohl. For me, the eighties also begin in 1979. From the perspective of the Rhineland, the change can be described in the following way: generally understandable, consumable art became increasingly important. Within the well-functioning art scene in

konzeptuelle Kunst bezogen. Ihre Gegen-position, die sie im Dialog mit konzep-tueller Kunst entwickelt haben, wurde wesentlich durch feministisches Denken, Pop Art sowie institutionelle Kritik beeinflusst. Sie bringen eine ganz neue Position ein, um sich als Generation abzusetzen oder abzulösen und dem Erbe der Pop Art und konzeptuellen Kunst etwas entgegenzusetzen. Das ist nicht ein Dekadenproblem, sondern eine Gruppen- oder Generationsformation.

WERNER BÜTTNER: Es ist ein Zufall, dass dies mit der Dekade der 80er Jahre übereinstimmt, auch wenn es bereits in den 70ern angefangen hat. Es gab eine Generation der 25-, 26-, 27-Jährigen, die rebellisch war und sich von den Alten unterscheiden wollte und musste. Und wenn bisher alles weiss, gerade und eckig war, musste es von nun an bunt, krumm und schrecklich sein. Das ist so bei Generationenwechseln, beziehungsweise so gehen Generationen miteinander um: sich voneinander absetzend.

ISABELLE GRAW: Ist es angemessen, die bisherige Geschichtsschreibung zu reproduzieren und von einer Polarisierung zwischen Konzeptkunst und so genanntem Neoexpressionismus auszugehen? Zumal es unter den vermeintlich Wilden Malern durchaus konzeptuelle Ansätze gegeben hat.

BENJAMIN H. D. BUCHLOH: Wirklich?

JUTTA KOETHER: Ja, absolut.

BENJAMIN H. D. BUCHLOH: Wo?

ISABELLE GRAW: So wie es Künstler der Konzept- und Appropriation-Linie gibt, in deren Arbeiten sich Reste einer expressiven Subjektivität finden, könnte man das Vorgehen von Martin Kippenberger

the Rhineland one had—based on the liveliness of current art—the illusion of being cosmopolitan. I can remember that artists like Jiri Dokoupil and Walter Dahn started to work conceptually, and then executed this in a gestural fashion. There was certainly a desire to get away from all that cerebral stuff.

BENJAMIN H. D. BUCHLOH: That it had to be done in painting was specifically German.

KASPER KÖNIG: Michael Werner in Cologne not only showed painters in his gallery, but also artists like Georges Brecht, Stanley Brouwn, and Niele Toroni, and later took an absolutely hard position and only looked after the core business of painting. His decision reflected the market intelligently.

BENJAMIN H. D. BUCHLOH: Such a change can best be traced with Michael Werner as a case in point, because he showed and supported Jörg Immendorff initially as a conceptual artist, but then redefined him as a pure painter. He acted the same way with Anselm Kiefer, who started as a postconceptual artist with photography books. That had nothing at all to do with painting.

KASPER KÖNIG: I think was John M Armleder said is right: the eighties have to be looked at first of all economically. Not that that was the mood then, but that is when the directions were set.

ISABELLE GRAW: What emerged in the 1980s is only becoming clear nowadays: the new definitional power of the market. Artistic criteria were replaced by economic ones. The point about Michael Werner and Jörg Immendorff is extremely important

oder Albert Oehlen als kritische Appropriation oder besondere Form der Institutionskritik charakterisieren.

JOHN M ARMLEDER: Ich bin eine pragmatische Person. Wenn Sie mich fragen, wann die 80er Jahre begannen, dann sage ich Ende 1979. Alle Krankheiten und Krisen der 80er Jahre waren vorher schon da. Doch worüber reden wir? Wenn wir über die 80er diskutieren, reden wir über Politik und Ökonomie, die sich zu dieser Zeit in der westlichen Welt radikal veränderten und allem eine andere Richtung gaben. Es handelte sich um eine gravierende Veränderung, die Umwälzungen in den verschiedensten Bereichen zur Folge hatte. Es geht nicht um Ideologie und darum, zu evaluieren, was besser oder schlechter war.

KASPER KÖNIG: Wenn Sie von Politik reden, dann müssen wir Margaret Thatcher, Ronald Reagan und Helmut Kohl erwähnen. Für mich beginnen die 80er ebenfalls 1979. Aus der Perspektive des Rheinlands kann der Wechsel folgendermassen beschrieben werden: Allgemein verständliche Kunst zum Konsumieren wurde zunehmend wichtig. Innerhalb des gut funktionierenden Kunstbetriebs des Rheinlands hatte man aufgrund der Lebendigkeit aktueller Kunst die Illusion, kosmopolitisch zu sein. Ich kann mich erinnern, dass Künstler wie Jiri Dokoupil und Walter Dahn angefangen haben, konzeptuell zu arbeiten, und dies dann gestisch ausgeführt haben. Es gab mit Sicherheit das Bedürfnis, von all dem verkopften Zeugs wegzukommen.

BENJAMIN H. D. BUCHLOH: Dass es sich hierbei um Malerei handeln musste, war spezifisch deutsch.

Die 80er Jahre fehlen mir überhaupt nicht. Ich bin froh, dass sie vorbei sind. Mal abgesehen von unserer Jugend … wir waren alle so jung.

I miss nothing about the 80s, I'm glad they're gone. Except for our youth... we were all so young.

CINDY SHERMAN

KASPER KÖNIG: Der Galerist Michael Werner in Köln stellte parallel zu den Malern auch Künstler wie Georges Brecht, Stanley Brouwn oder Niele Toroni aus, um hinterher eine absolut harte Position einzunehmen und sich nur noch um das Kerngeschäft Malerei zu kümmern. Seine Entscheidung war intelligent im Markt reflektiert.

BENJAMIN H. D. BUCHLOH: Bei Michael Werner kann man einen solchen Wechsel am besten nachvollziehen, weil er Jörg Immendorff zunächst als konzeptuellen Künstler ausgestellt und gefördert hat, ihn dann aber zum reinen Maler umdefinierte. Genauso ist er mit Anselm Kiefer verfahren, der als post-konzeptueller Künstler mit Fotobüchern angefangen hat. Das hatte überhaupt nichts mit Malerei zu tun.

KASPER KÖNIG: Was John M Armleder gesagt hat, halte ich für richtig: Die 80er Jahre müssen zunächst einmal ökonomisch betrachtet werden. Nicht, dass das die Stimmung gewesen wäre, aber damals wurden die Weichen gestellt.

ISABELLE GRAW: Was sich in den 80ern ab-zeichnete, kristallisiert sich erst heute heraus: die neue Definitionsmacht des Kunstmarkts. An die Stelle von künstlerischen Kriterien sind ökonomische getreten. Der Punkt mit Jörg Immendorff und Michael Werner ist in diesem Zusammenhang extrem wichtig. Immendorff als Künstler mit politischer Agenda — ob man diese ernst nimmt oder nicht ist eine andere Frage, aber der Galerist Werner hat seinen Austritt aus dem Kollektiv forciert und ihn zum Solitär stilisiert, der mit A. R. Penck eine Art Bruderschaft pflegt. Etwas Ähnliches

in this context. Immendorff as an artist with a political agenda—whether or not one takes that seriously is another question—but Michael Werner encouraged his leaving the collective and stylized him into a solitaire who maintains a kind of brotherhood with A. R. Penck. Something similar is true for Markus Lüpertz who at the end of the 1970s participated in Fluxus performances, had dealings with Wolf Vostell, and ran self-organized exhibition rooms. He, too, went to the Rhineland and was pushed as a painter genius.

WERNER BÜTTNER: Not everything was merely regional. The eighties for me were also the well-functioning network between the Rhineland, the Netherlands, and Switzerland with Jean-Christophe Ammann.

KASPER KÖNIG: Ammann put on sophisticated exhibitions in Lucerne, whereas in Basel he focused strongly on new talents. All the sophistication was suddenly gone, and Basel played an important role as an economically strong site. What John M Armleder in Geneva did remained rather more isolated. I think most things went on rather regionally after all.

PHILIPP KAISER: Can we see international stimuli despite the regionalist emphasis in art?

BENJAMIN H. D. BUCHLOH: It's interesting that a group of American women artists at the end of the 1970s consciously engaged with artists like Hans Haacke, Dan Graham, and Lawrence Weiner. Both this engagement, as well as Pop Art and especially Andy Warhol, were important. Cindy Sherman is unthinkable

gilt ja auch für Markus Lüpertz, der
sich Ende der 70er Jahre in Fluxus-
Performances engagierte, mit Wolf Vostell
zu tun hatte und selbst organisierte
Räume betrieben hat. Auch er ging
ins Rheinland und wurde zu einem Maler-
genie aufgebaut.

WERNER BÜTTNER: Es war nicht alles
nur regional. Die 80er waren für mich
auch das funktionierende Netzwerk
zwischen dem Rheinland, Holland und der
Schweiz mit Jean-Christophe Ammann.

KASPER KÖNIG: Ammann hat in Luzern
differenzierte Ausstellungen organisiert,
während er in Basel ganz stark auf neue
Talente fokussierte. Jegliche
Differenzierung war plötzlich weg, und
Basel spielte als ökonomisch fundierter
Ort eine wichtige Rolle. Was John M
Armleder in Genf gemacht hat, blieb
dagegen eher isoliert. Ich glaube, dass
alles mehr regional abgelaufen ist.

PHILIPP KAISER: Können nicht trotz dieser
stark regionalistischen Prägung der
Kunst auch internationale Impulse aus-
gemacht werden?

BENJAMIN H. D. BUCHLOH: Es ist interessant,
dass sich eine Gruppe amerikanischer
Künstlerinnen Ende der 70er Jahre bewusst
mit Künstlern wie Hans Haacke, Dan
Graham oder Lawrence Weiner auseinander
gesetzt haben. Sowohl diese Auseinander-
setzung als auch die Pop Art und
insbesondere Andy Warhol waren wichtig.
Cindy Sherman ist ohne die totale
Umkehrung der Warhol'schen Prinzipien
undenkbar. Die 80er Jahre wurden in
erster Linie von einem expliziten Dialog
mit der Pop Art dominiert.

KASPER KÖNIG: Cindy Sherman ist retrospektiv
die ganz grosse Figur der 80er Jahre.

without the total reversal of Warhol's principles. The 1980s were first and foremost dominated by an explicit dialogue with Pop Art.

KASPER KÖNIG: Looking back, Cindy Sherman is the great figure of the eighties.

BENJAMIN H. D. BUCHLOH: Pop Art has to be introduced into this discussion because the marketing of art did not just start in the 1980s. Art and commerce had already fused by then.

KASPER KÖNIG: A heads-up about Warhol: Initially he was regarded in New York as a gay, commercial, and vulgar artist, and was not accepted by the art world there. In Europe, the complexity of Warhol's Factory and his travesty of Hollywood was recognized earlier.

JUTTA KOETHER: Apart from Sherrie Levine, there was a strong Warhol reception by Nature Morte and other parts of the East Village scene who did not reflect the funny international stage, but a counterpart. It was a model for also thinking in terms of popular culture.

WERNER BÜTTNER: Warhol was the only living American artist I took any notice of; all the others were Europeans. Joseph Beuys, Dieter Roth, Sigmar Polke, and Jörg Immendorff—they interested me; that was where one looked, where one helped oneself, learning.

BENJAMIN H. D. BUCHLOH: Not Gerhard Richter?

WERNER BÜTTNER: Yes. Only one cannot build up an emotional close-ness to Richter. One learned from Warhol's book "From A to B and Back Again" that one need not shy away from economic success. And when the media started reporting about the boom, the applications at the academies

BENJAMIN H. D. BUCHLOH: Pop Art muss in diese Diskussion eingeführt werden, weil die Vermarktung der Kunst nicht erst in den 80ern beginnt. Kunst und Kommerz haben schon damals fusioniert.

KASPER KÖNIG: Ein Klimmzug in Sachen Warhol: Anfangs wurde er in New York als schwuler, kommerzieller und vulgärer Künstler betrachtet und von der dortigen Kunstwelt nicht akzeptiert. In Europa hat man die Komplexität der Warhol'schen Factory und seiner Hollywood-Travestie früher erkannt.

JUTTA KOETHER: Warhol wurde abgesehen von Sherrie Levine ganz stark von Nature Morte und anderen Teilen der East-Village-Szene rezipiert, die eben nicht die lustige, internationale Bühne, sondern ein Pendant reflektierten. Es war ein Modell, Popkultur mitzudenken.

WERNER BÜTTNER: Warhol war der einzige lebende amerikanische Künstler, den ich zur Kenntnis nahm, alle anderen waren Europäer. Joseph Beuys, Dieter Roth, Sigmar Polke und Jörg Immendorff – die haben mich interessiert, und da hat man hingeguckt und sich lernend bedient.

BENJAMIN H. D. BUCHLOH: Gerhard Richter nicht?

WERNER BÜTTNER: Doch auch. Nur kann man zu Richter keine emotionale Nähe aufbauen. Warhols Buch »From A to B and Back Again« brachte einem bei, dass man vor dem ökonomischen Erfolg keine Scheu haben musste. Und als die Medien anfingen, über den Boom zu berichten, stiegen die Bewerbungszahlen an den Akademien: Statt hundert haben sich nun tausend Studenten beworben. Von da an durften auch Ärzte- und Rechtsanwaltskinder Kunst studieren. So waren die schönen 80er.

ISABELLE GRAW

PHILIPP KAISER

Lassen Sie mich mit einer groben Verallgemeinerung beginnen, einem Szenario, das aufzeigt, weshalb die 80er so anders und speziell waren.

In den 50er und 60er Jahren war die Legitimation der Kunst auf Philosophen und Kritiker angewiesen, in den 70ern auf den Kurator. In den 80er Jahren verdankte sie ihre Legitimation minoritären Gruppen, deren Belange sie vertrat, in den 90ern dem Händler, und in der ersten Dekade des neuen Jahrtausends ist schliesslich der Sammler die entscheidende Figur.

Wenn man die Dinge so betrachtet, waren die 80er Jahre eine verrückte, fabelhafte und aufregende Zeit, die niemand vorhergesehen hatte. Wir wurden Zeuge des Zusammenbruchs einer Ästhetik, die sich als zu restriktiv und zu exklusiv erwiesen hat. Einer Ästhetik, deren universelle Werte nicht allgemeingültig waren und die das Tempo, das die Welt generell und vor allem der Kunstbetrieb vorgelegt hatten, nicht mehr mithalten konnte. Es gab damals eine Reihe von Faktoren, die einen gewissen Druck erzeugten: die Frage von Rasse und Gender, feministische Anliegen, die figurative Kunst, die Dezentralisierung der Finanz- und Medienmärkte, der Versuch, nationale Identität als neuen internationalen Stil zu deklarieren, schnell verfügbare und preiswerte Reiseangebote sowie bezahlbare Computer, das Internet und jpeg. Dieser Druck stürzte den Kunstbetrieb in eine Art herrliches, feierliches Chaos. Für eine kurze Zeitspanne gab es keine stilistische Vorherrschaft, kein verbrieftes Anrecht auf den Thron. Radikal war nicht etwa das Kunstwerk selbst, sondern der historische Augenblick. Die 80er waren nicht allein von der Jugend, von dem Wunsch nach etwas Neuem, einem – neuen – Stil getrieben. Diese Jahre gehörten weder der Avantgarde, noch waren sie bloss reaktionär. Alles war im Fluss, alles war erlaubt und vor allem war alles unberechenbar.

Let me start with a gross generalization. This is a scenario that sets up what makes the eighties different and special.

In the fifties and sixties, art was empowered by the philosopher/critic. In the seventies, it was the curator. In the eighties, art was empowered by the minority interest groups it sought to represent. In the nineties, it was empowered by the dealer, and in the first decade of the new millennium, the collector empowers it.

So with that in mind, let me say that the eighties was a mad fabulous exciting time that no one had predicted. We saw the breakdown of aesthetics that had proved too restrictive, too exclusive, to keep pace with the speed at which the world in general and the art world in particular was moving. An aesthetic in which universal values proved not to be universal. The pressures brought to bear by race and gender and feminist issues; by figuration and image-based art; by the decentralization of the financial and media markets; by the attempt to make national identity the new International Style; by quick, affordable travel and the computer, the internet, and the jpeg caused the art world to tumble into a kind of wonderful, celebratory chaos. It was, for a brief moment, a time in which there was no stylistic primogenitor; no guaranteed ascension to the throne. What was radical was not the art work per se but the moment itself. The eighties was not merely youth driven or new driven or style driven. It was no longer about the avant-garde, nor was it simply reactionary. It was fluid, it was inclusive, and above all, it was uncertain.

ERIC FISCHL

BENJAMIN H. D. BUCHLOH: Was war mit Marcel Broodthaers?

WERNER BÜTTNER: Er war selbstverständlich ein Riesenidol.

BENJAMIN H. D. BUCHLOH: Aber wenn Broodthaers Ende der 70er Jahre ernsthaft rezipiert worden wäre, hätte man denn dann gemalt?

WERNER BÜTTNER: Es musste ja gemalt werden.

BENJAMIN H. D. BUCHLOH: Wieso?

WERNER BÜTTNER: Weil es von den Minimalisten und Konzeptkünstlern verboten war. Die Malerei war das Letzte, spiessig, ruiniert und tot. Das konnte man einfach nicht mehr machen, also musste man es tun.

BENJAMIN H. D. BUCHLOH: Weil es ein Vaterverbot war.

WERNER BÜTTNER: Ja. Man malte, damit man sich davon absetzte.

ISABELLE GRAW: Es ging um das Pathos des Tabubruchs. Das war ein grosses Thema der frühen 80er Jahre.

BENJAMIN H. D. BUCHLOH: Aber auf Sie, Thomas Ruff, traff das nicht zu. Für Sie war Fotografie eben wichtig, wie die Bechers, und eben nicht die Gruppe, die Büttner gerade erwähnt hat.

THOMAS RUFF: 1980 war ich 22 Jahre alt und studierte in der Klasse von Bernd Becher an der Kunstakademie in Düsseldorf. Ich bin auf dem Land aufgewachsen und hatte die letzten drei Jahre auf dem Gymnasium keinen Kunstunterricht mehr. Zeitgenössische Kunst habe ich erst auf der Akademie kennen gelernt. Da wir als Studenten nicht viel Geld hatten, sind wir nur nach Aachen, Krefeld oder Köln zu Ausstellungen gefahren. Paris, Berlin oder gar New York kamen nicht infrage. Die Fotografie war damals

rose. Instead of a hundred applications, there were now a thousand. From then on, the children of doctors and lawyers were also allowed to study art. That is how the beautiful 1980s were.

BENJAMIN H. D. BUCHLOH: How about Marcel Broodthaers?

WERNER BÜTTNER: He was of course a huge idol.

BENJAMIN H. D. BUCHLOH: But if Broodthaers had received a serious reception in the late seventies, would one have painted then?

WERNER BÜTTNER: But one had to paint.

BENJAMIN H. D. BUCHLOH: Why?

WERNER BÜTTNER: Because it had been forbidden by the minimalists and conceptual artists. Painting was terrible, bourgeois, ruined, and dead. You simply couldn't do it anymore, so it had to be done.

BENJAMIN H. D. BUCHLOH: Because it was paternally proscribed?

WERNER BÜTTNER: Yes. You painted in order to distance yourself from that.

ISABELLE GRAW: It was all about the pathos of taboo breaking. That was a big topic of the early 1980s.

BENJAMIN H. D. BUCHLOH: But this didn't apply to you, Thomas Ruff. For you, photography was important, like the Bechers, and not the group mentioned by Büttner just now.

THOMAS RUFF: In 1980 I was twenty-two years old and a student in Bernd Becher's class at the Kunstakademie in Düsseldorf. I grew up in the countryside and for the final three years of school, I had no art classes. I only encountered contemporary art at the academy. Since as students we didn't have much money, we

in der Kunst ein Nebenschauplatz, nur wenige Leute interessierten sich für sie. Im Prinzip war sie ein leerer Acker, auf dem in den letzten fünfzig Jahren nichts »Wichtiges« passiert war. Wir sahen uns in der Tradition der sachlichen Fotografie der 20er Jahre, an die als erste Bernd und Hilla Becher wieder anknüpften. Es gab absolut nichts, gegen das man kämpfen oder gegen das man sich absetzen musste. Wir konnten bei null anfangen.

PHILIPP KAISER: Wie lässt sich die spezifische Situation einer radikalen Polarisierung, wie sie für die 80er Jahre konstitutiv war, präzisieren?

ISABELLE GRAW: Es gab in den 80ern noch Lagerkämpfe. Das ist insofern interessant, weil sich das künstlerische Feld heute weniger agonal organisiert. Es herrscht friedliche Koexistenz. Ich würde so weit gehen, das Ende der Programmgalerie zu diagnostizieren. Heute kooperieren Galerien miteinander und einigen sich auf bestimmte Künstler. Damals verfügte man noch über klare Feinde und Fronten – das hatte vielleicht auch mit der Konstellation während des Kalten Krieges zu tun. Heute ist es schwer vorstellbar, mit einem klaren Feindbild zu operieren. Damals wusste man, wogegen man ist.

BENJAMIN H. D. BUCHLOH: Das hatte nichts mit dem Kalten Krieg zu tun, sondern damit, dass Künstler und Kulturproduzenten sich für Projekte engagiert hatten, in denen die Perspektive noch eine integrale Dimension künstlerischer Praxis war.

WERNER BÜTTNER: Es gab damals auch eine schöne und gesunde Konkurrenz. Es war

only went to Aachen, Krefeld, or Cologne to see exhibitions. Paris and Berlin, let alone New York, were out of the question. Photography at that time was just on the sidelines, only a few people were interested in it. Basically, it was an empty field on which nothing "important" had happened over the past fifty years. We saw ourselves in the tradition of the objective photography of the 1920s, which the Bechers were the first to pick up again. There was absolutely nothing against which we needed to fight or from which we had to distance ourselves. We could start with nothing.

PHILIPP KAISER: How could we precisely grasp the specific situation of radical polarization that constituted the 1980s?

ISABELLE GRAW: In the 1980s, everything was still dominated by conflicts between antagonistic camps. That's interesting because today the artistic field is organized less agonistically. Today, we have peaceful coexistence. I would go as far as diagnosing the end of the program gallery. Today, galleries cooperate with each other and agree on certain artists. Then, there were still clear enemies and front lines—perhaps that had something to do with the constellation during the Cold War. Today it's difficult to imagine operating with a clear notion of an enemy. In the 1980s you knew what you were against.

BENJAMIN H. D. BUCHLOH: That had nothing to do with the Cold War, but rather with the fact that artists and cultural producers were committed to projects in which the

perspective was still an integral dimension of artistic practice.

WERNER BÜTTNER: At that time, there was also some nice healthy competition. It was clear that our group was against the Mühlheimer Freiheit. We didn't like what they did, just as we didn't like what the so-called Berliners did, and vice versa. At the beginning there was a lot of clamor to draw attention to oneself: the 1980 show "Aktion Pisskrücke (Geheimdienst am Nächsten)" in Hamburg—even the title was impossible, noisy, and adolescent—then also in 1980 "Finger für Deutschland" in Immendorff's studio in Düsseldorf, and one year previously "Elend" in Kippenberger's office in Berlin. In the end, the gallerists came along and perfected the game.

ISABELLE GRAW: Julian Schnabel embodies this kind of polarization. He was the absolute embodiment of the enemy for those art historians and critics in the U.S. who supported the "Pictures" generation and for whom all painting—from Georg Baselitz to David Salle—was negotiated under the falsely simplifying and undifferentiating term "neo-expressionism." And neo-expressionism had to be combated, also because of its position on the market. It was provocation par excellence.

KASPER KÖNIG: Gang wars are too romantic. The case of Schnabel is interesting. Schnabel went to Düsseldorf, showed in a third-class gallery, and wanted to be in the neighborhood of Polke, Beuys, and Richter at all cost. And then at some point he returned to the U.S. a star.

JUTTA KOETHER: In the eighties

klar, dass unsere Gruppe gegen die Mühlheimer Freiheit war. Was die machten, fanden wir nicht gut, genauso wie wir die so genannten Berliner nicht gut fanden und umgekehrt. Am Anfang gab es viel Geschrei, um auf sich aufmerksam zu machen: die Ausstellung »Aktion Pisskrücke (Geheimdienst am Nächsten)« 1980 in Hamburg – schon der Titel war unmöglich, marktschreierisch und pubertär –, dann ebenfalls 1980 »Finger für Deutschland« in Immendorffs Atelier in Düsseldorf und ein Jahr zuvor »Elend« in Kippenbergers Büro in Berlin. Schliesslich kamen die Galeristen und vervollkommneten das Spiel.

ISABELLE GRAW: Julian Schnabel verkörpert diese Polarisierung geradezu. Er war ja das absolute Feindbild derjenigen Kunsthistoriker und -kritiker in den USA, die sich für die »Pictures«-Generation stark gemacht haben und für die sämtliche Malerei – von Georg Baselitz bis zu David Salle – unter dem falsch pauschalisierenden und undifferenzierten Begriff des »Neoexpressionismus« verhandelt wurde. Und »Neoexpressionismus« musste man, auch aufgrund seiner Stellung auf dem Markt, bekämpfen. Er war das rote Tuch schlechthin.

KASPER KÖNIG: Bandenkriege sind zu romantisch. Der Fall Schnabel ist interessant. Schnabel ist nach Düsseldorf gegangen, hat dort in einer drittklassigen Galerie ausgestellt und wollte unbedingt in der Nachbarschaft von Polke, Beuys und Richter sein. Irgendwann ist er dann als Star in die USA zurückgekehrt.

JUTTA KOETHER: Jeder hat in den 80ern sein Bestes gegeben, um sich gegenseitig zu traumatisieren, und jeder musste sich

everybody did their best to
traumatize each other, and every-
body had to expose themselves
in an extreme way to the new
situation. What could you do but
get into it? You had to accept
that an art market existed
and that the hegemonic powers had
been redistributed. At this
moment of roughing everything up,
you had to navigate and find
a system for yourself to act. At
that point, I shifted my career
to another medium. My goal was to
establish a platform that
enabled me to negotiate things
and to make a product that would
also work in a new market
system. I wanted to formulate a
product form without having
to give up my product. In my case
it was the acceptance of the
paradigm of painting and
its revalidation. This coincided
with a feeling that participating
means that there is something
worth participating in.

ISABELLE GRAW: You have to ask
anyway what was at stake and what
were you fighting against. I
myself was rather ambivalent: on
the one hand I liked the
presumptuous shift to the
supposedly anachronistic medium
of painting, on the other
hand, one was—especially as
a woman—affronted by the blatant
sexism or by Günther Förg,
who in Stuttgart got up and
screamed "Heil Hitler, you ass-
holes," by which he meant the
collectors, but at the same
time he pursued an anti-
enlightenment cult of taboo-
breaking. There were also
decidedly unpleasant aspects to
the 1980s.

WERNER BÜTTNER: Society's silence
about the German past led to such
actions.

JUTTA KOETHER: That's what I mean by

37

1970–1980

completing education
travelling
forgetting education
travelling
seizing kaiseraugst
women's movement
travelling
forgetting education
art
travelling
women's movement
art
leaving
art

1980–1990

returning
art
career
travelling
stationing of pershing II
career
fulda gap
art
travelling
career
leaving
art
staying away
chernobyl
career
schweizerhalle
art
travelling
career
travelling
art
returning
art
fall of the wall

1970–1980

ausbildung abschliessen
reisen
ausbildung vergessen
reisen
kaiseraugst besetzen
frauenbewegung
reisen
ausbildung vergessen
kunst
reisen
frauenbewegung
kunst
weggehen
kunst

1980–1990

wiederkommen
kunst
karriere
reisen
stationierung pershing II
karriere
fulda gap
kunst
reisen
karriere
weggehen
kunst
wegbleiben
tschernobyl
karriere
schweizerhalle
kunst
reisen
karriere
reisen
kunst
wiederkommen
kunst
mauerfall

MIRIAM CAHN

Für mich sind die 80er wie eine Ansammlung von Inseln, auf denen sich jeweils ganz unter-
schiedliche Sachen abgespielt haben. Obwohl es zwischen den einzelnen Entwicklungen
gewisse Übereinstimmungen gab, waren die Tendenzen relativ uneinheitlich. Die Insel, auf der
ich damals mit etlichen anderen Künstlern zu Hause war, verdankte ihre Entstehung dem
Diskurs der späten 60er und der 70er Jahre. Diese Künstler haben sich mit anthropologischen,
sozialen und konzeptuellen Fragen auseinander gesetzt.

 Mitte der 80er Jahre kam es dann wie aus heiterem Himmel zu einer Explosion. Alles
veränderte sich plötzlich, und man hatte den Eindruck, dass sich eine tief greifende
Umwertung anbahnte. Allerdings hat der Diskurs bei den Beteiligten offenbar nicht den Wunsch
geweckt, herauszufinden, was eigentlich vor sich ging – genau genommen gab es gar keinen
Diskurs.

I see the 80s as an archipelago, in which
different things were going on, on
different islands. They were going on
concurrently but not always moving in the
same direction. I was part of an island
of artists who evolved out of the
discourse of the late 60s and 70s, who
dealt with anthropological, social, and
conceptual issues.

 In the mid-80s there was a sudden ex-
plosion. Things were changing, and there
seemed to be a reevaluation happening.
But the discourse did not really
challenge participants to try to figure
out what was going on—actually, there was
no discourse.

HAIM STEINBACH

der neuen Situation extrem ausliefern. Was konnte man anderes tun, als sich darauf einzulassen? Man musste akzeptieren, dass es einen Kunstmarkt gibt und die hegemonialen Kräfte neu verteilt werden. In diesem Moment der »Aufmischung« musste man navigieren und selbst ein System finden zu agieren. Ich habe meine Karriere damals auf ein anderes Medium verlegt. Mein Ziel war es, eine Plattform zu etablieren, die es ermöglichte, Dinge zu verhandeln und ein Produkt herzustellen, das auch in einem neuen Marktsystem funktionierte. Ich wollte eine neue Produktförmigkeit formulieren, ohne mein Produkt abgeben zu müssen. In meinem Fall war es das Annehmen des Paradigmas Malerei und deren Neuvalidierung. Dies koinzidierte mit dem Gefühl, dass es, indem man partizipiert, etwas gibt, wo es sich lohnt, dabei zu sein.

ISABELLE GRAW: Man muss sich überhaupt fragen, was damals auf dem Spiel stand und wogegen man sich wehrte. Ich selbst war eher ambivalent: Einerseits gefiel mir das anmassende Setzen auf die vermeintlich anachronistische Malerei, andererseits wurde man – zumal als Frau – mit unverhohlenem Sexismus konfrontiert oder mit Günther Förg, der in Stuttgart aufstand und »Heil Hitler, ihr Arschlöcher« schrie und damit zwar die Sammler meinte, aber zugleich einen antiaufklärerischen Kult des Tabubruchs betrieb. Es gab auch ausgesprochen unangenehme Seiten der 80er Jahre.

WERNER BÜTTNER: Das Schweigen der Gesellschaft über die deutsche Vergangenheit führte zu solchen Aktionen.

JUTTA KOETHER: Das meine ich mit aktiv werden in jeder Hinsicht, sowohl inhaltlich als auch als Reaktion. Es war plötzlich möglich, sich vehement zu äussern, sich dieses Recht zu nehmen …

ISABELLE GRAW: Und die Geschichte auf sich zu nehmen. Man hatte diese sozialdemokratische Form der Vergangenheitsbewältigung satt, die man verlogen fand. Man grenzte sich auch gegen die Hippies ab und setzte stattdessen auf eine Politik der Zumutung.

WERNER BÜTTNER: Gegen Hippies und gegen Betroffenheitsgespräche. Doch jede Generation, die gehört werden will, muss so tun, als sei mit ihr der Untergang des Abendlandes gekommen. Die Leipziger Maler sind die erste Künstlergeneration, die nicht mehr kritisch und zerrissen ist, sondern einfach nur schön malt. Wohl darum lieben die Amerikaner das Zeugs.

PHILIPP KAISER: Wie war die Situation in anderen westeuropäischen Ländern?

BENJAMIN H. D. BUCHLOH: Es ist sehr wichtig, dass man differenziert zwischen national-kulturellen Praktiken, die universell lesbar sind, und national-kulturellen Praktiken, die regional retardiert und spezifisch bleiben oder regional kommunizieren, aber nicht darüber hinausgehen. In Frankreich gab es Phänomene, die ungemein aktiv waren und sich ausbreiteten, aber nie über den Ozean gekommen sind, nicht mal nach Deutschland, im Grunde nicht mal über Paris hinaus. In Italien haben Sie die Arte povera, die sehr erfolgreich war und für die europäische Kunstgeschichte bedeutsam ist, in den USA jedoch nur zögernd Anklang gefunden hat. Es ist wichtig zu fragen, warum

becoming active in every aspect, both in terms of content and as a reaction. It was suddenly possible to voice opinions vehemently, to take this right...

ISABELLE GRAW: And to take on history. You were just sick of this Social Democratic way of "mastering of the past" that seemed so dishonest. You also distanced yourself from the hippies and instead tried a politics of impertinence.

WERNER BÜTTNER: Against hippies and against an emotional political culture of guilt and shame. But every generation that wants to be heard must act as if it represents the end of Western civilization. The Leipzig painters are the first generation of artists who are no longer critical and torn; they just paint beautifully. That's probably why the Americans love that stuff.

PHILIPP KAISER: How was the situation in other West European countries?

BENJAMIN H. D. BUCHLOH: It is very important to differentiate between national cultural practices that are universally legible and national cultural practices that remain regionally limited or communicate regionally, but don't go beyond that. There were phenomena in France that were incredibly active and spread, but never made it across the ocean, not even to Germany—well, actually not even beyond Paris. In Italy, you've got arte povera, which was very successful and very significant for the European history of art, but was accepted in the U.S. only with some hesitation. It is important to ask why Oehlen, Büttner, and Kippenberger were so important

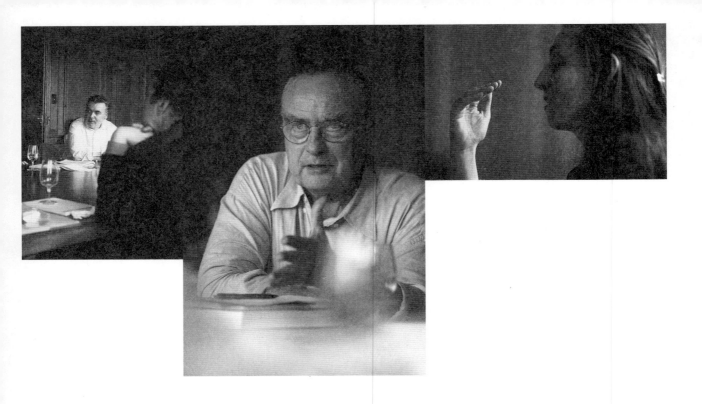

BENJAMIN H. D. BUCHLOH JUTTA KOETHER

with their painting in Europe, and why their reception in the U.S. was only brief or much later, as for example with Kippenberger. In America, it didn't go all that well.

WERNER BÜTTNER: That's not quite right. We were doing OK in America, but then Thomas Krens of the Guggenheim Museum in New York single-handedly ruined German painting. His exhibition "Refigured Painting: The German Image, 1960–88" at the end of the 1980s was so terribly organized and the museum was so stuffed with paintings that people were disgusted and said: "German painting is brown sludge." Chapeau, Thomas Krens!

BENJAMIN H. D. BUCHLOH: In return, it didn't work out all that well for the American generation, either. It took a while until American artists of the late 1970s and early 1980s like Sherrie Levine, Louise Lawler, and Richard Prince, finally arrived in Europe. There is a cultural border between the photographic post-conceptual practices of the Americans and the painterly post-conceptual practices of the Germans. I find it revealing that it still remains regionally specific. Who in Düsseldorf took an interest in Prince? This retardation, this delay and shift is interesting. Everything takes its time.

ISABELLE GRAW: But certain mediators are also required. Just think of the role that Donald Kuspit played for the enthusiastic reception of German painting on the U.S. art market. One person is required who does this work of translation that simplifies what is on offer and prepares it for the market by creating formulas for it.

Oehlen, Büttner und Kippenberger mit ihrer Malerei in Europa so wichtig gewesen sind und in den USA nur kurz oder erst sehr viel später rezipiert wurden, wie beispielsweise Kippenberger. In Amerika ist es doch nicht allzu gut verlaufen.

WERNER BÜTTNER: Das stimmt so nicht ganz. Wir waren in Amerika ziemlich gut unterwegs, aber dann hat Thomas Krens vom Guggenheim Museum in New York die deutsche Malerei souverän ruiniert. Seine Ausstellung »Refigured Painting. The German Image 1960–88« Ende der 80er Jahre war so grauenhaft organisiert und das Haus war so voll gehängt, dass die Leute angeekelt waren und gesagt haben: »Deutsche Malerei ist braune Matsche.« Chapeau, Thomas Krens!

BENJAMIN H. D. BUCHLOH: Im Gegenzug hat es ja für die amerikanische Generation auch nicht allzu gut geklappt. Es hat eine Weile gedauert, bis die Künstler der späten 70er und frühen 80er Jahre, wie Sherrie Levine, Louise Lawler und Richard Prince, in Europa angekommen sind. Es gibt eine kulturelle Grenze zwischen den fotografischen postkonzeptuellen Praktiken der Amerikaner und den malerischen postkonzeptuellen Praktiken der Deutschen. Ich finde es auf-schlussreich, dass es doch regional spezifisch bleibt. Wer hat sich denn in Düsseldorf um Prince gekümmert? Diese Retardierung, diese Verzögerung und Verschiebung ist interessant. Alles braucht seine Zeit.

ISABELLE GRAW: Es bedarf aber auch bestimmter Vermittler. Man denke nur an die Rolle, die Donald Kuspit damals für die Rezeption und begeisterte

Aufnahme deutscher Malerei auf dem US-amerikanischen Kunstmarkt gespielt hat. Es bedarf einer Person, die diese Übersetzungsarbeit leistet, die das Angebot vereinfacht und marktförmig macht, indem sie Formeln dafür schafft. Sonst funktioniert der Transfer nicht. Ich frage mich, welches die Bedingungen für einen gelungenen Transfer sind und woran genau es liegen könnte, dass bestimmte Phänomene lokal bleiben.

KASPER KÖNIG: Für Italien gilt: Das Branding der drei C – Francesco Clemente, Sandro Chia und Enzo Cucchi – war ein Profilierungsversuch von Achille Bonito Oliva, der sich in die Tradition von Germano Celant und der Arte povera stellen wollte. Doch dieser Versuch war unmittelbar marktkonform.

ISABELLE GRAW: Es gab Mitte der 80er Jahre auch einen Austausch zwischen Deutschland und Frankreich mit der so genannten Figuration libre und einem in Deutschland und in der Schweiz ja zeitweise erfolgreichen Künstler wie Jean-Charles Blais. Auf dem Kölner Kunstmarkt lief das für ein, zwei Saisons ganz gut.

WERNER BÜTTNER: Wir haben uns ausschliesslich mit den Situationisten beschäftigt. Das war die letzte ernst zu nehmende Generation Frankreichs. Die Franzosen haben sich zu sehr abgeschottet und auf Grande Nation und Splendid Isolation gesetzt, wofür sie jetzt auch den Preis zahlen: Sie haben seit Jahren keinen guten Künstler mehr hervorgebracht, und die Kunstschulen sind bedeutungslos, während der internationale Austausch Ländern wie den Niederlanden, der Schweiz oder auch Deutschland gut getan hat.

Otherwise, the transfer doesn't work. I wonder what the conditions for a successful transfer are and what exactly may be the reasons why certain phenomena remain local.

KASPER KÖNIG: For Italy it is true that the branding of the three Cs—Francesco Clemente, Sandro Chia, and Enzo Cucchi—was an attempt by Achille Bonito Oliva to make a name for himself; he wanted to place himself in the tradition of Germano Celant and arte povera. Yet this attempt was directly lined up with the market.

ISABELLE GRAW: In the mid-1980s there was also an exchange between Germany and France with so-called "figuration libre" and artists like Jean-Charles Blais, who were for a time quite successful in Germany and Switzerland. At the Kölner Kunstmarkt, at least, that sold quite well for one or two seasons.

WERNER BÜTTNER: We concerned ourselves exclusively with the Situationists. That was the last generation in France that you could take seriously. The French cut themselves off too much, insisted on the "grande nation" and splendid isolation, and now they are paying the price for it: for years now, they haven't produced any good artists, and the art schools are insignificant, whereas countries like the Netherlands, Switzerland, and Germany benefited from the international exchange.

PHILIPP KAISER: I would like to go back to the relationship between art and economics mentioned by John M Armleder at the beginning. What aftereffects did this liaison have?

KASPER KÖNIG: In the eighties, art
 fused with marketing, and it's no
 accident that at that time
 the first banks started to build
 up art collections.
WERNER BÜTTNER: At that time, a lot
 changed for the banks. Before,
 they wanted to project an
 image of venerable solidity which
 they demonstrated through oak
 paneling, leather chairs, and
 accepted art from the nineteenth
 century. Now they started
 furnishing with modern design,
 wore bright ties, collected
 contemporary art, and speculation
 and junk bonds became the order
 of the day. Solidity was replaced
 by youthfulness and being in.
JOHN M ARMLEDER: A general
 power change took place. Of
 course artists paid more
 attention to money than they had
 previously, but they weren't
 the only ones. It is a general
 social problem that the models of
 the 1970s collapsed. In the
 eighties, the capitalist system
 sought its new role, and art
 finally followed. The great
 political changes can easily make
 us lose our sense of focus.
 That the artists were ashamed to
 make money with art signaled
 this very change. Now one sends
 one's children to art academies,
 whereas previously they
 thought the child was lost
 forever if he or she received
 such a training. Making art now
 had become a viable alternative.
 Art was now made that was
 accessible, just as the whole
 system became more accessible.
 But we keep talking about
 the beginning of the 1980s. The
 1980s lasted for ten years,
 and in 1989 there was a different
 perspective than in 1979.
WERNER BÜTTNER: It is right that the
 eighties ended with the fall of

Die 80er Jahre sind noch zu frisch, um »historisch« zu sein. Wir haben inzwischen zwar eine gewisse Distanz zu jener Zeit, doch die Leute, die einmal die Geschichte dieser Ära schreiben werden, sind jetzt ungefähr acht Jahre alt. Wir erlebten diese Zeit und blicken noch immer auf sie zurück. Noch haben wir nicht genug Abstand zu unserer persönlichen Vergangenheit, um sie historisch bewerten zu können. Sich mit der Vergangenheit zu beschäftigen, solange sie noch in der Erinnerung fortlebt, hat durchaus gewisse Vorteile. Denn die gelebte Textur der Dinge bleibt der offiziellen Geschichtsschreibung meist verschlossen. Schliesslich werden die gelebten Gefühle zugleich mit uns verschwinden, es sei denn, wir bewahren sie durch Kunst. Geschichte ist dagegen etwas anderes. Was bleibt, sind einige Artefakte, ein paar Kommentare und Daten, über die irgendwer irgendetwas schreiben wird. Dieser Text wird allerdings kein Zeitzeugenbericht sein, denn solche Intimität ist der Historiografie fremd. Wir leben in einem Zwischenstadium, und die Leute fangen allmählich an, ihre Erinnerungen zu sammeln und sich mit der damaligen Zeit zumindest akademisch zu beschäftigen. Ich selbst sehe jene Periode aber nicht in einem historischen Licht, weil so viele Entwicklungen, die in den 80ern eingesetzt haben, bis heute fortwirken.

The eighties are too recent to be historical. It's far enough away to allow some detachment, but the people who are going to write the history of the period are now about eight years old. We went through it, and we're still looking back on what we experienced. We won't be able to see our past that historically. Starting to think about the past while you haven't lost your memory is probably a good idea. Properly written history is usually not very good when it comes to the lived texture of things. That lived feeling is something that disappears with us, probably, except when it's preserved in art. History is different. There are going to be some artifacts, some commentary, some data, and somehow that will be articulated. But it won't be an eyewitness account; it won't have that intimacy. This is an intermediate moment where people are going to reminisce and at least begin to study the period. But to me it doesn't seem historical because so many of the developments of the 80s are still unfolding.

JEFF WALL

Von den 80ern weiss ich kaum noch etwas, ausser, dass es der reinste Horror war. Ich habe zwar nach einem Stil gesucht, aber jeder hat ja ohnehin nur nach seiner eigenen Musik getanzt. Ich kann mich bloss noch daran erinnern, dass ich von dem ganzen schlechten Heroin, das ich mir reingezogen habe, kotzen musste. 1986 habe ich sogar geglaubt, ich müsste sterben, dabei habe ich nur ein paar Medikamente verwechselt, die der Arzt mir verschrieben hatte. 1987 bin ich dann schliesslich zum Psychiater gegangen, und der meinte nur, ich solle ihm alles sagen, und das habe ich auch getan, und allmählich hat er mich wieder zu Verstand gebracht.

I don't remember much about the eighties except that it was complete bummer. I was pretty much "stylin'" but everybody was grooving to another beat. My only memory was throwing up from all the shitty heroin I was taking. I thought I died in 1986, but it was only a mix-up in the medicine my doctor was giving me. I started seeing a psychiatrist in 1987 and he said tell me everything and I did and then he started doing my act.

RICHARD PRINCE

PHILIPP KAISER: Ich würde gerne noch einmal
auf den eingangs von John M Armleder
erwähnten Zusammenhang von Kunst und
Ökonomie zurückkommen. Welche
Folgeerscheinungen hatte denn diese
Liaison?

KASPER KÖNIG: In den 80er Jahren fusionierte
die Kunst mit dem Marketing, und
nicht zufällig begannen in dieser Zeit
die ersten Banken, Kunstsammlungen
aufzubauen.

WERNER BÜTTNER: In dieser Zeit änderte sich
für die Banken sehr viel. Davor legten
sie grossen Wert auf ehrwürdige Solidität
und zeigten dies durch Eichtäfelungen,
Ledersessel und anerkannte Kunst aus dem
19. Jahrhundert. Nun richtete man
sich aber in modernem Design ein, trug
grelle Krawatten, sammelte zeit-
genössische Kunst und setzte auf
Spekulation und Junk Bonds. Solidität
wurde ersetzt durch Jugendlichkeit
und In-Sein.

JOHN M ARMLEDER: Es erfolgte ein allgemeiner
»Powerchange«. Natürlich beschäftigten
sich die Künstler mehr mit Geld als
vorher, doch nicht nur sie. Es ist ein
generelles gesellschaftliches Phänomen,
dass die Modelle der 70er Jahre
kollabierten. In den 80ern suchte das
kapitalistische System seine neue Rolle,
der schliesslich die Kunst gefolgt
ist. Die grossen politischen Umwälzungen
lassen uns leicht unseren Fokus
verlieren. Dass die Künstler Scham
hatten, mit Kunst Geld zu machen, war ein
Signal für eben diese Veränderung.
Jetzt schickt man seine Kinder in Kunst-
hochschulen, während man früher geglaubt
hat, dass ein Kind verloren sei,
wenn es eine solche Ausbildung bekäme.

the Communist system in 1989.
From the on, Western art
didn't play any role anymore and
had to define itself anew.
Up to then, it had been a system
of the Cold War, supposed to
signal to behind the iron
curtain: look, we're allowed to
do everything! The only things
forbidden were Nazi art or art
that looked like socialist
realism. In 1991, when the U.S.
started the first Gulf War, the
market for Western art collapsed
completely. Of course also
because it was overheated, and
too much speculation was
taking place. But also because it
became clear that there's only
one superpower and the Cold World
War is over. Since then,
Western art has been seeking its
new role.

KASPER KÖNIG: It's illuminating that
the artists' hit list in
"Capital," a business magazine,
was an invention of the eighties.

BENJAMIN H. D. BUCHLOH: I would like
to attempt to introduce a
theoretical dimension into our
discussion. One can say that
David Salle is a central figure
of the art of the eighties,
indeed a cult figure who unifies
everything, because in the manner
of Francis Picabia he once
more mobilized the final
possibilities and impossibilities
of painting. Retrospectively, one
can see from Salle's relative
mistakes how often such a
model can be used. It can be
performed one to three times, but
finally its position will
remain obsolete, while the real
practices that have a historical
position and consequence,
will be effective. In twenty
years Salle will be spoken about
even less than today.
Important are those people who

Kunst zu machen war nun eine Alternative.
Es wurde Kunst gemacht, die zugänglich
war, wie auch das ganze System
zugänglicher wurde. Doch wir reden immer
über den Beginn der 80er. Die 80er
Jahre dauerten ganze zehn Jahre, und 1989
gab es eine andere Sicht als 1979.

WERNER BÜTTNER: Es ist richtig, dass
die 80er mit dem Fall des kommunistischen
Systems 1989 zu Ende gingen. Von da
an spielte die Westkunst auch keine Rolle
mehr und musste sich neu definieren.
Bisher war sie ein Produkt des Kalten
Krieges gewesen und sollte hinter
dem Eisernen Vorhang signalisieren: Seht
her, bei uns darf man alles machen!
Das einzig Verbotene war Nazikunst oder
Kunst, die nach Sozialistischem Realismus
aussah. 1991, als die USA den Ersten
Golfkrieg begannen, brach der Kunstmarkt
der Westkunst völlig zusammen. Natürlich
auch deshalb, weil er überhitzt war
und zu viel spekuliert wurde. Aber eben
auch, weil klar wurde, dass es nur
noch eine Supermacht gibt und der »Kalte
Weltkrieg« zu Ende ist. Seitdem
sucht die Westkunst ihre neue Rolle.

KASPER KÖNIG: Es ist aufschlussreich, dass
die Künstlerhitliste in »Capital«,
einem Wirtschaftsmagazin, eine Errungen-
schaft der 80er Jahre war.

BENJAMIN H. D. BUCHLOH: Ich möchte den
Versuch unternehmen, eine theoretische
Dimension in unsere Diskussion zu
bringen. Man kann sagen, dass David Salle
eine zentrale Figur in der Kunst der
80er Jahre ist, ja eine Kultfigur, in der
alles zusammenkommt, weil er in der
Manier von Francis Picabia nochmals die
letzten Möglichkeiten und Unmöglichkeiten
der Malerei mobilisiert hat. An den

relativen Fehlern von Salle ist retrospektiv abzulesen, wie oft sich ein solches Modell anwenden lässt: Man kann es ein- bis dreimal aufführen, doch letztlich wird seine Position obsolet bleiben, während die realen Praktiken, die eine historische Stellung und Konsequenz haben, wirksam sein werden. In zwanzig Jahren wird man über Salle noch weniger sprechen als heute. Wichtig sind diejenigen Leute, die die konventionellen Paradigmen abgelegt und sich nicht mit der Wiederbelebung von Picabia oder Warhol Genüge getan haben, sondern an neuen Paradigmen arbeiteten. Das ist die Praxis der Kunst der 80er und der 90er Jahre.

ISABELLE GRAW: Ich bin kein Fan von David Salle, aber mich hat der Versuch amerikanischer Theoretiker, ihn als die schlechte Appropriation, als Pastiche, zu disqualifizieren, nie wirklich überzeugt. Salle ist ja, wie viele andere auch, zuerst unter dem Banner der Appropriation Art gesegelt und wurde aufgrund seines Mediums – der Malerei – disqualifiziert. Tom Lawson hat in seinem Text »Last Exit Painting« versucht, für ihn (und auch für sich selbst) in die Bresche zu springen. Die bedeutenden Leistungen der 80er werden sich zu verschiedenen Zeiten jeweils anders darstellen. Aber warum nicht die Spannung zwischen – sagen wir dem Einsatz von Michael Asher und dem von Albert Oehlen – aushalten, zwischen zwei verschiedenen Formen, die auf so etwas wie Weltbezug insistieren? Warum soll das im Medium Malerei nicht auch eine linguistische Proposition sein können? Warum soll ein Versuch, Regression wie in

have discarded the conventional paradigms and who were not satisfied with a resuscitated Picabia or Warhol, but who worked on new paradigms. That is the practice of the art of the 1980s and 1990s.

ISABELLE GRAW: I'm not a fan of David Salle, but the attempt of American theoreticians to write him off as bad appropriation, as pastiche, never really convinced me. Salle did, like many others, first sail under the banner of appropriation art, and was disqualified because of his medium, painting. Tom Lawson in his essay "Last Exit Painting" tried to step in the breach for Salle (and also for himself). The significant achievements of the 1980s will represent themselves differently at different times. But why don't we just endure the tension between, let's say, the dedication of Michael Ashet and that of Albert Oehlen, between two different forms that aim at something like a worldly reference? Why should that not be a linguistic proposition also in the medium of painting? Why should the attempt to mobilize regression, as in an experiment, be disqualified at the outset as uncritical, while the critical element of other artists' appropriation is admitted immediately? Could it be possible that we might find in apparently expressive gestures also forms of an institutional critique? Could for example Kippenberger be considered an artist critical of institutions?

KASPER KÖNIG: I remember how in 1987 I brought Jeff Koons along to Münster where he made the work "Kiepenkerl." Thomas Schütte,

einer Versuchsanordnung zu mobilisieren, von vornherein als unkritisch disqualifiziert sein, während anderen Künstlern das Kritische ihrer Appropriation sofort zugestanden wird. Könnten sich nicht auch in scheinbar expressiven Gesten Formen einer Institutionskritik finden? Könnte Kippenberger zum Beispiel ein institutionskritischer Künstler sein?

KASPER KÖNIG: Ich erinnere mich, wie ich 1987 Jeff Koons nach Münster mitgebracht habe, wo er die Arbeit »Kiepenkerl« realisiert hat. Thomas Schütte, Harald Klingelhöller und andere haben sich so das Maul zerrissen. Wie kommt der König darauf, so einen Yuppie einzuladen?

JUTTA KOETHER: Die Voraussage, was bleiben wird, darf man nicht kategorisch einer bestimmten Art von Kunst zuordnen. Die Faktoren, welche die Rezeption steuern, unterliegen auch immer den Bedingungen der Jetztzeit. Es ist immer ein Zusammenspiel von Setzungen, künstlerischen Haltungen, der Vermarktung beziehungsweise Nicht-Vermarktung und dem, wie die Leute später damit umgehen. Das lässt sich nicht steuern.

BENJAMIN H. D. BUCHLOH: Es steuert sich selbst. Dabei ist es sehr wichtig zu verstehen, dass es bestimmte historische Legitimations- und Kommunikationsformen gibt, die man ignorieren kann, solange man will. Man kann sagen, Malerei ist immer wichtig und wird immer wichtig sein. In der Zwischenzeit weiss man jedoch, dass Malerei total abgelebt und sinnlos ist. Die Kommunikationsform der Kunstpraxis, der realen Kulturpraxis, ist unbekannter und unsichtbarer, aber letztlich viel

Harald Klingelhöller, and others were very unhappy and tore it apart. What was König thinking when he invited this yuppie?

JUTTA KOETHER: The prediction as to what remains mustn't be assigned categorically to one certain kind of art. The factors that regulate reception are always subjected to the conditions of the present. It is always a combination of layers, artistic stances, marketing or non-marketing, and of how people deal with it later on. You can't regulate that.

BENJAMIN H. D. BUCHLOH: It regulates itself. It is important to understand that there are certain forms of legitimation and communication that can't be ignored forever. One can say that painting is always important and will always be important. In the meantime one knows, however, that painting is completely over the hill and meaningless. The communicative form of the artistic practice, the real cultural practice, is however finally much more radical in its consequences, and therefore also much more communicative.

JUTTA KOETHER: The radical consequences lie therefore not exclusively in the artistic product.

BENJAMIN H. D. BUCHLOH: No, the consequences lie in the latency of the definition of what cultural praxis can be, what reception can be.

ISABELLE GRAW: The medium as such is never the problem. I think it is dubious and in the final analysis a conservative finalism to declare that a medium is over. Not painting, but certain uses of this medium turn out to be questionable. And don't we as critics have the

FORMEN DES ACHTEN JAHRZEHNTS

Cold

hungry

tired

are three words—off.

Roads are the home with
thousand cars filled in a dream.

 (où étais-tu pendant l'enterrement de J.F.K.?
 where have you been during the funeral of J.F.K.?)

Rehe am Waldrand — Feuer
 Temps moderns ed innocenza igl esser
Zeitlos, verweigernd und Distanz

cold, hungry and tired.

 Nightdarkness — midnight
 4 U extended
Weisheit und Wahrheit
 downward
Todesangst schwindet wie der
Morgenwind
 Darkgrey und sanft
Holz verbrannt — Erde

People of the West
fighting for the memory
dust of the Prairie

Irgendwo ruft ein weisser Kojote
Sie sagt, sie sei von Buenos Aires
ich spiele das Akkordeon mit vier Fingern
manchmal ist einer am Abzug einer Pistole
manchmal bringt sie mich zum Airport
draussen ruft ein weisser Kojote

Es schreit sich zu Tode,
oh du meine Ruh,
du meine Lust nach überwundener Angst.

Zorn in der linken Hand,
die rechte ist ausgestreckt, auf der Suche nach Moment und Liebe
Hölle oh Hölle bist du meine Mutter?
der Teufel kommmt täglich.
Es ist kalt draussen und
Schnee fällt.
Männer erfrieren auf der Strasse
 Darknight
 cold and black skies all over
 — happiness is a by-product of function
 44 and 69

HELMUT FEDERLE

opportunity to break up the rigid canon, which is set up by the market and its actors, and to drive it into other directions?

PHILIPP KAISER: Because of our extensive and passionate discussion about painting, one might get the impression that this medium established a position of hegemony in the 1980s. But for long a time, painting has no longer been a leading medium, and that didn't change in the eighties. But let us talk about the "conditions of the present," as Jutta Koether put it. What parameters determine the evaluation of the decade today? And how do such evaluations and periodizations change?

BENJAMIN H. D. BUCHLOH: Haim Steinbach, for example, is a radical artist who once did radical post-Duchampian, post-Warholian object art. And how does that look today?

JOHN M ARMLEDER: I see that differently, and I have the sense that I have the authority to judge history. It can be said that certain artists are at a certain time for one reason or another relevant. We define a time and we note that for example Haim Steinbach was significant at that time and therefore helped define it. Certain artists stand for certain achievements, but twenty or a hundred years later a different aspect of their work might suddenly become relevant. The linear description of history is only one way of reading. The reality of the 1980s has nothing to do with how we think about the 1980s. And that is what we are talking about today. We don't reconstruct the 1980s, but rather we're trying to find out how they are active for us today, whatever they may

radikaler in ihren Konsequenzen und deswegen auch viel kommunikativer.

JUTTA KOETHER: Die radikalen Konsequenzen liegen deshalb nicht ausschliesslich im künstlerischen Produkt.

BENJAMIN H. D. BUCHLOH: Nein, die Konsequenzen liegen in der Latenz der Definition dessen, was kulturelle Praxis überhaupt sein kann, was Rezeption sein kann.

ISABELLE GRAW: Das Medium per se ist doch niemals das Problem. Ich halte es für einen fragwürdigen, weil letztlich konservativen Finalismus, zu deklarieren, dass ein Medium am Ende sei. Nicht die Malerei, sondern bestimmte Verwendungsarten dieses Mediums erweisen sich als fragwürdig. Und haben wir als Kritiker nicht die Möglichkeit, den starren, rigiden Kanon, der vom Markt und seinen Akteuren errichtet wird, aufzubrechen und in andere Richtungen zu treiben?

PHILIPP KAISER: Durch unsere ausgedehnte und leidenschaftliche Diskussion über die Malerei könnte der Verdacht aufkommen, dass dieses Medium in den 80er Jahren die Stellung einer Vorherrschaft etabliert hätte. Doch tatsächlich ist die Malerei ja seit Langem nicht mehr Leitmedium, und das änderte sich auch nicht in den 80ern. Doch lassen Sie uns noch einmal über die »Bedingungen der Jetztzeit«, wie Jutta Koether es formuliert hat, reden. Welche Parameter bestimmen heute die Wertung der Dekade? Und wie ändern sich solche Wertungen und Periodisierungen?

BENJAMIN H. D. BUCHLOH: Haim Steinbach etwa ist ein radikaler Künstler, der einst radikale post-duchamp'sche,

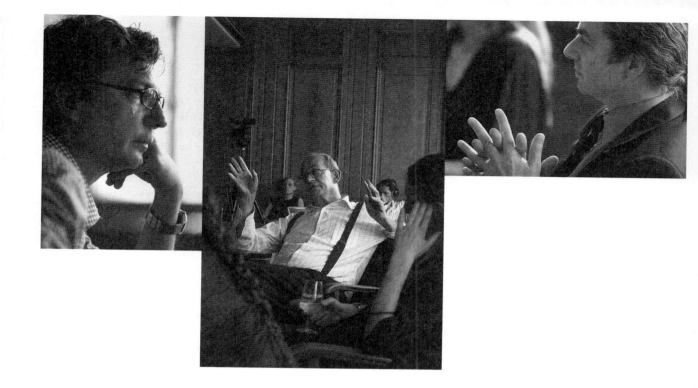

THOMAS RUFF KASPER KÖNIG JOHN M ARMLEDER

represent. It's bizarre to
believe the 1980s consisted only
of painting. There were so
many different practices, just
think of the photography boom or
of artists like Peter Halley.
For the short time of an
exhibition you can activate all
these souvenirs and present them
from a certain perspective.

ISABELLE GRAW: I often play a game
with friends in New York that
consists of remembering names
that were ubiquitous in
the eighties, but are completely
forgotten now. The retrospective
construction of the 1980s is
brutal, because it is based on
exclusion.

JOHN M ARMLEDER: There are two
different ways of determining
periods. We always tend to
want to know how it was before so
that we can see how it changed
afterwards. In order to develop
an idea of the eighties, it
is perhaps better to ask about
the nineties. Let's take
Daniel Buren to illustrate what I
mean. In the seventies, he is
not the same as in the eighties
or nineties. If you follow
a linear construction, then you
have to ask how his work changed.

BENJAMIN H. D. BUCHLOH: Buren in
1970 is like Picasso in 1912, and
in 1980 how Picasso was in 1930.
In the 1990s Buren is like
Picasso was in the 1950s and
1960s. Do I think Buren is the
best artist? Yes, sure.
Absolutely, until 1975.

JOHN M ARMLEDER: My point was not to
establish a moral value.
There is a transformation in the
work that I find interesting.

BENJAMIN H. D. BUCHLOH: It isn't a
moral question, it's an aesthetic
one. What interests me is
what an aesthetic practice means
at that time.

postwarhol'sche Objektkunst gemacht hat. Und wie sieht das heute aus?

JOHN M ARMLEDER: Ich sehe das anders, denn ich habe den Eindruck, dass ich über die Autorität verfüge, Geschichte zu beurteilen. Es lässt sich sagen, dass bestimmte Künstler zu einer bestimmten Zeit aus dem einen oder anderen Grund relevant sind. Wir definieren eine Zeit und stellen fest, dass etwa Haim Steinbach in dieser Zeit etwas bedeutete und diese deshalb mitdefinierte. Bestimmte Künstler stehen für bestimmte Errungenschaften, doch zwanzig oder hundert Jahre später kann plötzlich ein anderer Teil ihrer Arbeit relevant werden. Die lineare Beschreibung von Geschichte ist nur eine mögliche Lesart. Die Realität der 80er hat nichts damit zu tun, wie wir über die 80er Jahre denken. Darüber reden wir heute. Wir rekonstruieren nicht die 80er, sondern versuchen stattdessen herauszufinden, wie sie für uns heute aktiv sind, was immer sie auch repräsentieren. Es ist bizarr zu glauben, die 80er hätten nur aus Malerei bestanden. Es gab so viele unterschiedliche Praktiken, denken wir nur an den Boom der Fotografie oder an Künstler wie Peter Halley. Für die kurze Zeit einer Ausstellung kann man all diese Souvenirs aktivieren und aus einer bestimmten Perspektive heraus präsentieren.

ISABELLE GRAW: Mit Freunden in New York spiele ich oft ein Spiel, das darin besteht, sich an Namen zu erinnern, die in den 80ern omnipräsent waren und heute vollständig in Vergessenheit geraten sind. Die retrospektive Konstruktion der 80er ist eine brutale Konstruktion, weil sie auf Exklusion basiert.

ISABELLE GRAW: But apart from the always approximate reconstruction of certain conditions, aesthetic criteria change with the times and in reference to changing situations.

KASPER KÖNIG: There are certain artists who changed the conditions. Daniel Buren is one of them.

ISABELLE GRAW: He reflected in his work that institutional critique is welcomed by the institutions.

KASPER KÖNIG: He formed institutional critique.

JOHN M ARMLEDER: I didn't want to discuss one individual artist. Most artists adapt to the context, because that is the only way to survive, not financially but intellectually, and that happens again and again. We can also talk about other artists. Mel Bochner for example, who represented a radical conceptual side. Why did he do that? Because we needed this kind of painting? Or was it the aesthetics of the time? The taste? There are always situations that cause several people to do something similar. And perhaps that is what defines something.

JUTTA KOETHER: I want to ask the basic question: what happens at that moment when one sits down and looks back at the 1980s? What are we fabricating here? Is it a new reading? Is it a different hierarchy? Do we want to fill gaps with things we miss?

ISABELLE GRAW: First of all, we are undertaking an attempt at description. We are comparing different concepts of what should be understood by the 1980s. What do we regard, from today's perspective, as a hegemonic formation? How do we historicize

Ich habe damals mit einer Gruppe von Künstlern gegen die Folgen der »Reaganomics« im urbanen Raum gekämpft, wie zum Beispiel gegen einseitige Stadtentwicklung, Luxussanierungen und das »Generieren von Obdachlosigkeit«. Wichtige Punkte waren damals: die Kritik der Anti-Immobilien-Initiativen an der Stadt als Bild (dem Bild einer »gut verwalteten« Stadt), der britische Beitrag zur urbanen Geografie, die Birmingham School of Cultural Studies, die feministische Kritik an der Repräsentation von Stadt und urbanem Leben, das britische Filmjournal »Screen«, das »ZG Magazine« (insbesondere die Beiträge von Rosetta Brooks, Sylvia Kolbowski und Brian Hutton), die Ausstellung »Difference and Sexuality« im New Museum und damit verbunden die Publikationen von Rosalyn Deutsche über Kunst im öffentlichen Raum und Nail Smith über einseitige Stadtentwicklung sowie der Aktivismus von ACT UP, die Interventionen von Douglas Crimp, die Hausbesetzerkollektive im East Village, die Bullet Group und die Projekte von Group Material.

I was one among a group of artists active in an urban struggle against the effects of "Reaganomics," like uneven urban redevelopment, revitalization ("gentrification"), and the "production of homelessness"; the critique of the city as an image produced by real-estate action groups (the image of "well-managed" city); the British contribution to urban geography; the Birmingham school of cultural studies; the feminist critique of representation as related the image of the city and urban life; the British film journal "Screen," "ZG Magazine" (in particular the writings of Rosetta Brooks, Sylvia Kolbowski, and Brian Hutton); The New Museum exhibition called "Difference and Sexuality," as seen in the context of writings by Rosalyn Deutsche on public art and Nail Smith on uneven de-velopment; and the activism of ACT UP, the interventions of Douglas Crimp, the East Village squatters' collectives, the Bullet Group and the projects of Group Material.

KRZYSZTOF WODICZKO

the eighties? This question hasn't been settled yet. We can't assume that it was this or that at the time. We are not concerned with a purportedly authentic reconstruction of events.

JUTTA KOETHER: At the moment there is a new interest in the 1980s—be it in their historicization or in the fact that certain practices such as, for example, painting are reemerging. But current painting is something else, more conceptual and in smaller formats. It is no longer emotional painting, even if the current Schnabel retrospective or Jean-Michel Basquiat in New York might suggest something else. Right now, certain things are being picked out from the eighties, and one has to ask what view is being prepared, and why. Does that simply happen after twenty years? Or are there once again constellations at work that want to direct attention in a certain direction?

ISABELLE GRAW: There is a cyclical return of decades. In fashion we can also observe a recourse to the insignia of the 1980s. At the same time, the renewed interest in artists like Schnabel has something to do with the interest in drastic positionings and with the increased definitional power of the art market. Younger artists are once more interested in leaving the space of what is considered possible—at least that is what I observe at the art school. There is also a great interest in self-organized contexts, dilettantism, and apodictic poses of assertiveness.

PHILIPP KAISER: What other reasons do you see for examining the 1980s today?

KASPER KÖNIG: In contrast to the 1960s, the "operating system" of

JOHN M ARMLEDER: Es gibt zwei unterschiedliche Arten, Perioden zu bestimmen. Wir tendieren immer dazu, wissen zu wollen, wie es vorher war, um zu sehen, wie es sich hinterher verändert hat. Um eine Idee der 80er zu entwickeln, ist es vielleicht besser, nach den 90ern zu fragen. Lassen Sie uns dies an Daniel Buren veranschaulichen. In den 70ern ist er nicht derselbe wie in den 80ern oder 90ern. Wenn man einer linearen Konstruktion folgt, muss man fragen, warum sich sein Werk verändert hat.

BENJAMIN H. D. BUCHLOH: Buren ist 1970, wie Picasso 1912 war, und 1980, wie Picasso 1930 war. In den 90ern ist Buren, wie Picasso in den 50ern und 60ern war. Denke ich, dass Buren der beste Künstler ist? Ja, klar. Absolut, bis 1975.

JOHN M ARMLEDER: Mein Punkt war nicht, einen moralischen Wert heraufzubeschwören. Es gibt eine Transformation in der Arbeit, die ich interessant finde.

BENJAMIN H. D. BUCHLOH: Es ist nicht eine moralische, sondern eine ästhetische Frage. Mich interessiert: Was bedeutet eine ästhetische Praxis in dieser Zeit?

ISABELLE GRAW: Aber einmal abgesehen von der ja immer nur annähernden Rekonstruktion bestimmter Bedingungen, ändern sich ästhetische Kriterien doch auch mit der Zeit und im Hinblick auf wechselnde Situationen.

KASPER KÖNIG: Es gibt bestimmte Künstler, die die Bedingungen geändert haben. Daniel Buren ist einer von ihnen.

ISABELLE GRAW: Er hat in seiner Arbeit reflektiert, dass institutionelle Kritik vonseiten der Institutionen gutgeheissen wird.

KASPER KÖNIG: Er formte die institutionelle
 Kritik.
JOHN M ARMLEDER: Ich habe nicht einen
 einzelnen Künstler diskutieren wollen.
 Die meisten Künstler passen sich
 dem Kontext an, weil es die einzige Art
 ist zu überleben, nicht finanziell,
 sondern intellektuell, und das passiert
 immer wieder. Wir können auch über
 andere Künstler sprechen. Mel Bochner
 beispielsweise, der eine radikale
 konzeptuelle Seite vertreten hat. Warum
 hat er dies getan? Weil wir diese Malerei
 brauchten? Oder war es die Ästhetik
 der Zeit? Der Geschmack? Es gibt immer
 Situationen, die mehrere Leute dazu
 bringen, gleichzeitig etwas Ähnliches zu
 tun. Und vielleicht wird gerade hier
 etwas Bestimmtes definiert.
JUTTA KOETHER: Ich möchte die grundsätzliche
 Frage stellen: Was passiert in dem
 Moment, in dem man sich hinsetzt und eine
 Rückschau der 80er Jahre vornimmt.
 Was fabrizieren wir hier? Ist es ein
 neues Reading? Ist es eine andere
 Hierarchie? Wollen wir Löcher füllen mit
 Dingen, die uns fehlen?
ISABELLE GRAW: Wir versuchen zunächst einmal
 zu beschreiben. Wir vergleichen
 unterschiedliche Konzeptionen dessen, was
 unter den 80er Jahren zu verstehen
 ist. Was sieht man aus heutiger Sicht als
 hegemoniale Formation an? Wie
 historisiert man die 80er Jahre? Diese
 Frage ist noch nicht geklärt. Wir können
 nicht davon ausgehen, dass es damals
 so und so gewesen ist. Es geht ja nicht
 um eine Rekonstruktion vermeintlich
 authentischer Begebenheiten.
JUTTA KOETHER: Im Moment gibt es
 eine erneute Aufmerksamkeit für die 80er

Jahre – sei es für deren Historisierung oder sei es dafür, dass bestimmte Praktiken, wie etwa die Malerei, wieder auftauchen. Die heutige Malerei ist jedoch anders, konzeptueller und kleinformatiger. Sie ist keine Gefühlsmalerei mehr, wenngleich die aktuelle Schnabel-Retrospektive oder Jean-Michel Basquiat in New York eine andere Setzung nahe legten. Zurzeit werden gewisse Dinge aus den 80ern herausgegriffen, wobei man sich fragen muss, welcher Blick sich hier anbahnt und warum? Passiert das einfach nach zwanzig Jahren? Oder sind da wieder Konstellationen am Werk, die den Blick in eine bestimmte Richtung führen möchten?

ISABELLE GRAW: Es gibt die zyklische Wiederkehr von Dekaden. In der Mode lässt sich ja ebenfalls ein Rückgriff auf die Insignien der 80er Jahre beobachten. Zugleich hat das erneute Interesse für Künstler wie Schnabel mit dem Interesse an drastischen Setzungen und mit der zugespitzten Definitionsmacht des Kunstmarktes zu tun. Jüngere Künstler interessiert es wieder, aus dem Raum des als möglich Erachteten auszusteigen – das beobachte ich jedenfalls an der Akademie. Es gibt auch ein grosses Interesse für selbst organisierte Kontexte, Dilettantismus und apodiktische Behauptungsposen.

PHILIPP KAISER: Welche Gründe sehen Sie noch, sich heute mit den 80er Jahren zu beschäftigen?

KASPER KÖNIG: Im Unterschied zu den 60er Jahren hat sich das Betriebssystem aktueller Kunst in den 80ern vervielfacht. Diese Veränderung ist für uns heute entscheidend, wo es von

allem fünfzigmal so viel gibt:
Ausstellungen, Museen und Einladungen.

BENJAMIN H. D. BUCHLOH: Das wäre ein
Phänomen, warum wir die 80er Jahre be-
trachten: Damals wurde der Knoten
geschürzt, an dem wir gegenwärtig leiden.
Die Beziehungen, mit denen wir heute
konfrontiert werden, in einer Brutalität,
wie wir sie nie geahnt hätten,
sind damals entstanden. Deshalb ist es
interessant, sich auf die 80er zu be-
ziehen und zu benennen, wie es angefangen
hat.

JUTTA KOETHER: Zu klären wie es angefangen
hat und wie man jetzt handlungsfähig
sein kann.

BENJAMIN H. D. BUCHLOH: In der konzeptuellen
Kunst war noch eine relative Autonomie
gegeben, eine Autonomie der Praxis.
Ich kann mich erinnern, dass ich mich
Ende der 70er Jahre mit Sherrie
Levine gestritten habe, weil ich sie für
eine Zynikerin hielt. Ihr Realismus-
prinzip kam mir im Vergleich zu meinem
Postkonzeptualismus affirmativ vor.
Das ist Anpassungskunst, dachte ich, weil
es die Intelligenz der Konzeptkunst in-
ternalisiert und sich dann in eine
Machtposition der totalen Warhol'schen
Affirmation transferiert hatte. Das
war für mich der Schock dieser Begegnung.
Nach und nach habe ich das besser
verstanden. Die 80er sind wirklich
interessant, weil vieles damals
entstanden ist: Corporate Culture mit
Zynismus, totalem Kommerzialismus,
totaler Assimilation. Damals wurde auch
die Kunst als Bereich der Autonomie
aufgegeben. Es war keine Frage mehr:
Kunst war eine Industrie wie jede andere
auch.

contemporary art multiplied in
the 1980s. This change
is decisive for us today, where
there's fifty times as much of
everything: exhibitions, museums,
and invitations.

BENJAMIN H. D. BUCHLOH: Another
reason why we look at the 1980s:
at that time, the knot was
bound which we still suffer
from today. The relations that
confront us today with a
brutality that we never thought
possible, developed then.
That's why it's interesting to
relate back to the 1980s
and specify how it all started.

JUTTA KOETHER: To clarify how it
started and how one can
be capable of acting today...

BENJAMIN H. D. BUCHLOH: In
conceptual art there was still a
relative autonomy, an autonomy of
practice. I remember arguing
in the 1970s with Sherrie Levine
because I thought she was a
cynic. Compared to my post-
conceptualism, her principle of
realism seemed affirmative to me.
That is assimilation art, I
thought, because it internalizes
the intelligence of conceptual
art and then transfers itself
into a power position of a total
Warholian affirmation. That for
me was the shock of this
encounter. Step by step, I came
to understand it better.
The 1980s are really interesting
because so much developed then:
corporate culture with its
cynicism, total commercialism,
total assimilation. At that time,
art as a field of autonomy
was abandoned. It was no longer a
question: art was an industry
like any other.

KASPER KÖNIG: But where was autonomy
abandoned? Rather, it
evaporated due to the constraints
of the business.

ISABELLE GRAW: Yes, but the definitional power of the market has spread. The art business, which had operated on a small business retail model, changed into an industry. As a cultural producer, you are confronted with a situation where the constraints have increased and where you can't even with the best intentions assume that there are any imaginary unconstrained spaces anymore. If you look at the 1980s, you ask yourself: What space for action was available then, and are there today new constraints and new liberties?

PHILIPP KAISER: It's interesting, Benjamin Buchloh, that you saw Sherrie Levine's work initially as cynical. Perhaps the reformulation of conceptual art in the 1970s was not legible right away. From today's perspective, it is becoming increasingly clear that conceptual practices never stopped and therefore were not just resurrected in the 1990s, as "context art" suggested. What role does conceptuality play for you in the 1980s?

BENJAMIN H. D. BUCHLOH: An apparatus—if one might call it that—understood quite well by the artists of the 1980s was the radical reduction to the linguistic principle of conceptual art. This had historical limits that had to be overthrown. They all insisted on Lawrence Weiner's position and said that a work of art is a linguistic proposition. It was important to recognize that the formulation itself had to be reversed and inscribed into mass culture, rather than remaining stuck in a late modernist self-reflection. The early Jenny

KASPER KÖNIG: Wo wurde denn die Autonomie aufgegeben? Sie hat sich doch eher betriebsbedingt verflüchtigt.

ISABELLE GRAW: Ja, aber die Definitionsmacht des Marktes hat sich ausgedehnt. Der früher am Einzelhandelsmodell orientierte Kunstbetrieb verwandelte sich in eine Industrie. Als Kulturproduzent sieht man sich mit einer Situation konfrontiert, in der die Zwänge zugenommen haben und man beim besten Willen nicht mehr von einem imaginären Freiraum ausgehen kann. Wenn man sich die 80er ansieht, fragt man sich: Welche Handlungsräume gab es damals, und wie sieht es heute mit neuen Zwängen und neuen Freiheiten aus?

PHILIPP KAISER: Es ist interessant, dass Sie, Benjamin Buchloh, Sherrie Levines Arbeit zunächst als zynisch verstanden haben. Vielleicht war gerade die Umformulierung der Konzeptkunst Ende der 70er Jahre nicht sofort lesbar. Aus heutiger Sicht stellt sich immer mehr heraus, dass konzeptuelle Praktiken nie ein Ende fanden und auch nicht erst in den frühen 90ern wiederauferstanden sind, wie dies die »Kontext-Kunst« suggerierte. Welche Rolle spielt für Sie Konzeptualität in den 80er Jahren?

BENJAMIN H. D. BUCHLOH: Ein Dispositiv – wenn man das so nennen darf –, das die Künstler der 80er in New York sehr gut verstanden haben, war die radikale Reduktion auf das linguistische Prinzip der konzeptuellen Kunst. Diese hatte historische Grenzen, die man umwerfen musste. Sie alle haben auf der Position von Lawrence Weiner bestanden und gesagt: Das Kunstwerk ist eine linguistische Proposition. Es war wichtig zu erkennen, dass die Formulierung

Holzer did just that: the reduction to the linguistic process on the one hand, the production of language as a carrier of ideology on the other. That was an important dialogue. For Prince, it was different. He was not as intelligent, got stuck on the Warhol thing and expanded it. He once more propagated machismo.

JUTTA KOETHER: The consciousness of conceptual art changed and docked onto mass culture in order to find new forms there. That was a fundamental shift that can be transferred to all levels. What previously had been subculture was now fed into a professional pattern, and appropriated—a completely accessible culture, the apparent democratization of art.

ISABELLE GRAW: The 1980s are the primal scene for that.

KASPER KÖNIG: Do you voluntarily think about the 1980s?

JUTTA KOETHER: I do, sure.

ISABELLE GRAW: They loom into the present, don't they, and it was a fabulous time—especially from the perspective of retrospective idealization.

JUTTA KOETHER: My students ask about Basquiat, see his exhibition, and then ask me what that means and where that comes from.

THOMAS RUFF: As far as technology is concerned, today we live in a completely different world from the 1980s. Students can't imagine a world without e-mail, SMS, or the internet. I also think that today's students live in a completely different visual world than we did at their age, so they have no idea what Basquiat means or where he comes from.

ISABELLE GRAW: First and foremost it was appropriation art, which

"The eighties" was until recently a four-letter word among many art journalists and curators, especially those under forty, compared with the ardently beloved sixties and seventies that accompanied their own childhoods. It would be nice if this very fruitful and labor-intensive decade was finally to be fundamentally and seriously investigated by those people. I mean, not just "Wild Painting," barroom gossip (Kippi [Martin Kippenberger]), brilliant boys, and difficult, exceptional girls, but a precise analysis of the various streams—sculpture, painting, photography, video, etc.—that emerged in the 1980s, whether as a break with or a continuation of the seventies. Oral history can only make a difference when the right people are invited to the discussion rounds. One tip: not only Germany, but especially Switzerland and the U.S. played an important role for us young artists in the eighties. Without the many committed collectors and mediators there who advocated German art, this exciting period would not have existed in the form we know.

Die 80er Jahre waren bis vor Kurzem bei vielen Kunst-journalisten und Kuratoren, speziell unter vierzig, ein Schimpfwort – von ihnen heiss geliebt waren dagegen die 60er und 70er Jahre, die die eigene Kindheit begleiteten. Schön wäre es, wenn dieses sehr fruchtbare und arbeits-intensive Jahrzehnt von den Erwähnten endlich einmal fundiert und seriös aufgearbeitet würde. Also nicht nur Wilde Malerei, Thekenklatsch (Kippi), geniale Jungs und schwierige Ausnahmemädchen, sondern eine präzise Darstellung der vielen Strömungen – Skulptur, Malerei, Fotografie, Video et cetera –, die in den 80er Jahren entstanden sind, ob als Bruch oder als Fortführung der 70er. »Oral History« bringt nur dann etwas, wenn in den Diskussionsrunden auch die Richtigen eingeladen werden. Ein Tipp: Nicht nur Deutschland, sondern besonders die Schweiz und die USA haben in den 80er Jahren für uns junge Künstler eine wichtige Rolle gespielt. Ohne die vielen, dort engagierten Sammler und Vermittler, die sich für die deutsche Kunst eingesetzt haben, hätte es diese aufregende Zeit so nicht gegeben.

KATHARINA FRITSCH

Die 80er? Ich halte sie längst nicht für so interessant und produktiv wie die 70er Jahre. In den 80ern hat man sich vor allem mit den Ideen der 70er beschäftigt und sie wiederholt.

About the 80s: I think that they weren't as interesting and productive as the 70s; mostly, the ideas developed in the 70s were explored and repeated.

ILYA KABAKOV

selbst umgekehrt und der Massenkultur eingeschrieben werden musste, statt sich weiterhin in einer spätmodernistischen Selbstreflexion aufzuhalten. Die frühe Jenny Holzer hat genau dies getan: die Reduktion auf das linguistische Verfahren einerseits, die Produktion der Sprache als Ideologieträger andererseits. Das war ein wichtiger Dialog. Für Prince war das anders. Er war nicht so klug, hat sich auf die Warhol-Geschichte eingeschossen und diese expandiert. Er hat den Machoismus noch einmal propagiert.

JUTTA KOETHER: Das Bewusstsein der Konzeptkunst hat sich verändert und an die Massenkultur angedockt, um daraus neue Formen zu schöpfen. Dies war eine grundsätzliche Verschiebung, die man auf alle Ebenen übertragen kann. Was vorher noch Subkultur war, wurde in ein professionelles Muster eingespeist und vereinnahmt – eine total zugängliche Kultur, die scheinbare Demokratisierung der Kunst.

ISABELLE GRAW: Die 80er Jahre sind dafür die Urszene.

KASPER KÖNIG: Machen Sie sich über die 80er freiwillig Gedanken?

JUTTA KOETHER: Ich schon.

ISABELLE GRAW: Sie ragen doch in die Gegenwart hinein, und es war eine tolle Zeit – gerade aus der Sicht einer retrospektiven Verklärung.

JUTTA KOETHER: Meine Studenten fragen nach Basquiat, sehen seine Ausstellung und fragen mich, was das bedeutet und wo das herkommt.

THOMAS RUFF: Wir leben heute in einer technologisch ganz anderen Welt als in den 80er Jahren. Die Studenten

können sich eine Welt ohne E-Mail, SMS oder Internet nicht mehr vorstellen. Ich denke auch, dass die heutigen Studenten in einer ganz anderen Bildwelt leben als wir in diesem Alter, also haben sie keine Ahnung, was Basquiat bedeutet oder wo es herkommt.

ISABELLE GRAW: In erster Linie war es die Appropriation Art, die sich auf die Massenmedien bezog und sich kritisch zu deren Bildarsenalen verhielt. Oft wurde »Appropriation« mit einer »politischen Intervention« gleichgesetzt, was im Nachhinein überzogen wirkt. Während Richard Prince als dubios galt, weil das Verhältnis zu seinem Material eher fanhaft und fetischisierend war, schrieb man Sherrie Levine »Kritik« gut, obgleich sich auch in ihren Arbeiten Spuren einer ödipalen Faszination mit ihrem Material finden.

THOMAS RUFF: Wie viel Prozent der Künstler waren das? Die wenigsten Künstler haben so gearbeitet.

ISABELLE GRAW: Ich kann eine Liste machen. »Appropriation« war der gemeinsame Nenner zahlreicher Künstler. Auf diesen, eine »Relation« zur Aussenwelt evozierenden Begriff lassen sich die 80er durchaus bringen.

PHILIPP KAISER: Hat man sich in Deutschland für Medienkritik und Appropriation Art überhaupt interessiert?

ISABELLE GRAW: Durchaus, wenn ich an die Zeitschrift »Wolkenkratzer Art Journal« denke, für die ich Interviews mit Levine oder Prince gemacht habe. Aber auch Galerien wie etwa die von Daniel Buchholz in Köln haben Künstler aus dem Programm der Galerie Nature Morte ausgestellt.

related to the mass media and positioned itself critically vis-à-vis the visual arsenals of the mass media. Often "appropriation" was equated with "political intervention," which in retrospect seems exaggerated. While Richard Prince was considered a bit dubious because his relation to his material was fetishistic and fanlike, Sherrie Levine was considered "critical," even though in her work we can find traces of an Oedipal fascination with their material.

THOMAS RUFF: But what percent of all artists did that? Only very few artists worked like that.

ISABELLE GRAW: I could make a list. "Appropriation" was the common denominator of numerous artists. The 1980s can certainly be summed up under that term, which evokes a "relation" to the exterior world.

PHILIPP KAISER: Were people in Germany at all interested in media critique and appropriation art?

ISABELLE GRAW: Indeed, when I think of the magazine "Wolkenkratzer Art Journal," for which I did interviews with Levine or Prince. But also galleries like Daniel Buchholz's in Cologne showed artists from the program of the gallery Nature Morte.

KASPER KÖNIG: I remember hearing that an artist appropriated photographs by Walker Evans. That did make me quite curious—appropriating Walker Evans. I didn't know Levine, but I thought it was a most interesting strategy, combining social history with the art market. The eighties are a time of an incredible opening, with all the inflationary disadvantages. You can't reduce that all,

WERNER BÜTTNER

JUTTA KOETHER

because even Philip Guston was rediscovered.

BENJAMIN H. D. BUCHLOH: The rediscovery of Guston was a strategy to reintroduce figuration. Georg Baselitz also referred back to Guston.

ISABELLE GRAW: There are indeed differences between the formation of appropriation art and the situation in the Rhineland. For example, around the constellation of appropriation art, there was a pronounced interest in theory. The import of French post-structuralism above all, and they developed a more fragmented understanding of authorship and subjectivity. In Germany, that didn't happen to the same degree among artists. It was partly because of this theory deficit that we founded the magazine "Texte zur Kunst" in 1990.

PHILIPP KAISER: Can a polarity between the German and the American situation really always be maintained so clearly? Couldn't it be claimed that Kippenberger also established a kind of artistic practice that isn't all that different from certain New York practices?

BENJAMIN H. D. BUCHLOH: The theorization of the author, which came from France, was decisive for the U.S. At issue was a new theorization of the role of the author in terms of gender theory. This led to a different artistic practice than with Kippenberger. For me, he is somebody who, despite those attempts at theory, still reveled in the masculine subject, even if as travesty.

KASPER KÖNIG: Of course he recognized the signs of the times and maneuvered himself into that corner quite consciously.

KASPER KÖNIG: Ich erinnere mich, dass sich eine Künstlerin Fotos von Walker Evans angeeignet haben soll. Das hat mich schon sehr neugierig gemacht … sich Walker Evans zu Eigen machen. Ich kannte Levine nicht, fand das aber eine überaus interessante Strategie, Sozialgeschichte mit dem Kunstmarkt zu verbinden. Die 80er Jahre sind eine Zeit der enormen Öffnung, mit allen inflationären Nachteilen. Man kann das alles nicht so reduzieren, denn selbst Philip Guston wurde wieder entdeckt.

BENJAMIN H. D. BUCHLOH: Die Wiederentdeckung von Guston war eine Strategie, um die Figuration wieder einzuführen. Georg Baselitz hat sich auch auf Guston bezogen.

ISABELLE GRAW: Zwischen der Formation Appropriation Art und der Situation im Rheinland bestehen tatsächlich Gegensätze. Zum Beispiel gab es um die Konstellation der Appropriation Art herum ein ausgeprägtes Theorieinteresse. Der Import des französischen Poststrukturalismus wäre hier an erster Stelle zu nennen, und man entwickelte ein gebrocheneres Autoren- und Subjektverständnis. Das fand in Deutschland unter KünstlerInnen nicht in demselben Masse statt. Auch aufgrund dieses Theoriedefizits haben wir 1990 die Zeitschrift »Texte zur Kunst« gegründet.

PHILIPP KAISER: Ist die Polarität der deutschen und der amerikanischen Situation tatsächlich immer so klar aufrechtzuerhalten? Liesse sich nicht behaupten, dass Kippenberger ebenfalls eine Art künstlerische Praxis etabliert hat, die sich von gewissen

Nun, für einen jungen Künstler war das eine ziemlich gute Zeit – und ein toller Platz. Die Mieten waren sehr günstig, und grosse Speicherräume gab es noch en masse. Um mich, wenn auch bescheiden, über Wasser zu halten, habe ich damals ein paar Mal in der Woche abends gekellnert. Zu der Zeit waren unglaublich viele Künstler und Schriftsteller unterwegs, allerdings auch wieder nicht so viele, dass man sie nicht alle hätte kennen können. Die meisten von uns haben damals in SoHo oder in TriBeCa gewohnt, wo es kaum andere Leute gab. Das war fast wie eine eigenständige Gemeinde. Die Jahre zwischen der Einführung der Pille und den ersten Schreckensmeldungen über Aids haben uns einen wundervollen Freiraum eröffnet. Wir haben uns total frei gefühlt, alles schien möglich. Diese Zeit lässt sich nicht mit der Situation vergleichen, mit der es heute junge Künstler zu tun haben, wenn sie nach New York kommen. Obwohl – die nostalgischen Gefühle gelten natürlich vor allem meiner eigenen Jugend. Ich bin froh, dass ich diese Jahre nicht vergeudet habe.

Um 1983 war es dann vorbei mit der Unbeschwertheit. In meinem Freundeskreis gab es die ersten Aidstoten. Die Mieten schossen in schwindelnde Höhen. Das bisschen Arbeit langte mir hinten und vorne nicht mehr zum Leben … Meiner Ansicht nach – und das sage ich ungeachtet meines Narzismus – haben dann Mitte der 80er Gier und Blödheit endgültig die Oberhand gewonnen. Damals habe ich auch begriffen, dass man meine Kunst einmal in einem politischen Kontext bewerten würde.

Well, it was a pretty great time and place to be a young artist. Rents were very cheap, and large raw spaces were plentiful. I was able to support myself, though not lavishly, by waitressing a few nights a week. There were lots of artists and writers around, but not so many that you couldn't know virtually everyone. Most of us lived in SoHo or TriBeCa, and very few other people lived there. It was kind of a parish in that sense. There was that small window of opportunity, after the pill and before we knew about AIDS. We felt extremely free, and everything seemed possible. So I think it was quite different from the situation young artists coming to New York face now. But having said that, I do think a good deal of my nostalgia is for my own youth. I'm glad I didn't waste it.

By 1983, things had become grimmer. I started losing friends to AIDS. Rents had skyrocketed. I could no longer support myself by working very little ... By the mid-80s, I sensed that greed and crassness were overly abundant, even given my narcissism. I understood that the art I made would be seen in a political context.

SHERRIE LEVINE

New Yorker Praktiken gar nicht so stark
unterscheidet?

BENJAMIN H. D. BUCHLOH: Die Theoretisierung
des Autors, die aus Frankreich kam,
war für die USA wesentlich. Es ging um
eine neue Theoretisierung der Autoren-
rolle in gender-theoretischen Terms.
Das hat zu einer anderen künstlerischen
Handlungspraxis geführt als bei
Kippenberger. Er ist für mich jemand, der
trotz dieser Theorieversuche immer
noch das männliche Subjekt, wenn auch als
Travestie, zelebriert hat.

KASPER KÖNIG: Er hat natürlich die Zeichen
der Zeit erkannt und sich bewusst in
diese Ecke manövriert.

BENJAMIN H. D. BUCHLOH: Jemand wie Polke,
der schon in den späten 60er Jahren
Dekorationsstoffe zum Bildsubjekt gemacht
hat, ist viel radikaler als Kippenberger
in Bezug auf die Autorenschaft.
Er hat das Gestische, die Identität, das
Autorenhafte und so weiter befragt
und gibt es mit den Fetzen, die er als
Malerei präsentiert, total auf.
Dies ist eine radikale Kritik der Male-
rei, auch in gender-theoretischen
Terms. Bei Kippenberger ist es eine Tour
zu Picabia, der ebenfalls mit den
Mitteln der Malerei den rabiaten Versuch
der Rekonstruktion männlicher
Subjektivität darstellte.

JUTTA KOETHER: Aber Kippenbergers
Rekonstruktionsversuch war kein abge-
schlossener. Er war offen und voller
Zweifel. Das ist der grosse Unterschied
zwischen Picabia und Kippenberger.

KASPER KÖNIG: Er musste die Welt jeden Tag
neu erfinden. Ganz schön anstrengend.

ISABELLE GRAW: Der männliche Künstler,
der das Gescheiterte und Tragische seiner

Subjekthaftigkeit thematisiert, ist natürlich ein Klassiker und nicht zuletzt ein Klischee. Ich finde es viel interessanter, über Kippenberger als approprierenden und institutionskritischen Künstler nachzudenken. Seine Ausstellung in Paris, wo er sich selbst als Kandidat für eine Retrospektive anbot – zu einer Zeit, als es in Deutschland kaum Institutionen gab, die bereit waren, ihn auszustellen –, die Einladungskarte, die sein ganzes Support- und Lobbysystem abbildete – wodurch das Abgründige dieser Form von Lobbyismus und freundschaftlicher Unterstützung sichtbar wurde –, kommt einer Analyse der informellen Institutionen des Kunstbetriebs gleich.

JUTTA KOETHER: Dennoch insistiere ich auf dem Geschlechterdiskurs. Wenn ich mir noch einmal vor Augen führe, welche Modelle es in Deutschland zu dieser Zeit gab, bei denen man sich als weibliche Künstlerin abarbeiten konnte und ein Diskurs möglich war, dann ist mir die Figur Kippenberger immer noch lieber als manch anderes, denn sie hatte Potenzial.

ISABELLE GRAW: Die Bedeutung der Appropriation Art bestand für mich darin, dass sie eine der ersten historischen Formationen war, in der Künstlerinnen eine massgebliche Rolle spielten. Ein Pendant dazu hat es in Deutschland nicht gegeben. Dort regierte nach wie vor das Prinzip Ausnahmefrau. In den 90ern gab es diesbezüglich eine Veränderung, weil die Identität »Künstlerin« zu einer begehrten Ware wurde. Mittlerweile sorgen Galerien dafür, dass sie mehrere Künstlerinnen im Angebot

BENJAMIN H. D. BUCHLOH: Somebody like Polke, who already in the 1960s took decorative fabrics as the subject of his pictures, is much more radical than Kippenberger, as far as authorship is concerned. He interrogated the gestural, identity, the author, and so on, and with the shreds that he presents as painting abandoned them entirely. This is a radical critique of painting, also in terms of gender theory. With Kippenberger, it's a return to Picabia, who also represented with the means of painting a furious attempt of the reconstruction of male subjectivity.

JUTTA KOETHER: But Kippenberger's reconstruction attempt wasn't finished. It was open and full of doubts. That's the great difference between Picabia and Kippenberger.

KASPER KÖNIG: He had to invent the world anew every day. Quite exhausting...

ISABELLE GRAW: The male artist who thematizes the failed and the tragic elements of his subjectivity is of course a classic, and a cliché. I think it is much more interesting to think about Kippenberger as an appropriating artist, interested in institutional critique. His exhibition in Paris, where he offered himself as a candidate for a retrospective—at a time when there were no institutions in Germany willing to exhibit him—the invitation that showed his whole support and lobbying system, which made the abyss of this form of lobbyism and support based ion friendship visible, is in effect an analysis of the informal institutions of the art world.

JUTTA KOETHER: Nevertheless, I insist on the gender discourse. If I remember what models were available in Germany for a woman artist to challenge and confront, and where a discourse was possible, then I prefer the figure of Kippenberger to many others, because it had potential.

ISABELLE GRAW: For me, the significance of appropriation art lay in the fact that it was one of the first historic formations where women artists played an important role. An equivalent to that simply didn't exist in Germany. There, the principle of the exceptional woman was still dominant. In the 1990s, there was a change in that respect because the identity "woman artist" became a desired commodity. By now, galleries see to it that they have several woman artists in their program, though not necessarily as a sign of their feminist enlightenment, but rather as a tribute to the logic of the market, which does not stop at any limit—including that of gender.

BENJAMIN H. D. BUCHLOH: One needn't privatize or isolate that so much. One might cite as a productive comparison that the fifties were in the U.S. the historical moment when homosexuality became an integral element of subjectivity, one that could determine artistic identity. In the same way in which John Cage, Merce Cunningham, Robert Rauschenberg, and Cy Twombly defined themselves as new subjects in the 1950s, after Abstract Expressionism, it could be said that the woman artists of the 1980s radically redefined subjectivity through a

haben, allerdings nicht unbedingt als Zeichen ihrer feministischen Aufgeklärtheit, sondern als Tribut an die Marktlogik, die vor keiner Grenze – auch nicht der des Geschlechts – Halt macht.

BENJAMIN H. D. BUCHLOH: Man muss das nicht so sehr privatisieren oder isolieren. Als produktiven Vergleich könnte man anführen, dass die 50er Jahre in den USA der historische Moment waren, in dem Homosexualität zum integralen Subjektivitätselement wurde, das künstlerische Identität bestimmen konnte. In der gleichen Weise wie John Cage, Merce Cunningham, Jasper Johns, Ellsworth Kelly, Robert Rauschenberg, Cy Twombly und Andy Warhol sich in den späten 50er Jahren, nach dem Abstrakten Expressionismus, als neue Subjekte definierten, könnte man sagen, dass die Künstlerinnen der 80er Jahre durch die feministische Perspektive Subjektivität radikal neu definiert haben. Das zieht sich durch das ganze 20. Jahrhundert.

KASPER KÖNIG: Man muss gerade bei Künstlern wie Twombly oder Cage wissen, dass sie zwar schwul waren, aber keine schwule Kunst gemacht haben.

BENJAMIN H. D. BUCHLOH: Im Gegensatz zum Abstrakten Expressionismus aber schon.

KASPER KÖNIG: Sie entsprachen nicht diesem Machobild. Dagegen gab es jedoch feministische Künstlerinnen, die zielgerichtet politisch engagiert waren.

BENJAMIN H. D. BUCHLOH: Nicht in den 80ern, denn das waren keine feministischen Pragmatikerinnen. Sie redefinierten in erster Linie die Subjektivität in der Kunst. Von dieser Perspektive aus

feminist perspective. You can
find that throughout the entire
twentieth century.

KASPER KÖNIG: But for artists like
Twombly and Cage, it is clear
that although they were gay, they
didn't make gay art.

BENJAMIN H. D. BUCHLOH: In
comparison to Abstract Expression-
ism, they did.

KASPER KÖNIG: They didn't conform to
that macho image. But there
were feminist woman artists whose
political commitment was very
goal-oriented.

BENJAMIN H. D. BUCHLOH: Not in the
1980s, because they were not
feminist pragmatists. First and
foremost, they redefined
subjectivity in art. Seen from
this perspective, it is
interesting to ask in what
relation Kippenberger, Büttner,
Oehlen, Salle, and Schnabel stand
to these radical definitions.
And Twombly? Try to save whatever
could be saved?

ISABELLE GRAW: Well, how was it with
you guys, Werner? Were you
thinking about male subjectivity
and gender-based inequalities
or the classic distribution of
roles?

WERNER BÜTTNER: I think no artists'
group of the 1980s produced
as many self-portraits as we did,
and self-portraits are always
roles congealed in paint.
Oehlen's "Selbstbildnis mit
blauer Mauritius und
verschissener Unterhose,"
Kippenberger's self-portrait as a
Turkish cleaning lady, and my
"Selbst als Schädling
im Apfelbaum" or "Selbst als
Eierwärmer" are of course
engagements with the role of the
male artist.

PHILIPP KAISER: In the context
of the reformulation of artistic
subjectivity, I'd be interested

gesehen, ist es interessant zu fragen, wie Kippenberger, Büttner, Oehlen, Salle und Schnabel in Bezug zu diesen radikalen Definitionen stehen. Wie Twombly? Versuchen zu retten, was zu retten ist?

ISABELLE GRAW: Wie war das denn bei euch, Werner? Gab es ein Nachdenken über männliche Subjektivität und geschlechtsbedingte Ungleichheiten oder klassische Rollenverteilungen?

WERNER BÜTTNER: Ich glaube, keine Künstlergruppierung der 80er Jahre hat so viele Selbstbildnisse produziert wie wir, und Selbstbildnisse sind immer zu Farben geronnene Rollen. Oehlens »Selbstbildnis mit blauer Mauritius und verschissener Unterhose«, Kippenbergers Selbstdarstellung als türkische Putzfrau und mein »Selbst als Schädling im Apfelbaum« oder »Selbst als Eierwärmer« sind natürlich Auseinandersetzungen mit der männlichen Künstlerrolle.

PHILIPP KAISER: Im Zusammenhang mit der Neuformulierung der künstlerischen Subjektivität würde mich interessieren, ob es auch in Westeuropa aktivistische Bestrebungen vonseiten der Künstler gab. Als Folge der Aids-Epidemie formierten sich in den USA Gruppierungen wie Gran Fury oder ACT UP, die künstlerische Praxis als politischen Aktivismus verstanden.

KASPER KÖNIG: In dieser Zeit wurden insbesondere von der Neuen Gesellschaft für bildende Kunst in Westberlin theoretisch wirklich interessante Ausstellungen gemacht. Frank Wagner hat sich mit einer solchen Thematik sehr intensiv auseinander gesetzt. Das wurde

whether in Western Europe there was also activism among artists. As a consequence of the AIDS epidemic, groups like Gran Fury or ACT UP formed in America who understood artistic praxis as political activism.

KASPER KÖNIG: At that time, theoretically really interesting exhibitions were put on by the "Neue Gesellschaft für bildende Kunst" in West Berlin. Frank Wagner engaged with these topics very intensively. But this was noted much more in the intellectual world than in the art world, because the market played no role in this context. It's difficult to find a comparison to the situation in New York.

PHILIPP KAISER: Was there any interest in Western Europe in producing politically committed art at that time? Werner Büttner, were your works of the eighties political?

WERNER BÜTTNER: I wouldn't want to advertise myself as a political artist. There would be too much potential for misunderstandings in that. I work with gentle appeals. "Mutwillig zerstörte Telefonzelle" was intended to be understood as a gentle appeal to be more careful with things. And the painting "Badende Russen" is a gentle appeal not to demonize the Russians.

JUTTA KOETHER: There was a conscious appearance and working in groups, as a network, which also signals a certain intention.

WERNER BÜTTNER: Those who all thought alike and the classic career pack. Young people in the twentieth century always did that: form a group, publish a manifesto, and claim to be the end of Western civilization.

in der intellektuellen Welt jedoch viel stärker rezipiert als in der Welt der Kunst, weil der Markt in diesem Zusammenhang keine Rolle spielte. Es ist schwierig, einen Vergleich zur Situation in New York zu finden.

PHILIPP KAISER: Gab es in Westeuropa zu dieser Zeit überhaupt ein Interesse, politisch engagierte Kunst zu produzieren? Waren Ihre Arbeiten der 80er Jahre, Werner Büttner, politisch?

WERNER BÜTTNER: Ich würde mich selbst nicht als politischen Künstler annoncieren wollen. Das birgt zu viele Miss-verständnisse. Ich arbeite mit zarten Appellen. »Mutwillig zerstörte Telefonzelle« sollte als zarter Appell verstanden werden, mit den Dingen etwas pfleglicher umzugehen. Und das Gemälde »Badende Russen« ist ein zarter Appell, die Russen nicht zu dämonisieren.

JUTTA KOETHER: Es gab ein bewusstes Auftreten und Arbeiten in Gruppierungen, im Verbund, was ja auch eine bestimmte Absicht signalisiert.

WERNER BÜTTNER: Gesinnungsgenossen und das klassische Karriererudel. Das haben junge Leute im 20. Jahrhundert immer gemacht: sich zusammenschliessen, ein Manifest herausgeben und behaupten, man sei der Untergang des Abendlandes.

ISABELLE GRAW: Das Etikett »politische Kunst« ist als Begriff schwierig, weil ein politischer Inhalt noch lange nicht die Politizität der Kunst garantiert. Man müsste genau definieren, wann, unter welchen Umständen und im Hinblick auf welche Situation man eine künstlerische Arbeit für politisch erklärt. Was eure Formation ausgemacht hat, war das Insistieren auf einen

ISABELLE GRAW: The label "political art" is difficult as a term, because a political content does not at all guarantee the art's political character. You'd have to define precisely when, under what circumstances, and in view of what situation, one can declare a work of art political. What characterized your formation was the insistence on a critical-mocking relation to the world and to the media. But what about that was political?

KASPER KÖNIG: Büttner also worked with Goya-slogans. In that respect, there were indeed aspects of the political.

ISABELLE GRAW: But there is no consensus about what political art is. Of course there is art that claims to be political, but you'd have to show what that consists of.

WERNER BÜTTNER: Would anybody say Goya's art is political? I, at any rate, don't consider it political. I think he viewed his time sensitively and thought about it with paint.

KASPER KÖNIG: In contrast to the others in the gang, you, after all, set political targets.

WERNER BÜTTNER: I prefer to speak of gentle appeals.

ISABELLE GRAW: I find it interesting that you say appeal, because what I always liked was the way in which pictures became speech acts through literally integrated appeals. Linguistic propositions and the insistence on legibility and mediation—these are actually characteristics of conceptual art.

WERNER BÜTTNER: It was important that the pictures could not be misunderstood.

JOHN M ARMLEDER: The subtext was in the 1980s more legible and

kritisch-spöttischen Welt- und Medien-
bezug. Doch was war daran politisch?

KASPER KÖNIG: Büttner hat ja auch mit Goya-
Parolen gearbeitet. Insofern gibt
es da schon Aspekte.

ISABELLE GRAW: Nur ist nicht ausgemacht,
was politische Kunst ist. Es gibt
natürlich eine Kunst mit Anspruch auf
Politizität, aber dann müsste man zeigen,
worin diese besteht.

WERNER BÜTTNER: Würde jemand sagen, Goyas
Kunst sei politisch? Ich halte sie
jedenfalls nicht für politisch. Aber er
hat seine Zeit mit sensiblem Blick
betrachtet und malerisch mitgedacht.

KASPER KÖNIG: Im Gegensatz zu den anderen
der Bande hast du aber politische
Vorgaben gemacht.

WERNER BÜTTNER: Ich rede lieber von zarten
Appellen.

ISABELLE GRAW: Ich finde das interessant,
dass du Appell sagst, denn was mir immer
so gut gefiel, war die Art und Weise,
wie Bilder durch buchstäblich integrierte
Appelle zu Sprechakten wurden.
Linguistische Propositionen sowie das
Insistieren auf Lesbarkeit und
Vermittlung – eigentlich sind das
Eigenschaften der Konzeptkunst.

WERNER BÜTTNER: Es war wichtig, dass man die
Bilder nicht falsch verstehen konnte.

JOHN M ARMLEDER: Der Subtext war in
den 80ern lesbarer und zugänglicher als
in den 60ern.

BENJAMIN H. D. BUCHLOH: Es kommt mir so vor,
als könnte man eine sehr elementare
Unterscheidung zwischen den USA
und Europa treffen. Das ist fast banal,
aber vielleicht nicht klar genug: Wenn es
um kulturelle Praxis geht, befinden
sich die Amerikaner oft in der verzweifel-

more accessible than in the 1960s.

BENJAMIN H. D. BUCHLOH: It seems to me one might make a very elemental distinction between the U.S. and Europe. This is almost banal, but perhaps not clear enough: as far as cultural practice is concerned, Americans are often in the desperate position that what should really be at issue is a real intervention in the present. At the best moments in American art of the last fifty years or more, there was always something at stake. The fact that in the final analysis it was just culture was secondary. In Europe, on the other hand, the question whether a real transformation can be effected through cultural practice is never raised. Here, the question is always right away: can the art be received in the cultural context? That is to say, the political effect doesn't play any role whatsoever. At issue is only whether one can still or yet again comply with the criteria of the cultural superego, which is generally valid in Europe. In the U.S., the opposite question is important: can we do anything that has an effect in reality? And this difference is strange. Artists in the U.S. always worked with that goal in mind, artists in Europe have never asked such questions. Feminism, gay culture, and Group Material are political. In Europe they do culture, in the U.S. they attempt to do politics with cultural means. That is very desperate, but necessary. And it is a marked difference.

ISABELLE GRAW: But activist groups like ACT UP or Group Material were initiatives that

ten Position, dass es eigentlich um eine reale Intervention in der Gegenwart gehen müsste. In den besten Momenten der amerikanischen Kunst der letzten fünfzig Jahre oder mehr stand deshalb immer etwas auf dem Spiel. Die Tatsache, dass es sich letzten Endes nur um Kultur handelte, ist sekundär. Dagegen stellt sich in Europa nie die Frage, ob mit der kulturellen Praxis eine reale Transformation vorgenommen werden kann. Hier fragt man immer von vornherein: Ist die Kunst kulturell rezipierbar? Das heisst, der politische Effekt spielt überhaupt keine Rolle. Es geht nur darum, ob man den Kriterien des kulturellen Überichs, das in Europa so allgemein gültig ist, noch oder wieder entspricht. In den USA geht es um die gegenteilige Frage: Kann man irgendetwas machen, was in der Realität eine Auswirkung hat? Und diese Unterscheidung ist merkwürdig. Künstler in den USA haben mit diesem Anspruch gearbeitet, Künstler in Europa haben diese Fragen nie gestellt. Feminismus, Gay Culture und Group Material sind politisch. In Europa macht man Kultur, in den USA versucht man, mit kulturellen Mitteln, Politik zu machen. Das ist sehr verzweifelt, aber notwendig. Und das ist ein markanter Unterschied.

ISABELLE GRAW: Aber aktionistische Gruppen wie ACT UP oder Group Material waren doch Initiativen, die unmittelbar in die Kultur eingespeist wurden – man denke nur an die tolle Group-Material-Ausstellung in der Dia Art Foundation in New York. In diesem Zusammenhang ist auch Douglas Crimp eine interessante Figur, an der man die Spannung zwischen Kultur und

Aktivismus gut aufzeigen kann. Er war zunächst kunsthistorisch tätig, hat sich dann aber zugunsten seines aktivistischen Engagements aus der Kunsttheorie zurückgezogen.

KASPER KÖNIG: In Deutschland hat es aber auch Figuren wie Wolfgang Max Faust gegeben.

ISABELLE GRAW: Er hatte »Hunger nach Bildern« geschrieben – eine Hymne an die neue Malerei – und hatte zugleich einen identitätspolitischen Einsatz.

WERNER BÜTTNER: 1968 waren wir erst 14 Jahre alt, doch diese Zeit haben wir bewusst miterlebt. Wir haben kurz mit der RAF sympathisiert, uns dann aber für eine Kunsttätigkeit entschieden und nicht für den Untergrund.

KASPER KÖNIG: Welche Position hatte in diesem Kontext die Fotografie? Die Wiederentdeckung von August Sander und anderen Fotografen der Weimarer Zeit fand in den 70er Jahren mit einem politischen Anspruch statt.

BENJAMIN H. D. BUCHLOH: In diesem Zusammenhang sind Thomas Ruffs Foto-montagen interessant. Sehen Sie diese als historische Travestie des Heartfield'schen Erbes?

THOMAS RUFF: Mit einer künstlerischen Arbeit kann man natürlich keine Politik beeinflussen oder bewegen, man kann nur versuchen, dem Gesabber der Politiker auszuweichen oder zurückzuspucken. Aus diesem Grund habe ich angefangen, Collagen und Montagen mit Schrift zu machen. Ich habe Ereignisse ausgewählt, die mich damals besonders aufgeregt haben, wie etwa die fran-zösischen Atomwaffentests in der Südsee oder das Massaker an chinesischen

fed directly into the culture—just think of the fabulous Group-Material show at the Dia Art Foundation in New York. In this context, Douglas Crimp is an interesting figure who illustrates the tension between culture and activism quite well. Initially he worked as an art historian, but then withdrew from art theory in favor of his activist commitments.

KASPER KÖNIG: In Germany there were figures like Wolfgang Max Faust.

ISABELLE GRAW: He wrote Hunger nach Bildern—a hymn to new painting—but at the time he had in investment in identity politics.

WERNER BÜTTNER: In 1968, we were only fourteen, but we were conscious of what went on. We sympathized briefly with the Red Army Faction, but then decided on working in art rather than going underground.

KASPER KÖNIG: Which position did photography have in this context? The rediscovery of August Sander and other photographers of the Weimar period in the 1970s also made claims to political relevance.

BENJAMIN H. D. BUCHLOH: Thomas Ruff's photomontages are interesting in this context. Do you see those as a historical travesty of the Heartfield heritage?

THOMAS RUFF: With a work of art you can't of course influence politics or move something politically, you can only try to avoid the blubbering of politicians, or spit back. For that reason, I started doing collages and montages with writing. I chose events that upset me particularly at the time, like for example the French nuclear bomb tests in the

South Sea or the massacre among
Chinese students on Tiananmen
Square in Beijing. The collages
were intended as a mixture
of Heartfield montages and bad
film posters from the fifties; I
wanted to represent the
politicians responsible as
appalling actors in bad B-movies.
In Germany and in the U.S.,
the series, which I showed
in 1997, was completely rejected.
Nobody was interested in the
pictures.
But I would like to briefly
recapitulate the 1980s from my
perspective. In the late
1970s, there was a first small
turn for photography as an
artistic medium. In 1977, after
the documenta 6 with the
exhibition "150 Jahre Foto-
grafie," many thought now
photography was fully established
as an art form. Shortly after
that, though, there was the wave
with wild painting that was
enormously successful. In
Cologne, new galleries opened, or
galleries moved into bigger
spaces. This painting "occupied"
all exhibition spaces and
exhibition possibilities. But
suddenly, in the mid 1980s,
nobody wanted to see or hear any-
thing of this expressive
painting anymore. At that point
there were a few sculptors in
Düsseldorf, the so-called
Modellbauer, or model builders.
You could call the works of
Harald Klingelhöller, Reinhard
Mucha, Thomas Schütte,
and others quite objective. But
apparently people were at
that time on the lookout for an
even more objective medium.
And as a consequence, the first
Becher students were
successful. And when I showed my
large portraits for the first

Die frühen 80er Jahre waren eine bewegte Zeit in New York, denn die »französischen Theoretiker«, wie wir sie nannten, wurden von Leuten unterschiedlichster Hintergründe gelesen, von allen möglichen Künstlern. Für mich stellte ihre Arbeit eine Fortsetzung der Avantgarde der 60er dar. Ich habe immer gemeint, dass Foucault ein Philosoph des Raums war. Meiner Meinung nach ist er der Erste, der geschildert hat, auf welche Art und Weise Raum gemäss den sozialen Machtverhältnissen konstruiert wird. Er hat ganz klar und fast bildnerisch veranschaulicht, wie sozialer Raum durch verschiedene Formen kontrolliert wird, besonders in seinem Buch über Gefängnisse. Zur gleichen Zeit war die Vorstellung von Roland Barthes für ziemlich viele Künstler wichtig, dass die Zeichen eines Kunstwerks nicht durch eine einzige Interpretation bestimmt werden, sondern, dass sie im Gegenteil eine unendliche Kette von Interpretationen auslösen. Was Baudrillard angeht, so hatte er in seiner Simulakra-Periode eine sehr bestimmte Intuition bezüglich Sprache und dem, was wir heute das digitale Zeitalter nennen. Er bezog sich darauf, wie technologische Gesellschaften hermetisch geworden sind, und zeigte, wie wir mit den Mitteln der Technologie eine Art universelle Autoreferenz geschaffen haben, die auf sich selbst zurückfällt.

The beginning of the 1980s in New York was a passionate time because the "French theoreticians," as we called them, were being read by people from very different worlds, by all sorts of artists. For me, their work represented a continuation of the avant-garde of the 60s. I've always thought that Foucault was a philosopher of space. He is, to my mind, the first to have evoked the way in which space is constructed in terms of social power. He clearly and almost sculpturally explained how social space is controlled by different forms, notably in his book on prisons. At the same time Roland Barthes's idea that the signs included in a work of art were not determined by a single interpretation, but rather that they create an infinite chain of interpretations, has been very important to a good number of artists. For his part, Baudrillard had, in his period of simulacra, a kind of very determinant intuition about language and about the sense for what we now call the numeric age. He made reference to the way technological societies had become impenetrable and showed how we have created, by means of technology, a sort of universal auto-referent that turns back on itself.

PETER HALLEY

The '80s have been around before. Back then I happened to come across Thomas Kuhn's "The Structure of Scientific Revolutions." The Italian Transavanguardia and its various national counterparts were just on the rise, and I thought we'd see whether what Kuhn said was true—that when a paradigm shift occurs, some group always comes to the fore, but it's not one that stands for the future. And this has persisted ever since. One hoped that Kuhn's insight was right (that the stars of the day would not remain parameters). It really is true, but luckily there has not been much new in the meantime, and the old fogeys (from Beuys to Warhol) have departed this life to the relief of all concerned, and new imbeciles have established themselves. Since those days we have been involved in continual paradigm shifts. But Kuhn's "new" is keeping us waiting.

Die 80er gab es schon. Mir fiel damals Thomas Kuhns »Die Struktur wissenschaftlicher Revolutionen« in die Hände. Die italienische Transavanguardia sowie die diversen nationalen Pendants waren gerade auf dem Vormarsch, und ich dachte mir, jetzt schauen wir doch mal, ob das, was Thomas Kuhn meint, stimmt, nämlich, dass bei einem Paradigmenwechsel immer eine Gruppe hochkommt, diese dann aber nicht für die Zukunft steht. Und das perseveriert sich seit damals. Man hoffte, dass Kuhns Einsicht richtig ist (dass die Stars von damals keine Parameter blieben). Dem ist wirklich so, aber viel Neues gab's zum Glück einstweilen noch nicht, und der alte Schlatz (von Beuys bis Warhol) segnete zur allgemeinen Erleichterung das Zeitliche, und neue Trottel etablierten sich. Seit damals befindet man sich im kontinuierlichen Paradigmenwechsel. Kuhns Neues lässt auf sich warten.

FRANZ WEST

time in 1986–87, people were so
impressed by the precision
of the pictures that they didn't
care whether it was a painted
picture, a silk-screen print, or
a photographic print. They
were the first pictures of mine
that had a physical presence that
could not be ignored.

PHILIPP KAISER: It seems illumina-
ting to me that just at the
moment that painting lost terrain
on the art market, large tableau
photography appeared. Is
that not almost a schizophrenia
of history?

THOMAS RUFF: Painting is painting,
photography is photography.
I never saw myself in an
art historical tradition, like
Jeff Wall does. I'd rather
concern myself with how the mass
medium photography is misused,
bent, manipulated, and used
in our Western industrialized
consumer-oriented world. I try to
clean up a bit.

BENJAMIN H. D. BUCHLOH: But the
pressure on the format of
photography certainly comes from
painting. It doesn't matter
whether you refer to Jeff Wall or
not.

ISABELLE GRAW: The large Ruff
portraits are a phenomenon of the
1980s, not least because they
wanted to demonstrate a certain
cool, uninvolved attitude.
The portraits have something to
do with the then current
New Wave pose.

THOMAS RUFF: Of course at that time
we were all cool. When I
started with the portrait series
in 1981, I had experienced
the RAF terrorism hysteria of the
German state and the German
police. I remember very well that
time when you had to always
present your ID. That was one
aspect of the portraits. And we

Studenten auf dem Platz des Himmlischen
Friedens in Peking. Die Collagen
sollten eine Mischung aus Heartfield-
Montagen und schlechten Filmplakaten aus
den 50ern werden, die verantwortlichen
Politiker wollte ich als miserable
Akteure schlechter B-Movies darstellen.
In Deutschland und den USA wurde
die Serie, die ich 1997 ausgestellt habe,
total abgelehnt. Die Bilder haben
niemanden interessiert.
Doch ich möchte aus meiner Sicht kurz die
80er rekapitulieren: In den späten 70ern
gab es für die Fotografie als
künstlerisches Medium eine erste kleine
Wende. 1977, nach der »documenta 6«
mit der Ausstellung »150 Jahre
Fotografie«, hatten viele gedacht, die
Fotografie sei als Kunstform nun
endgültig etabliert. Kurz danach kam dann
aber die Welle der Wilden Malerei,
die enorm erfolgreich war. In Köln wurden
neue Galerien gegründet, oder die
Galerien sind in grössere Räume gezogen.
Diese Malerei »besetzte« alle
Ausstellungsflächen und Ausstellungs-
möglichkeiten. Doch plötzlich, Mitte der
80er Jahre, wollte niemand mehr etwas
von dieser expressiven Malerei sehen und
hören. Zu diesem Zeitpunkt gab es
in Düsseldorf einige Bildhauer, die so
genannten Modellbauer. Die Arbeiten
von Harald Klingelhöller, Reinhard Mucha,
Thomas Schütte und anderen konnte
man schon sehr sachlich nennen. Scheinbar
wurde aber zu der Zeit nach einem
Medium Ausschau gehalten, das noch
sachlicher war. In der Folge hatten die
Becher-Schüler ihre ersten Erfolge.
Und als ich 1986/87 zum ersten Mal meine
grossformatigen Porträts ausstellte,

had all read Orwell's "1984" and were interested in what the year 1984 would bring. The gaze of those portrayed into "my" camera was the gaze into the surveillance camera. The gaze was supposed to be cool, not show the emotions and sympathies of the portrayed. And at the same time I wanted to make beautiful portraits of my friends and colleagues at the academy, portraits that did them justice.

ISABELLE GRAW: Perhaps we should examine the overlays between art scene and subculture more closely and ask how exactly the concrete bridges look. Which relations of exchange existed? Where were the borders and bridges, say, between the Becher school, Kraftwerk, and New Wave? You can only understand artistic phenomena properly in view of the productions in the popular culture that tied into them and with which they communicated.

KASPER KÖNIG: It would be fatal to claim the 1980s belonged to young people between twenty-five and twenty-eight years old.

PHILIPP KAISER: The engagement with German history, with Hitler and the RAF, was at the beginning of this conversation dismissed as a post-adolescent reflex. But I would be interested in what notion of historicity characterized the 1980s. If you read the legendary discussion among Jean-Christophe Ammann, Anselm Kiefer, Jannis Kounellis, Enzo Cucchi, and Beuys, you get the impression that a very diffuse view of history was being developed there. How do you see that with respect to the 1980s?

ISABELLE GRAW: German history was claimed and rediscovered as an

waren die Leute von der Präzision der Bilder so beeindruckt, dass es ihnen egal war, ob es sich um ein gemaltes Bild, einen schönen Siebdruck oder »nur« um einen fotografischen Abzug handelte. Es waren meine ersten Bilder, die eine »physische Präsenz« hatten, an der keiner mehr vorbei konnte.

PHILIPP KAISER: Es erscheint mir aufschlussreich, dass just in dem Moment, als die Malerei auf dem Kunstmarkt an Terrain verliert, die grossformatige Tableaufotografie auftaucht. Ist dies nicht gewissermassen eine Schizophrenie der Geschichte?

THOMAS RUFF: Malerei ist Malerei, Fotografie ist Fotografie. Ich habe mich nie wie Jeff Wall in einer kunstgeschichtlichen Tradition gesehen. Ich beschäftige mich lieber damit, wie das »Massenmedium« Fotografie in unserer westlichen, industrialisierten, konsumorientierten Welt missbraucht, verbogen, manipuliert und benutzt wird. Ich versuche, ein wenig aufzuräumen.

BENJAMIN H. D. BUCHLOH: Aber der Druck auf das Format der Fotografie kommt mit Sicherheit von der Malerei. Es spielt dabei keine Rolle, ob Sie sich auf Jeff Wall beziehen oder nicht.

ISABELLE GRAW: Die grossformatigen Ruff-Porträts sind nicht zuletzt deshalb ein Phänomen der 80er Jahre, weil es in ihnen darum ging, eine bestimmte kühle, unbeteiligte Haltung an den Tag zu legen. Die Porträts haben etwas mit der damaligen New-Wave-Pose zu tun.

THOMAS RUFF: Natürlich waren wir damals alle »cool«. Aber als ich 1981 mit der Porträt-serie begann, hatte ich meine Erfahrungen mit der RAF-Hysterie des deutschen

Staates und der deutschen Polizei
gemacht. Ich erinnere mich gut an diese
Zeit, in der man ständig seinen
Personalausweis zeigen musste. Das war
ein Aspekt der Porträts. Und wir hatten
alle George Orwells »1984« gelesen
und waren auf das Jahr 1984 gespannt. Der
Blick der Porträtierten in »meine«
Kamera war der Blick in die Überwachungs-
kamera. Der Blick sollte cool
sein und die Gefühle und Sympathien des
Porträtierten nicht zeigen. Und
gleichzeitig wollte ich schöne, stimmige
Porträts von meinen Freunden und Kollegen
an der Akademie machen.

ISABELLE GRAW: Vielleicht müsste man sich
die Überlagerungen zwischen Kunstszene
und Subkultur genauer ansehen und
fragen, wie genau die konkreten Übergänge
eigentlich aussehen. Welche Aus-
tauschbeziehungen hat es gegeben? Wo
verlaufen die Grenzen und die Übergänge
etwa zwischen der Becher-Schule,
Kraftwerk und New Wave? Man versteht
künstlerische Phänomene nur angemessen im
Hinblick auf die popkulturellen
Produktionen, in die sie eingebunden
waren und mit denen sie kommunizierten.

KASPER KÖNIG: Es ist fatal zu behaupten, die
80er gehörten den Jugendlichen zwischen
25 und 28 Jahren.

PHILIPP KAISER: Die Auseinandersetzung mit
der deutschen Geschichte, mit
Hitler und der RAF, wurde eingangs als
postpubertärer Reflex abgetan. Mich würde
jedoch interessieren, welche Art
von Historizität und welcher Begriff von
Geschichtlichkeit die 80er Jahre
charakterisiert haben. Liest man das
mittlerweile legendäre Gespräch zwischen
Jean-Christophe Ammann, Anselm Kiefer,

Jannis Kounellis, Enzo Cucchi und Joseph Beuys, so ereilt einen der Eindruck, dass hier ein sehr diffuses Geschichtsbild entwickelt wird. Wie sehen Sie das im Hinblick auf die 80er Jahre?

ISABELLE GRAW: Die deutsche Geschichte wurde als künstlerisches Thema behauptet und wieder entdeckt. Man erklärte einfach, dass das Genre »Historienbild« wieder möglich sei. Allerdings müsste man aus heutiger Sicht differenzieren zwischen den Heldenbildern von Baselitz, den Stahlhelmen von Lüpertz und dem Hitlerbild von Oehlen – in jedem Fall stand etwas anderes auf dem Spiel.

BENJAMIN H. D. BUCHLOH: Das gilt doch nicht ausschliesslich für die 80er Jahre. Beuys, Richter und andere haben bereits in den 60ern versucht, sich damit in Bezug zu setzen.

ISABELLE GRAW: Du hast Recht, das ist ein durchgehendes Interesse, nur haben Beuys, Richter und Kiefer zunächst nicht in derselben Weise auf »Figuration« und die Provokation des Historienbildes gesetzt.

BENJAMIN H. D. BUCHLOH: Büttner hat etwas Interessantes gesagt: »Wir konnten keine Betroffenheitsdiskussionen mehr führen.« Auf wen bezog sich das? Auf Beuys? Und weshalb hat er das gesagt? Um die Falschheit dieser Diskussionen zu entlarven und zu kritisieren? Das könnte ich als Motivation gut verstehen.

WERNER BÜTTNER: Händchen haltend Rotwein trinken und sich über die Welt beklagen, das ging nicht mehr.

BENJAMIN H. D. BUCHLOH: Spezifisch deutsche Betroffenheitsdiskussionen. Kiefer wäre für Sie dann doch eine wichtige Figur gewesen.

artistic topic. It was simply declared that the genre "historical painting" was possible again. Although from today's perspective we have to differentiate between the heroic pictures by Baselitz, the steel helmets by Lüpertz, and the Hitler picture by Oehlen—in every case something different was at stake.

BENJAMIN H. D. BUCHLOH: But that is not exclusively true for the 1980s. Already in the 1960s Beuys, Richter, and others tried to position themselves in that respect.

ISABELLE GRAW: You are right, that is an interest that goes right through, but Beuys, Richter, and Kiefer did initially not use figuration and the provocation of the historical picture in the same way.

BENJAMIN H. D. BUCHLOH: Büttner said something interesting: "We couldn't bear any more discussions of shame and guilt [Betroffenheitsdiskussionen] anymore." Whom did you mean? Beuys? And why did he say that? To unmask the falseness of these discussions and criticize it? That I could understand very well as a motivation.

WERNER BÜTTNER: Holding hands, drinking red wine, and complaining about the world, that was no longer possible.

BENJAMIN H. D. BUCHLOH: Specifically German discussions of their shame and guilt. Kiefer should have been an important figure for you then.

WERNER BÜTTNER: We thought Kiefer appalling right from the start. You can't deal with history and myths in such a design fashion. Beuys on the other hand was important to us, but not his talk. His theories of

capitalism and creativity were unbearable for us. But the work after all doesn't lie. You can benefit from looking at it. Immendorff and Polke were also important. We learned a lot from them.

BENJAMIN H. D. BUCHLOH: In 1976 I organized the first big Polke retrospective in Düsseldorf and Tübingen. At the entrance of the exhibition, he clandestinely showed a plywood replica of the Auschwitz phrase "Arbeit macht frei." I was fired as curator, and Polke had to decide whether the exhibition was to be opened or closed. The attention was almost zero: no reception, no reviews. It was, however, important to position oneself with such a stance, to say we demand a way of dealing with history, but a different way to the one that was familiar up to then.

ISABELLE GRAW: In the course of our discussion, I am noticing more and more what was one of the characteristics of that time: it is this strange and rather dark and inscrutable sense of humor that operates with trying to outdo one another, with impertinences. In a way I am also glad that that time is now over. That is probably because initially I was very interested in the various attempts to make socially relevant art, but then I had to note that for me, as a female cultural producer, there was no space available. Then I went to America, where I was confronted with "appropriation" as a process with a relation to society. There they had a much more enlightened consciousness about gender relations, and they were willing to critique the

WERNER BÜTTNER: Kiefer fanden wir von Anfang an abartig. So designmässig geht man mit Geschichte und Mythen nicht um. Beuys hingegen war wichtig für uns, nicht aber sein Gerede. Seine Kapitalismus- und Kreativitätstheorien waren für uns unerträglich. Aber das Werk lügt ja nicht. Das kann man mit Gewinn betrachten. Immendorff und Polke waren ebenfalls wichtig. Von ihnen lernten wir viel.

BENJAMIN H. D. BUCHLOH: 1976 habe ich in Düsseldorf und Tübingen die erste grosse Polke-Retrospektive organisiert. Am Eingang der Ausstellung hat er klammheimlich eine Sperrholzreplik des Auschwitzer Schriftzugs »Arbeit macht frei« gezeigt. Ich wurde als Kurator gefeuert, und Polke musste sich entscheiden, ob die Ausstellung eröffnet oder geschlossen werden sollte. Die Aufmerksamkeit war gleich null: keine Rezeption, keine Kritik. Es war jedoch wichtig, sich in einer solchen Haltung zu positionieren, zu sagen, wir fordern einen Umgang mit der Geschichte, aber in einer anderen Weise als das bisher geschehen ist.

ISABELLE GRAW: Es fällt mir im Laufe unseres Gesprächs immer mehr auf, was zu den Merkmalen dieser Zeit gehört: Es ist dieser eigentümliche und etwas abgründige Humor, der mit Überbietungen und Zumutungen operiert. Gewissermassen bin ich aber auch froh, dass diese Zeit ein Ende gefunden hat. Das liegt sicher daran, dass ich zwar zunächst an den unterschiedlichen Versuchen, eine gesellschaftlich relevante Kunst zu machen, sehr interessiert war, dann jedoch rasch feststellen musste, dass für

subject which in art is just
assumed. I saw new possibilities
for positioning and for
asserting myself. In Germany,
that was hardly possible at that
time.

WERNER BÜTTNER: This fact has also
historical reasons. Quite a
lot of artists—Kippenberger, me
too—were and are concerned
with the "Imitatio Christi," and
that unfortunately is a
role that was not intended for
you ladies...

ISABELLE GRAW: I'm speechless!
Nothing never ends. The 1980s are
in our midst.

mich als Kulturproduzentin in dieser
Formation kein Platz vorgesehen war.
Daraufhin bin ich nach Amerika gegangen,
wo ich mit »Appropriaton« als einem
Verfahren mit Gesellschaftsbezug
konfrontiert wurde. Dort gab es ein viel
aufgeklärteres Bewusstsein über
Geschlechterverhältnisse sowie eine
Kritik an dem in der Kunst vor-
ausgesetzten Subjekt. Hier sah ich neue
Möglichkeiten, mich zu verorten und
zu behaupten. In Deutschland war das zu
dieser Zeit kaum möglich.

WERNER BÜTTNER: Diese Tatsache hat auch
historische Gründe. Ziemlich viele
Künstler – Kippenberger oder auch ich –
waren und sind in der Imitatio
Christi unterwegs, und das ist eine
Rolle, die für euch Damen leider nicht
vorgesehen ist.

ISABELLE GRAW: Ich bin sprachlos … nichts
geht nie zu Ende. Die 80er Jahre sind
unter uns.

JOHN M ARMLEDER Born in Geneva in 1948; since the 1960s, John M Armleder's works have been exhibited in the most famous galleries in Europe, the United States, Asia, and Oceania and at international events such as the Biennale in Paris (1975), the Biennale in Venice (Swiss Pavilion 1986), PROSPECT (Frankfurt, 1986), the Biennale in Sydney (1986), Dokumenta (Kassel, 1987), Metropolis (Berlin, 1991), the Biennale in Lyons (1993), Toayama Now (the Japanese Triennale 1993), Posthuman (1993), „Open Ends" at the Museum of Modern Art (New York, 2000) and the World Exhibition in Seville. He is professor at the Hochschule der Bildenden Künste (HKB) in Braunschweig and at the École des Beaux-Arts (ECAL) in Lausanne. He was a member of the Swiss Confederation Art Commission from 1992 to 2000. Among numerous honors, he was awarded the Prix de la Ville de Genève (1994), and he has worked on important official contracts, including the recent „Chapelle dite du Souvenirs des Charcutiers" in Sainte-Eustache, Paris (2000). Armleder lives and works in Geneva and New York.

BENJAMIN H. D. BUCHLOH, art historian and critic, has been recently named Florence and Franklin D. Rosenblatt Professor of Post War Art History at Harvard University, Cambridge. His second volume of collected essays, "Formalism and Historicity", is scheduled to be published by MIT Press in 2006. Buchloh is also an editor of "October" and a coauthor of the recently published "Art Since 1900".

WERNER BÜTTNER, born in 1954 in Jena, Thuringia, is now based in Hamburg. In 1960 he moved with his parents from East to West Germany, and in 1974 he began law studies in West Berlin. While still in college he joined with Albert Oehlen to found the Liga zur Bekämpfung des widersprüchlichen Verhaltens (League to Combat Inconsistent Behavior) and organized political actions. The first issue of the league's principal organ, "DumDum", appeared in 1977. Büttner's works were most recently on view in a comprehensive retrospective shown at the Deichtorhallen, Hamburg. Since 1990 Werner Büttner has been a professor at the Hochschule für Bildende Künste, Hamburg.

ISABELLE GRAW, born in 1962 in Hamburg, is active as an art critic in Berlin. In 1990 she collaborated with Stefan Germer to found the journal "Texte zur Kunst", which she continues to edit and publish. She is author of the books "Silberblick. Texte zu Kunst und Politik"

JOHN M ARMLEDER ist 1948 in Genf geboren, lebt und arbeitet in Genf und New York. Seit den 60er Jahren sind seine Arbeiten regelmässig in den namhaftesten Galerien in Europa, den USA, Asien und Ozeanien zu sehen. Er war mit Werken bei folgenden internationalen Ausstellungen vertreten: »Biennale« in Paris (1975), »Biennale« in Venedig (Schweizer Pavillon 1986), »PROSPECT« in Frankfurt am Main (1986), »Biennale« in Sydney (1986), »documenta 8« in Kassel (1987), »Metropolis« in Berlin (1991), »Weltausstellung« in Sevilla (1992) und »Biennale« in Lyon (1993). Ferner war er mit Arbeiten an »Toayama Now« (japanische Triennale 1993), »Posthuman« (1993) und »Open Ends«, MoMA in New York (2000) beteiligt. John M Armleder hat in Europa, den USA, Asien und Ozeanien zahlreiche Vorträge gehalten und Workshops geleitet. Er ist Professor an der Hochschule für Bildende Künste (HBK) in Braunschweig und an der École cantonale d'art (ECAL) in

Lausanne. Von 1992 bis 2000 war er Mitglied der Eidgenössischen Kunstkommission. Neben vielen anderen Auszeichnungen hat John M Armleder auch den Prix de la Ville de Genève (1994) erhalten. Darüber hinaus hat er wichtige öffentliche Auftragsarbeiten ausgeführt, zuletzt die »Chapelle dite du souvenir des charcutiers« in Sainte-Eustache in Paris (2000).

BENJAMIN H. D. BUCHLOH hat vor Kurzem an der Harvard University (Cambridge) die Franklin-D.-and-Florence-Rosenblatt-Professur für Kunstgeschichte der Nachkriegsära übernommen. Der zweite Band seiner gesammelten Essays erscheint 2006 unter dem Titel »Formalism and Historicity« bei MIT Press. Er ist ausserdem Mitherausgeber der Zeitschrift »October« und hat zusammen mit drei weiteren Autoren 2005 den Band »Art Since 1900« veröffentlicht.

WERNER BÜTTNER, 1954 in Jena (damals DDR) geboren, lebt und arbeitet in Hamburg. 1960 siedelte er mit seinen Eltern nach Westdeutschland über. Ab 1974 studierte er in Berlin Jura. Noch während des Studiums gründete er mit Albert Oehlen die »Liga zur Bekämpfung des widersprüchlichen Verhaltens« und organisierte politische Aktionen. 1977 folgte die erste Ausgabe des Zentralorgans der Liga, »Dum Dum«. Seine Werke wurden 2003 in einer umfassenden Retrospektive in den Deichtorhallen Hamburg gezeigt. Werner Büttner ist seit 1990 Professor an der Hochschule für Bildende Künste in Hamburg.

ISABELLE GRAW, 1962 in Hamburg geboren, lebt als Kunstkritikerin in Berlin. 1990 gründete sie gemeinsam mit Stefan Germer die Zeitschrift »Texte zur Kunst«, deren Herausgeberin und Redakteurin sie seither ist. Darüber hinaus hat sie folgende Bücher veröffentlicht: »Silberblick. Texte zu Kunst und Politik« (1999) und »Die bessere Hälfte. Künstlerinnen des 20. und 21. Jahrhunderts« (2003). Als Autorin ist sie unter anderem für »Wolkenkratzer Art Journal«, »Flash Art«, »Artis«, »artforum« und zahlreiche Ausstellungskataloge tätig. Isabelle Graw ist Professorin für Kunsttheorie an der Städelschule Frankfurt.

KASPER KÖNIG wurde 1943 in Mettingen/Westfalen geboren. Von 1972 bis 1976 war er ausserordentlicher Professor für Kunstgeschichte am Nova Scotia College of Art and Design in Halifax (Kanada). 1973 gründete er an dieser Hochschule »The Press of the Nova Scotia College of Art and Design«. Er war 1977, 1987 und 1997 Kurator der »Skulpturenprojekte Münster«, die er auch 2007 wieder verantworten wird. Für die Museen der Stadt Köln hat er 1979 »Westkunst. Zeitgenössische Kunst seit 1939« konzipiert, in Düsseldorf hat er 1984 die Ausstellung »von hier aus« organisiert. Er lehrte an der Frankfurter Städelschule und war Gründungsdirektor des Frankfurter Portikus. Seit 2000 ist Kasper König Leiter des Museums Ludwig in Köln. Das Nova Scotia College of Art and Design in Halifax hat ihm vor Kurzem die Ehrendoktorwürde verliehen.

JUTTA KOETHER (ver)malt, (ver)lehrt, (ver)spielt (sich) meistens in New York City oder What we don't talk about when we don't talk about ...

THOMAS RUFF, 1958 in Zell am Harmersbach geboren, lebt und arbeitet in Düsseldorf. Er studierte von 1977 bis 1985 bei Bernd Becher an der Kunstakademie in Düsseldorf. Seine Arbeiten wurden in zahlreichen Museen, Galerien und internationalen Ausstellungen gezeigt, unter anderem auf der »documenta 9« in Kassel (1992), im deutschen Pavillon der »Biennale« in Venedig (1995) und 2002 in einer Retrospektive an der Staatlichen Kunsthalle Baden-Baden. Thomas Ruff ist Professor an der Staatlichen Kunstakademie Düsseldorf.

and "Die bessere Hälfte. Künstlerinnen des 20. und 21. Jahrhunderts". She is a regular contributor to "Wolkenkratzer Art Journal", "Flash Art", "Artis", "Artforum", and to numerous exhibition catalogues. Isabelle Graw is professor of art theory at the Städelschule, Frankfurt.

KASPER KÖNIG, born in 1943 in Mettingen/Westfalen, was associate professor of art history from 1972 to 1976 and the founder of the Press of the Nova Scotia College of Art and Design in Halifax, Canada. He has curated major exhibitions, including "Skulptur Projekte Münster" in 1977, 1987, and 1997; was the initiator and superintendent of "Westkunst" at the Museen der Stadt Köln (1979) and "von hier aus" in Düsseldorf (1984). He taught at the Städelschule and was founding director of Portikus in Frankfurt am Main. Since 2000 Kaspar König has been the director of the Museum Ludwig in Cologne. He recently received an honorary degree at the Nova Scotia College of Art and Design.

JUTTA KOETHER (ver)malt, (ver)lehrt, (ver)spielt (sich) meistens in New York City oder What we don't talk about when we don't talk about ...

THOMAS RUFF, born in 1958 in Zell am Harmersbach, lives and works in Düsseldorf. He studied from 1977 to 1985 with Bernd Becher at the Düsseldorf Art Academy. His works have been shown in a range of museums, galleries, and international exhibitions, including Documenta IX (1992) in Kassel, the German Pavilion at the Venice Biennale (1995), and, most recently, at the Staatliche Kunsthalle Baden-Baden. Thomas Ruff is Professor at the Staatliche Kunstakademie Düsseldorf.

Über die 80er sollte man besser schweigen.

Best to stay quiet about the eighties.

ROBERT GOBER

LOUISE LAWLER Why Pictures Now, 1981

JACK GOLDSTEIN The Bomber, 1980

SHERRIE LEVINE
After Walker Evans: 1-22, 1981

RICHARD PRINCE Untitled
(hand with cigarette), 1980

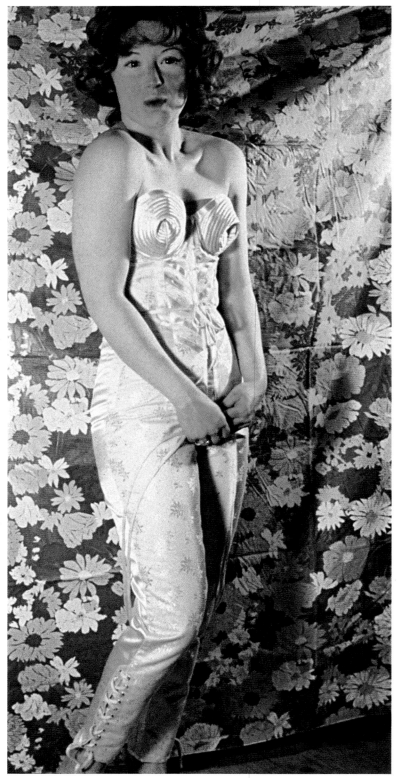

CINDY SHERMAN Untitled #131A, 1983

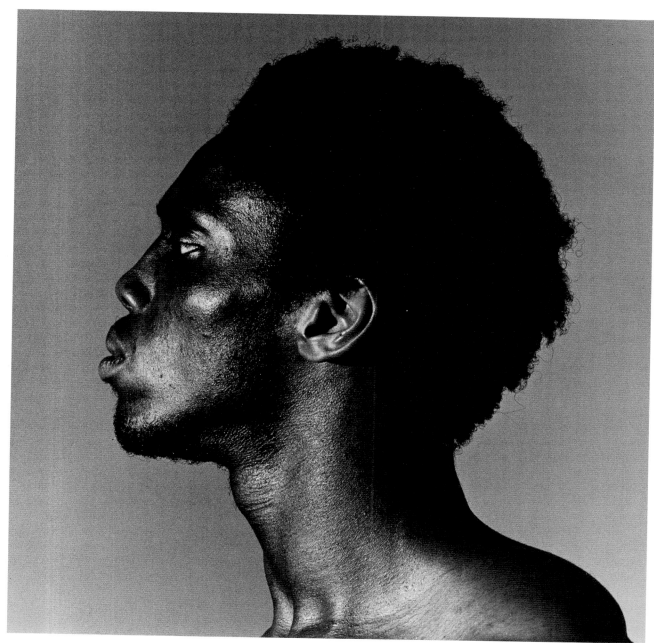

ROBERT MAPPLETHORPE Untitled, 1980

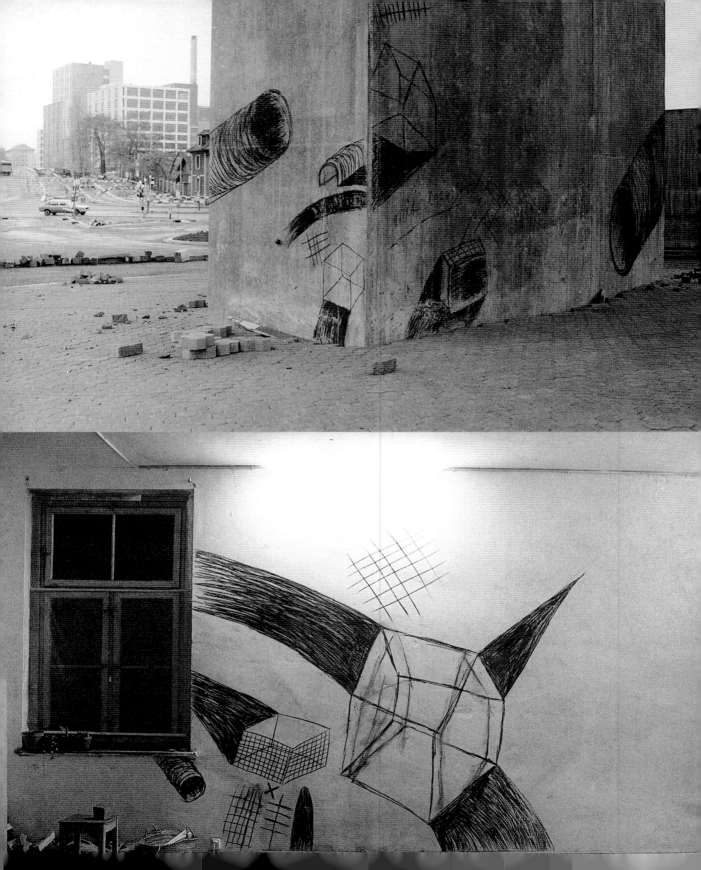

Mitzerstört (mein frausein ist mein öffentlicher teil),
1979/80

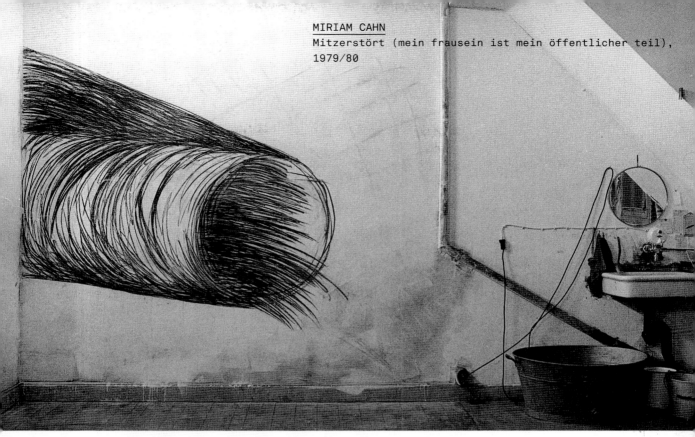

mein frausein ist mein öffentlicher teil (Tote Orte),
1979/80

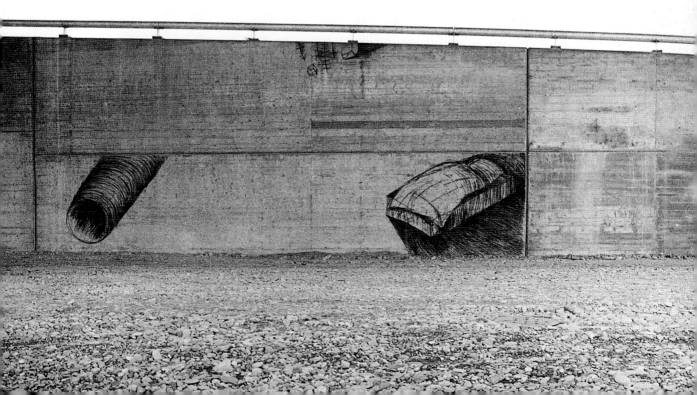

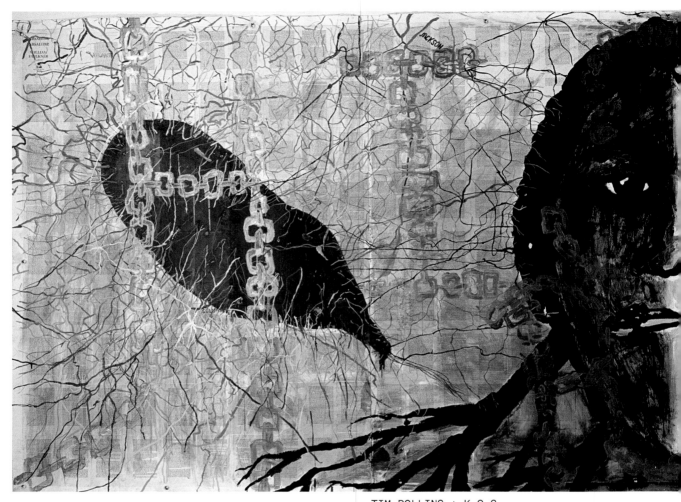

TIM ROLLINS + K.O.S.
Absalom! Absalom!, 1983-1985

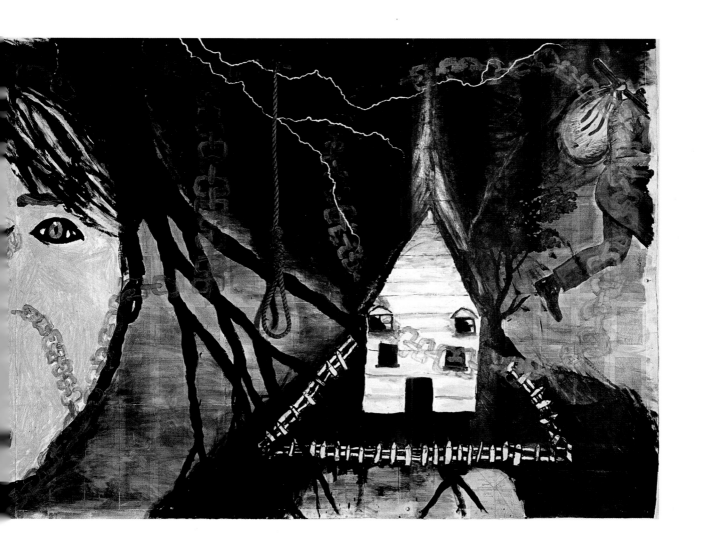

GROUP MATERIAL
AIDS Timeline, University Art Museum, University of
California at Berkeley, 1989

"Like any representation of history, this project is
subjective in that it includes certain information
and excludes other information... The timeline
documents the impact that homophobia, heterosexism,
sexism, and racism have had on the formation of
effective public policy. Virtually all the major social
inequities that compromise democracy in the US
are reflected in the decade-long history of AIDS."

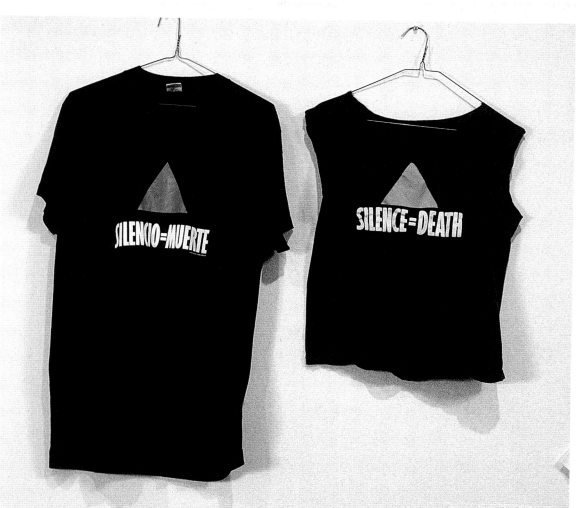

SILENCIO=MUERTE

SILENCE=DEATH

Yolanda Serrano, ADAPT's executive director, announces that ADAPT will distribute sterile needles to I.V. drug users to prevent the spread of HIV (through blood left in shared needles), as a form of civil disobedience. *New York Times*, *The Today Show*, and *20/20* cover the issue. In response the Department of Health freezes ADAPT's money and shuts down the office 48 hours. On January 31, Governor Mario Cuomo revises his stand and supports experimental needle exchange.

As the market for AIDS drugs increases, Lyphomed drug company competes for FDA approval of aerosol Pentamidine to prevent PCP pneumonia, and charges I.V. Pentamidine users 300% more; increasing the cost from $24.95 to $99.95. The cost to actually make the drug drops from $6.00 to $1.80 per 300mg.

January, New York State Health Commissioner David Axelrod still has not ruled on a request for free needle distribution made by 2 City Health Commissioners, and first proposed by ADAPT in 1985.

1988

Randy Shilts' book, "And the Band Played On" is distributed by St. Martin's press. It quickly becomes a national bestseller. The book chronicles the unfolding of the AIDS epidemic as a medical, political and cultural crisis from 1978 to 1985. It inspires controversy in the gay community due to the dramatization of facts.

AZT(Azidothymidine) is approved by the FDA. It is an anti-retroviral drug that interferes with HIV replication and the only drug that can be legally prescribed by doctors to treat AIDS. It is also very toxic and can cause blood, nervous and gastrointestinal disorders. Many patients (40-80%) become intolerant after a year to a year and a half. The manufacturer, Burroughs Wellcome, is granted a 7 year marketing license on July 17, under the Orphan Drug Act. In addition Burroughs Wellcome takes out a patent that extends its monopoly of the drug for 17 years. Burroughs Wellcome charges close to $10,000 per year per person for AZT, another example of profiteering from healthcare. They charge this exhorbinant amount of money despite the fact that the government (the National Cancer Institute) actually developed the drug in 1964 for cancer, gave the monopoly to Burroughs Wellcome to entice them to produce it, and provided their first raw materials necessary to make the drug.

In December, Burroughs Wellcome reduces the cost of AZT by 20% to assuage critics. Even as they do this, they raise the price of Zovirax, a drug for herpes, by a similar amount.

28,788 new cases
93,377 total cases
60,679 deaths to date

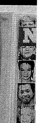

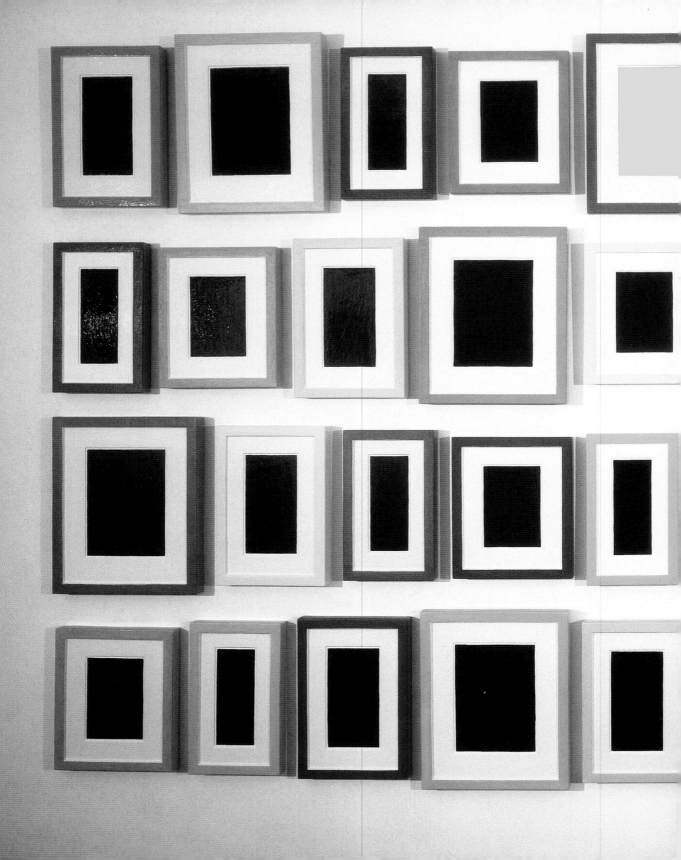

ALLAN McCOLLUM
Plaster Surrogates, 1982

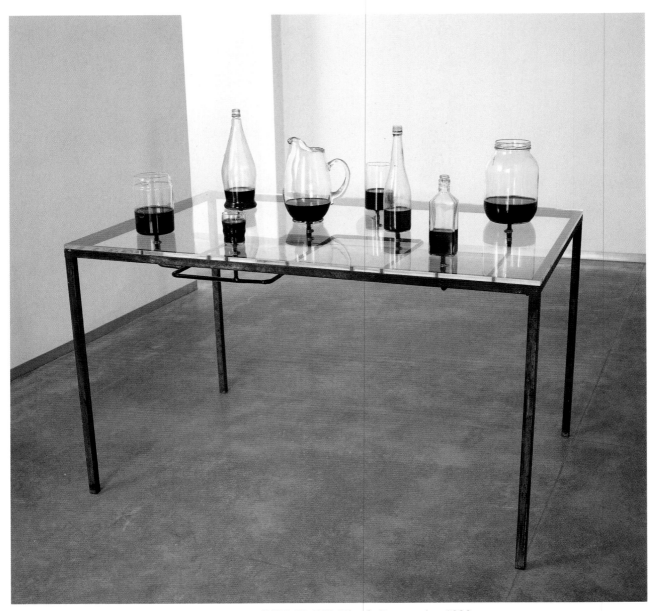

CHARLES RAY Viral Research, 1986

→ JEFF KOONS New Hoover Convertibles New Shelton Wet/Drys
5-Gallon Doubledecker, 1981–1986

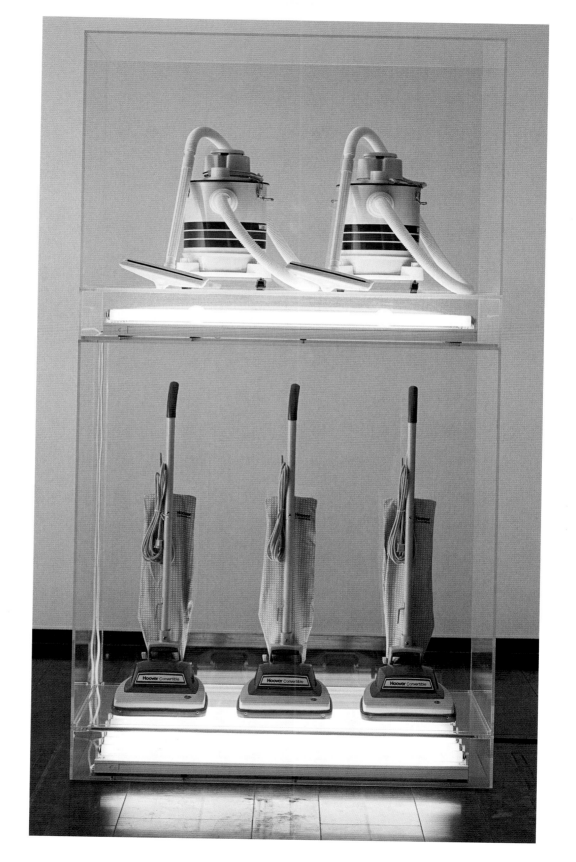

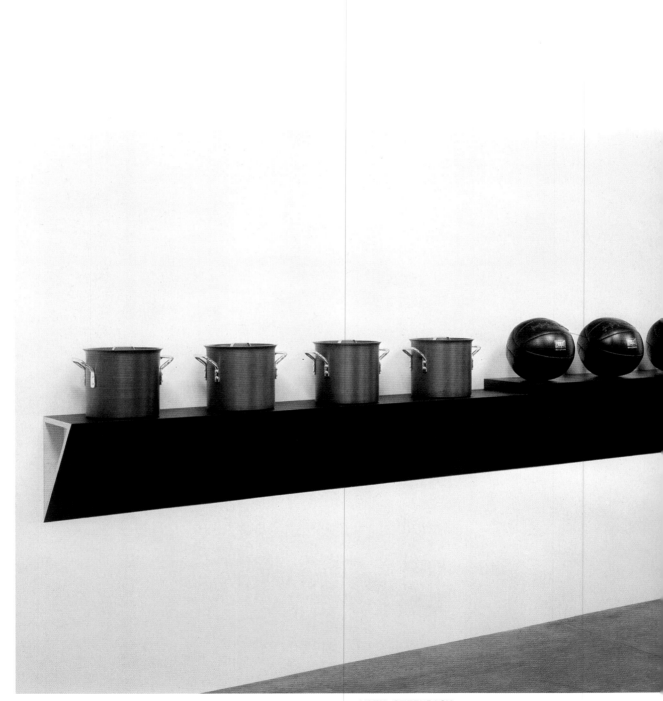

HAIM STEINBACH
one minute managers IV-2, 1989

118

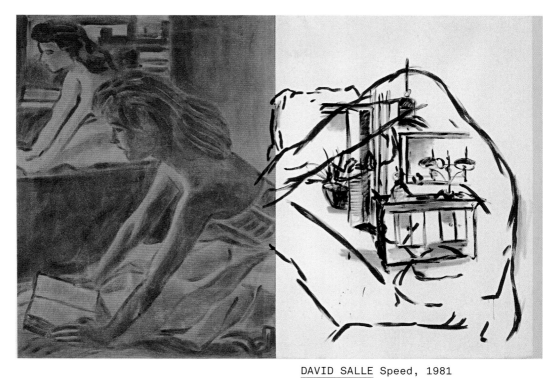

DAVID SALLE Speed, 1981

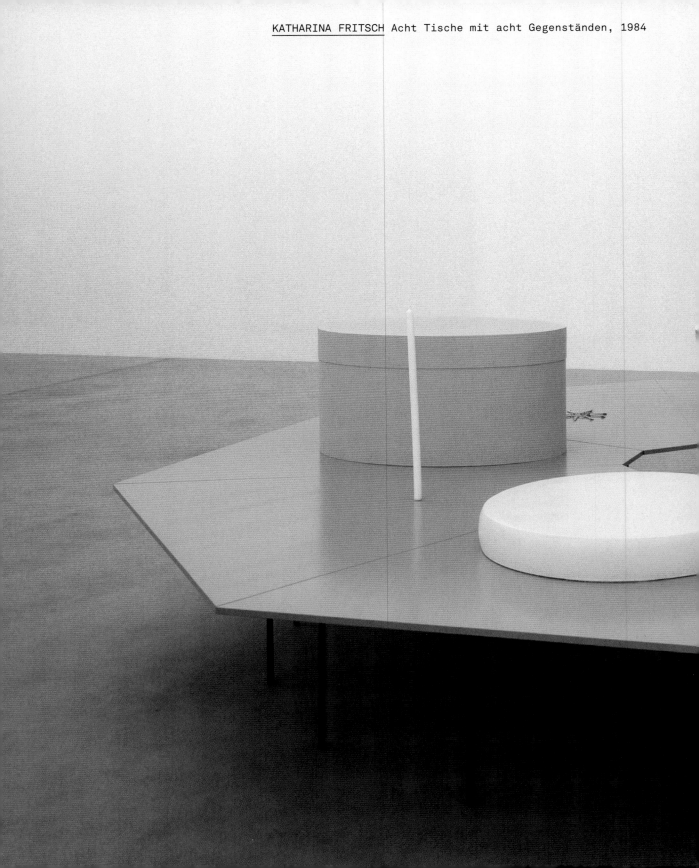

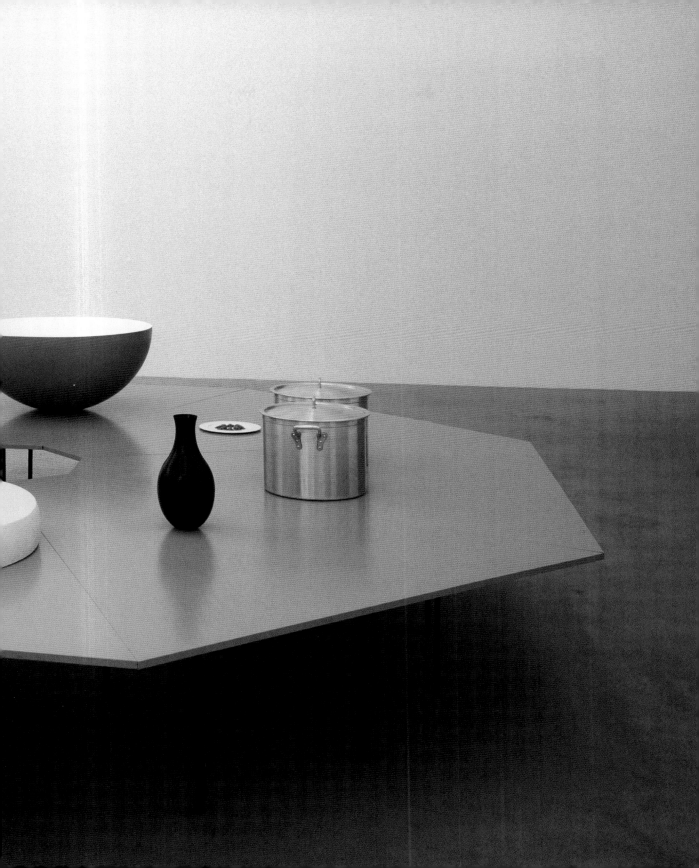

PETER HALLEY White Cell with Conduit, 1986

ROSEMARIE TROCKEL
Ohne Titel, 1987

124

THOMAS RUFF Porträt, 1988

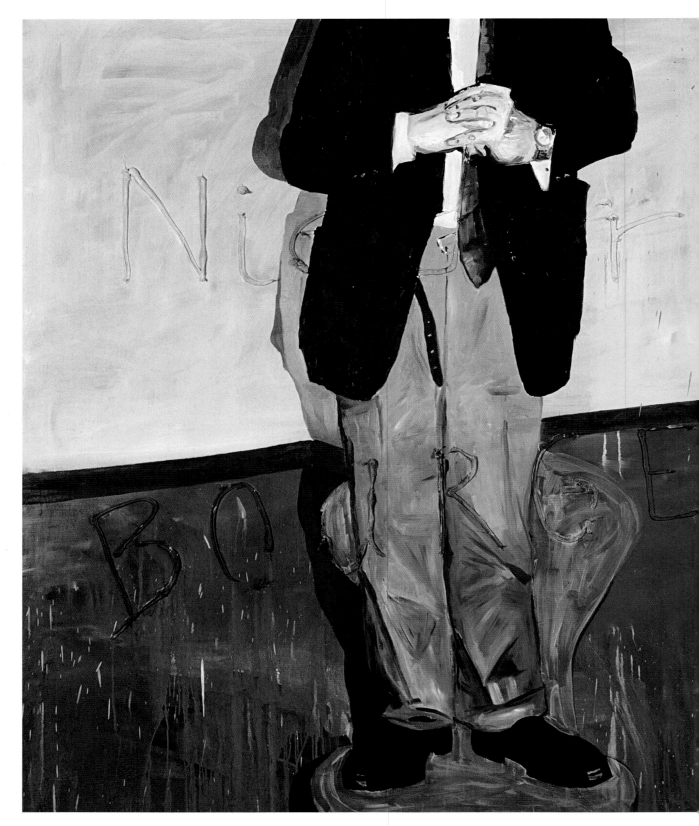

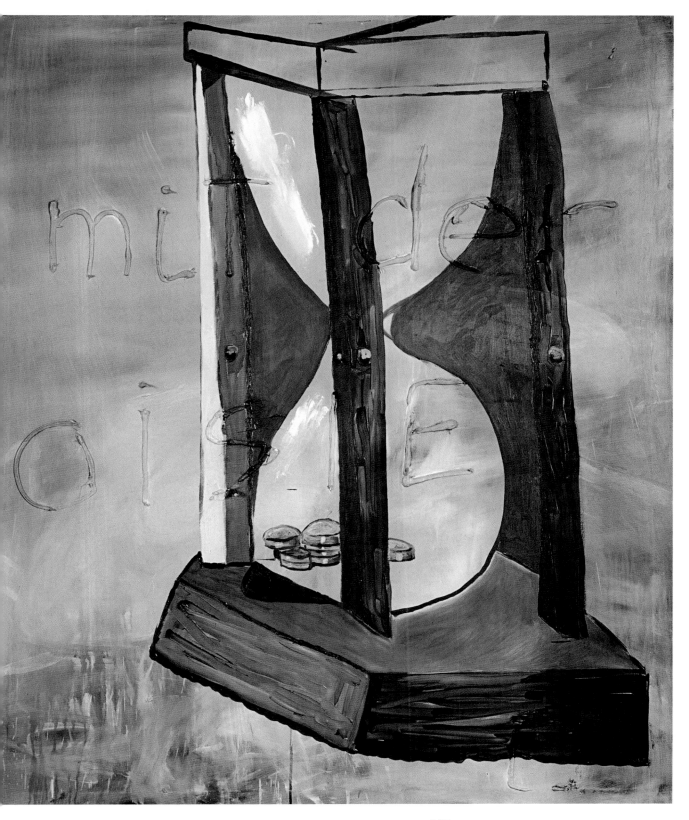

←← MARTIN KIPPENBERGER Nieder mit der Bourgeoisie, 1983

ALBERT OEHLEN
Morgenlicht fällt ins Führerhauptquartier, 1982

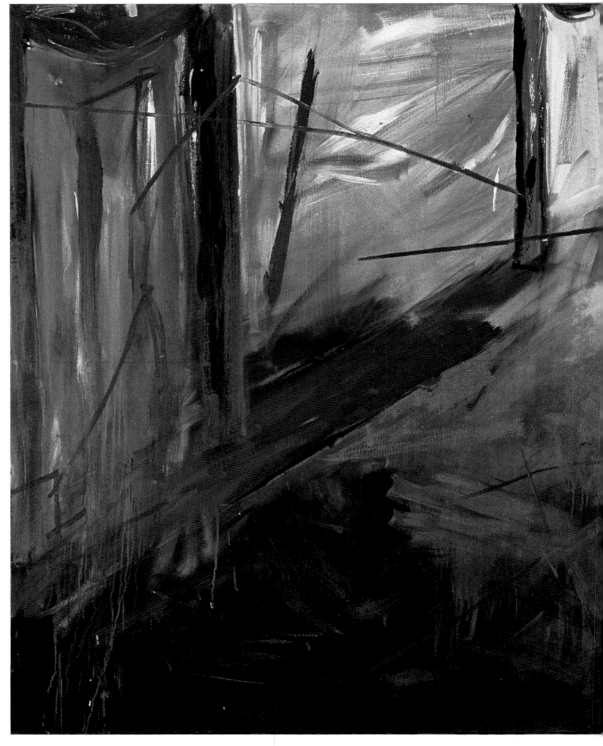

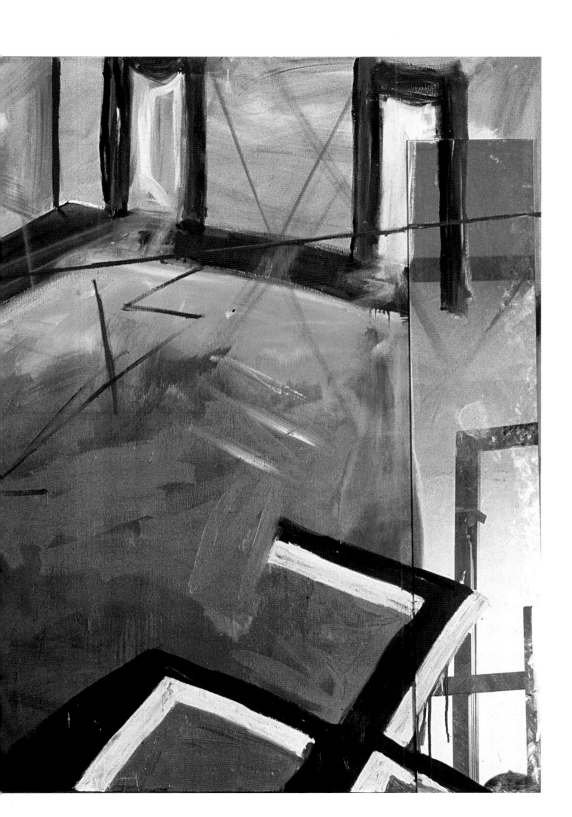

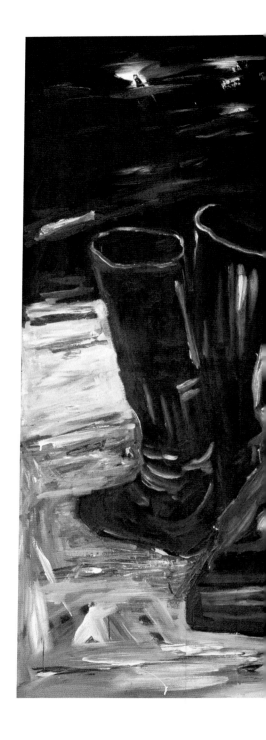

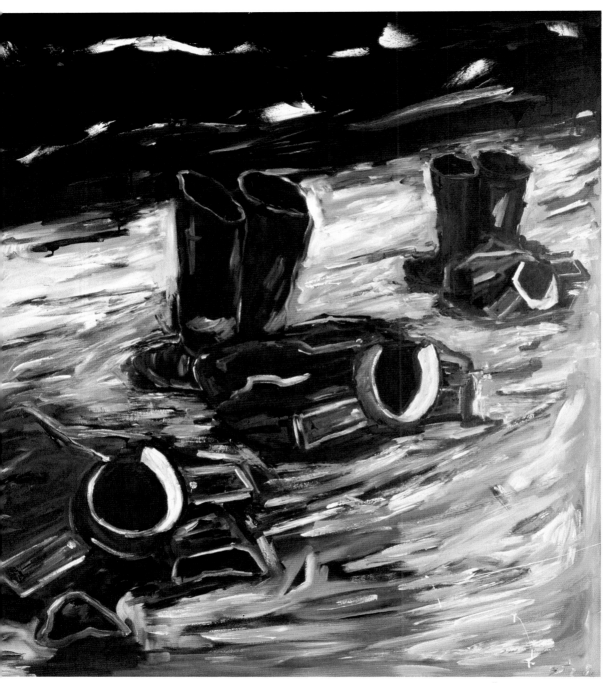

WERNER BÜTTNER
Badende Russen, 1982

WALTER DAHN
Ohne Titel, 1983

ILYA KABAKOV Gastronom, 1981

HELMUT FEDERLE Asian Sign, 1980

→ GÜNTHER FÖRG Treppe Villa Malaparte, 1983/2005

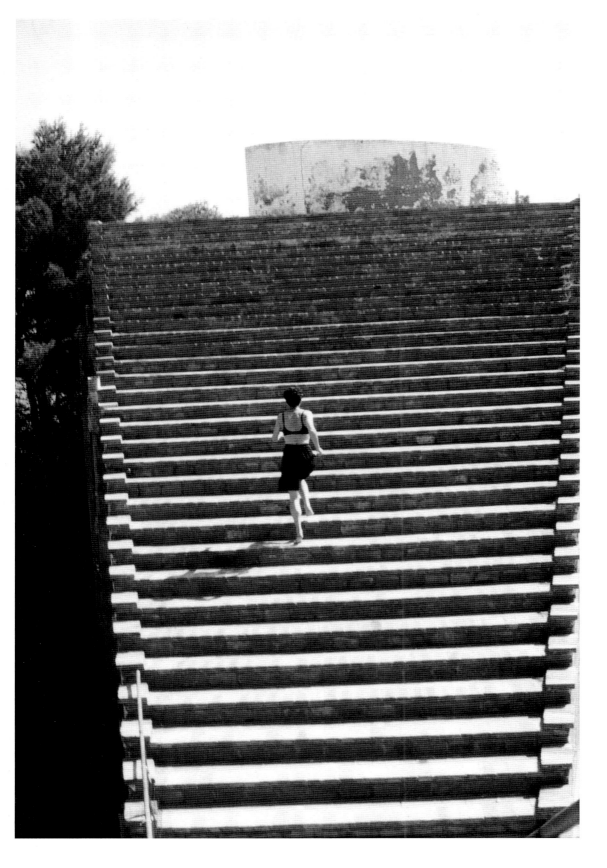

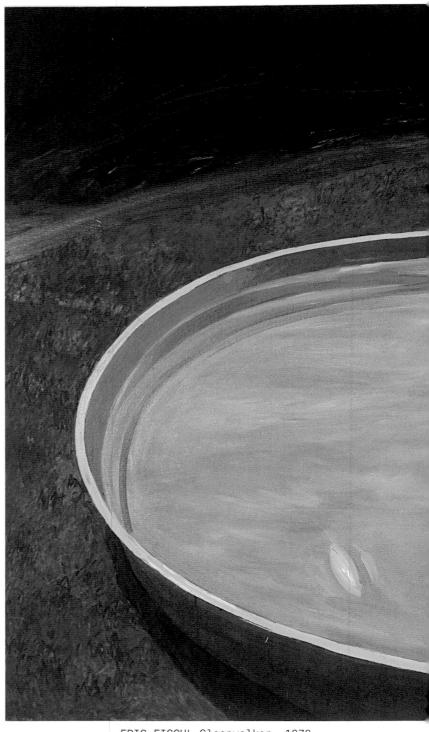

ERIC FISCHL Sleepwalker, 1979

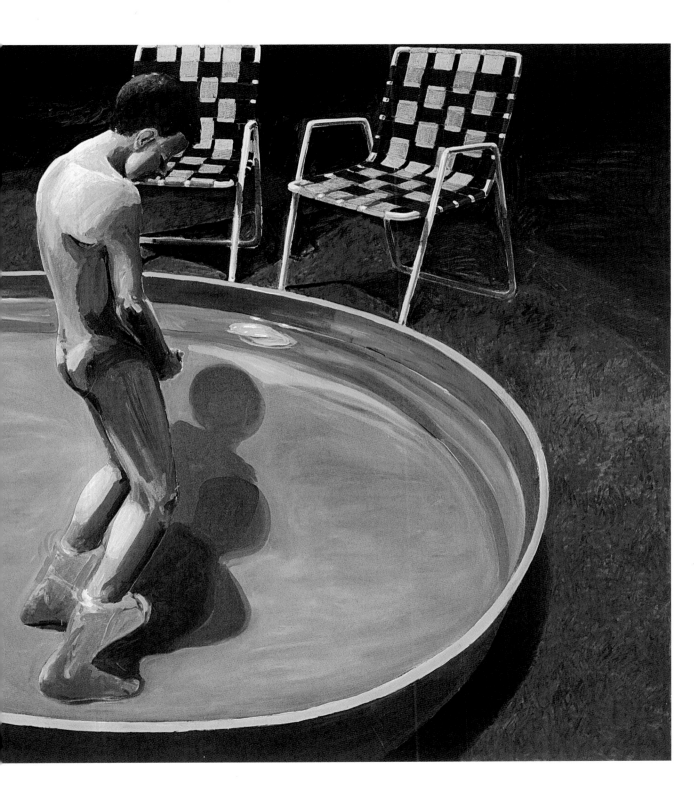

FRANCESCO CLEMENTE Ohne Titel, 1984

JOHN M ARMLEDER
Ohne Titel, 1984

142

JEAN-FRÉDÉRIC SCHNYDER
Madonna mit Kind, 1986

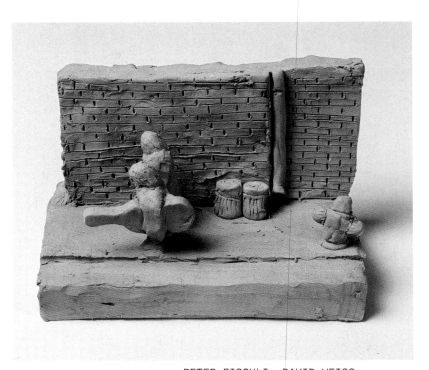

PETER FISCHLI DAVID WEISS
Mick Jagger und Brian Jones befriedigt auf
dem Heimweg, nachdem sie »I Can't
Get No Satisfaction« komponiert haben, 1981

→ GEORG HEROLD Dürerhase, 1984

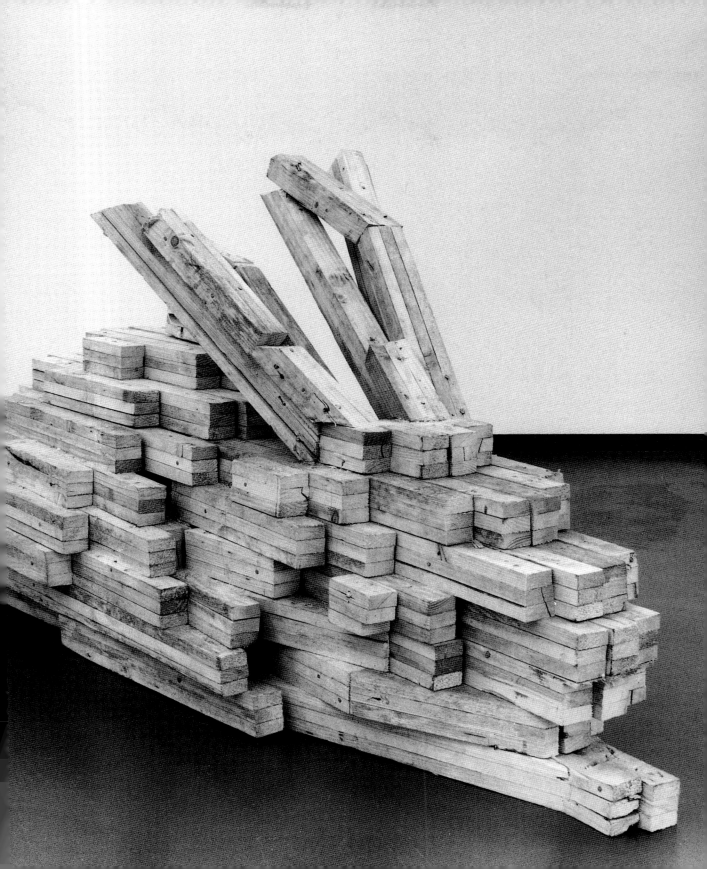

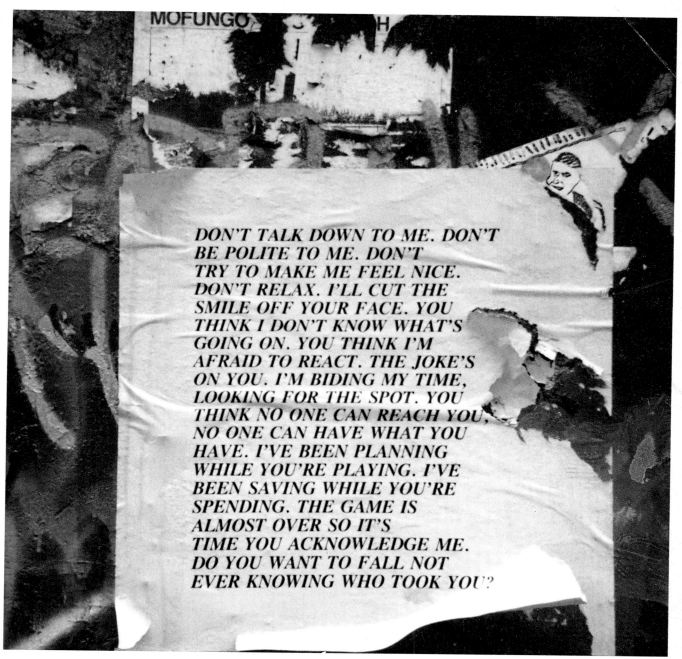

DON'T TALK DOWN TO ME. DON'T
BE POLITE TO ME. DON'T
TRY TO MAKE ME FEEL NICE.
DON'T RELAX. I'LL CUT THE
SMILE OFF YOUR FACE. YOU
THINK I DON'T KNOW WHAT'S
GOING ON. YOU THINK I'M
AFRAID TO REACT. THE JOKE'S
ON YOU. I'M BIDING MY TIME,
LOOKING FOR THE SPOT. YOU
THINK NO ONE CAN REACH YOU,
NO ONE CAN HAVE WHAT YOU
HAVE. I'VE BEEN PLANNING
WHILE YOU'RE PLAYING. I'VE
BEEN SAVING WHILE YOU'RE
SPENDING. THE GAME IS
ALMOST OVER SO IT'S
TIME YOU ACKNOWLEDGE ME.
DO YOU WANT TO FALL NOT
EVER KNOWING WHO TOOK YOU?

JENNY HOLZER
Inflammatory Essays, 1979–1982

KRZYSZTOF WODICZKO
Projektzeichnung/Proposal
The Kunstmuseum Basel Projection, 2005

KRZYSZTOF WODICZKO The Hirshhorn Projection,
Washington D.C., 1989

"The projection was organized by the Hirshhorn Museum
and Sculpture Garden as part of the exhibition
series WORKS and took place over three consecutive
nights during the week preceding the 1988 United States
presidential election."

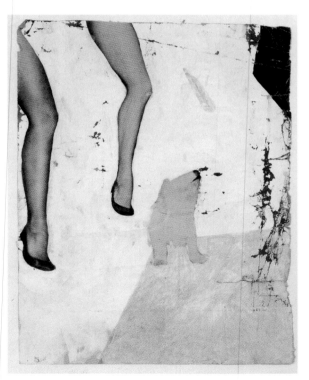

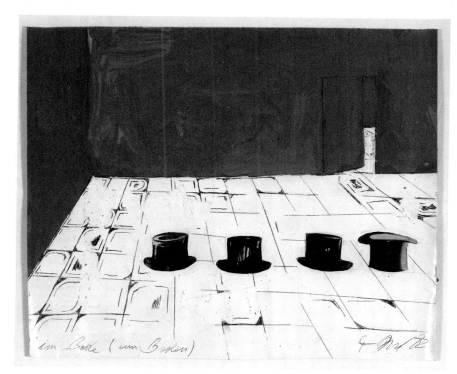

FRANZ WEST Im Bade (am Boden), 1982
↖ FRANZ WEST Znaimer Rösselsprung
(Vulgärfassung), 1981
← FRANZ WEST Ohne Titel, 1981
←←FRANZ WEST Geile Lippen, 1981

MIKE KELLEY Notebook Drawings, 1986–1991

→ CADY NOLAND Tanya as a Bandit, 1989

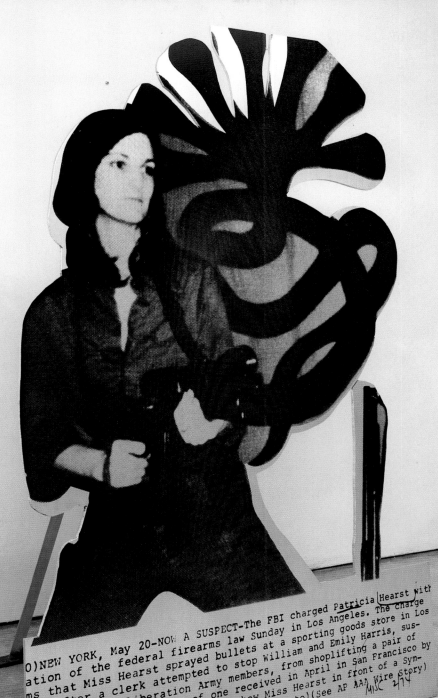

O)NEW YORK, May 20-NOW A SUSPECT-The FBI charged Patricia Hearst with ation of the federal firearms law Sunday in Los Angeles. The charge ms that Miss Hearst sprayed bullets at a sporting goods store in Los les after a clerk attempted to stop William and Emily Harris, sus- ed Symbionese Liberation Army members, from shoplifting a pair of s. This photo is a copy of one received in April in San Francisco by o station KSAN and purports to show Miss Hearst in front of a Sym- ese Liberation Army insignia. (AP Wirephoto)(See AP AAA Wire Story) 01J5fls)1974.

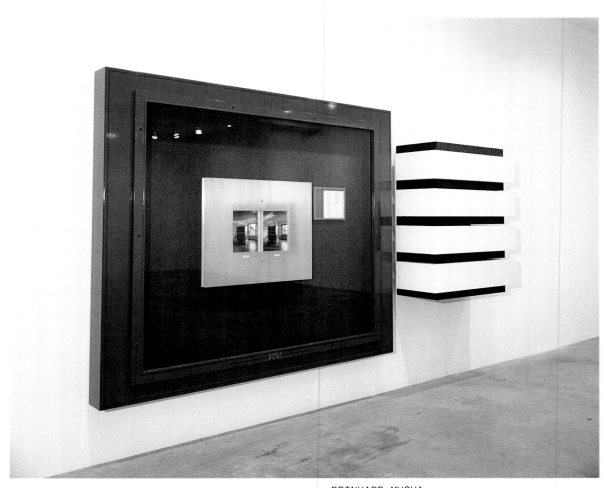

REINHARD MUCHA
Ohne Titel (»Pohlschröder«,
Ausstellung der Galerie
Schellmann & Klüser, München 1982), 1993

154

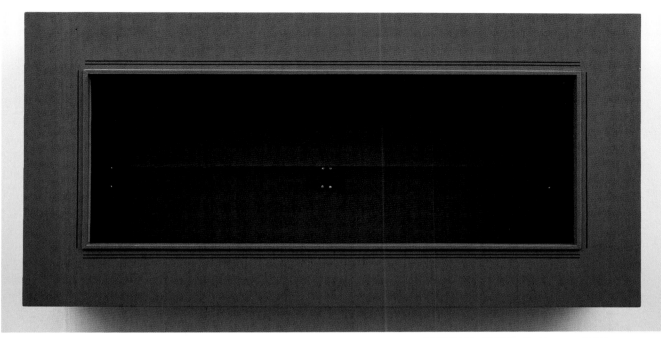

REINHARD MUCHA Bottrop, 1984

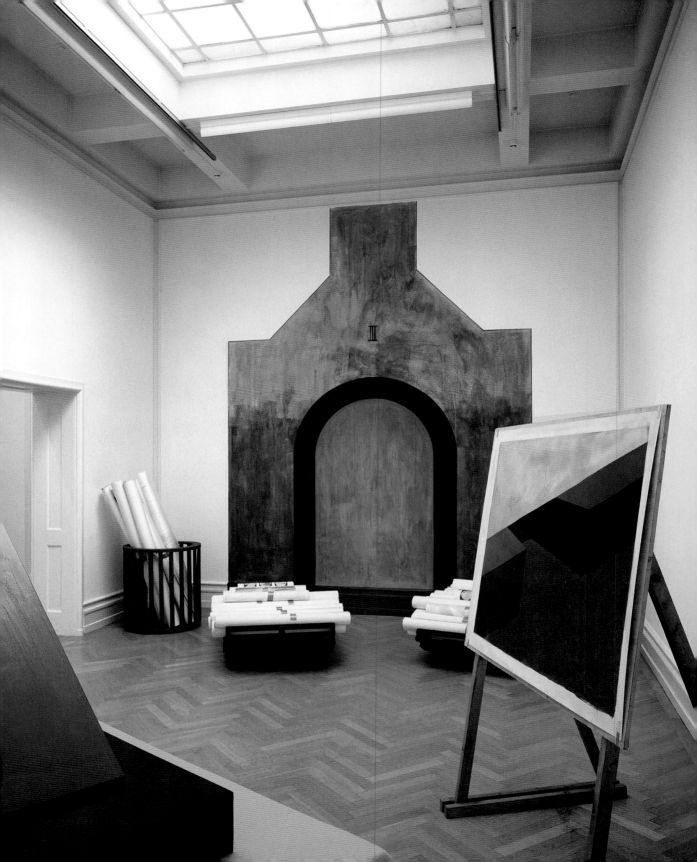

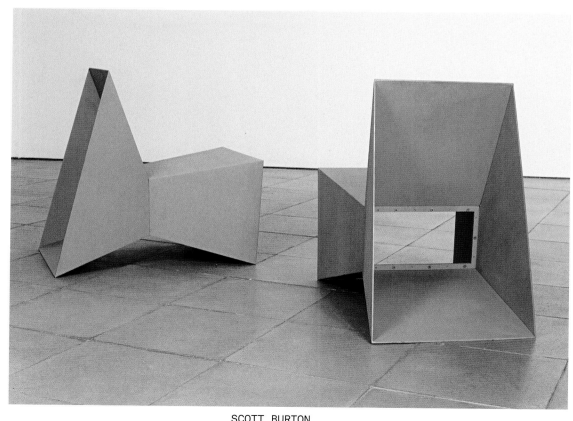

SCOTT BURTON
Pair of Steel Chairs (Prototype), 1987/88

← THOMAS SCHÜTTE Modell für ein Museum, 1981/82

157

<u>JEFF WALL</u> A Woman and her Doctor, 1980/81

JAMES COLEMAN So Different... and Yet, 1980

WERKE IN DER AUSSTELLUNG
WORKS IN THE EXHIBITION

JOHN M ARMLEDER

(*1946 Genève, lebt/lives in
Genève und/and New York)
Ohne Titel, 1984
Lack auf Leinwand/lacquer on
canvas
289,5 x 220 cm
Kunstmuseum Bern, Schenkung
Stiftung Kunst Heute
Abb. S. 142
Ohne Titel (Furniture Sculpture),
1987
Acryl auf Leinwand, auf Holztisch
montiert/acrylic on canvas
mounted on wooden table
Durchmesser/diameter: 64 cm
Länge/length: 66 cm
Art & Public - Cabinet P. H.

SCOTT BURTON

(*1939 Greensboro, Alabama,
†1989 New York)
Pair of Steel Chairs (Prototype),
1987/88
Edelstahl/stainless steel
Je/each 80 x 55 x 81 cm
Abb. S. 157

WERNER BÜTTNER

(*1954 Jena, lebt/lives in
Hamburg)
Badende Russen, 1982
Öl auf Leinwand/oil on canvas
150 x 190 cm
Sammlung Grässlin, St. Georgen
Abb. S. 130
Detail aus einem Massenmord, 1986
Öl auf Leinwand/oil on canvas
240 x 190 cm
Galerie Bärbel Grässlin,
Frankfurt am Main

MIRIAM CAHN

(*1949 Basel, lebt/lives in Basel
und/and Maloja)
mein frausein ist mein öffentlicher
teil, 1979/80
(Auswahl aus Fotoserie/selection
from series)
Fotografien auf Papier/
photographs on paper
Je/each 30 x 21 cm
Sammlung der Künstlerin
Abb. S. 108
nach der nacht (schauen) (das
nasenwachsen), januar 1983, 1983
Schwarze Schulkreide auf
Pergament, 11 Blätter/Black chalk
on parchment, 11 sheets
Gesamt/total: 95 x 1000 cm
Courtesy STAMPA, Basel
L.I.S. blutungsarbeit 27.11.87, 1987
Kreide auf Papier/chalk on paper
Heft/folder: 54 x 62 cm
Courtesy STAMPA, Basel
A- + H-tests 20.4.91, 1991
Aquarell auf Papier/watercolor on
paper
193 x 300 cm
Courtesy STAMPA, Basel

FRANCESCO CLEMENTE

(*1952 Napoli, lebt/lives in New
York, Madras und/and Rom)
Ohne Titel, 1984
Acryl auf Tuch/acrylic on cloth
353,5 x 445,5 cm
Emanuel Hoffmann-Stiftung,
Depositum in der Öffentlichen
Kunstsammlung Basel 1985
Abb. S. 140

JAMES COLEMAN

(*1941 Ballaghaderreen, lebt/
lives in Dublin)
Connemara Landscape, 1980
Projektion/projected image
Courtesy of the artist

WALTER DAHN
 (*1954 St. Tönnis, lebt/lives in
 Köln und/and Braunschweig)
Ohne Titel, 1983
 Dispersion auf Nesseltuch/
 dispersion on muslin
 200,5 x 125,5 cm
 Emanuel Hoffmann-Stiftung,
 Depositum in der Öffentlichen
 Kunstsammlung Basel 1983
 Abb. S. 132
Portrait H. D., 1986
 Acryl auf Leinwand/acrylic
 on canvas
 190,5 x 200,6 cm
 Kunstmuseum Basel, Geschenk von
 Max Schmid sen. 1986

HELMUT FEDERLE
 (*1944 Solothurn, lebt/lives in
 Wien und/and Düsseldorf)
Asian Sign, 1980
 Dispersion auf Leinwand/
 dispersion on canvas
 234 x 288 cm
 Kunstmuseum Basel, Ankauf aus
 Mitteln des Birmann-Fonds 1982
 Abb. S. 134
Ohne Titel, 1980
 Dispersion auf Leinwand/
 dispersion on canvas
 236,4 x 393 cm
 Kunstmuseum Bern, Schenkung
 Stiftung Kunst Heute

ERIC FISCHL
 (*1948 New York, lebt/lives in
 New York)
Sleepwalker, 1979
 Öl auf Leinwand/oil on canvas
 176 x 267 cm
 Privatsammlung
 Abb. S. 138

PETER FISCHLI DAVID WEISS
 (*1952 Zürich, lebt/lives in
 Zürich)
 (*1946 Zürich, lebt/lives in
 Zürich)
Aus/from »Plötzlich diese
 Übersicht«, 1981:

Der Alemanne Wolo gründet
 Wollishofen
 Tonplastik, ungebrannt/unfired
 clay sculpture
 22,5 x 13 x 16 cm
 Emanuel Hoffmann-Stiftung,
 Depositum in der Öffentlichen
 Kunstsammlung Basel 2000
Autobahn (Version II)
 Tonplastik, ungebrannt/unfired
 clay sculpture
 14 x 20 x 7 cm
 Emanuel Hoffmann-Stiftung,
 Depositum in der Öffentlichen
 Kunstsammlung Basel 2001
Beliebte Gegensätze: Gut und
 Schlecht
 Tonplastik, ungebrannt/unfired
 clay sculpture
 34,5 x 17,5 x 14 cm
 Emanuel Hoffmann-Stiftung,
 Depositum in der Öffentlichen
 Kunstsammlung Basel 2001
Bibeli und Bobeli im Frühling
 Tonplastik, ungebrannt/unfired
 clay sculpture
 33 x 34 x 10 cm
 Emanuel Hoffmann-Stiftung,
 Depositum in der Öffentlichen
 Kunstsammlung Basel 2000
Der gestiefelte Kater
 Tonplastik, ungebrannt/unfired
 clay sculpture
 19 x 14 x 18 cm
 Emanuel Hoffmann-Stiftung,
 Depositum in der Öffentlichen
 Kunstsammlung Basel 2001

Einheimischer Waldboden (Version II)
Tonplastik, ungebrannt/unfired
clay sculpture
24 x 18,5 x 9 cm
Emanuel Hoffmann-Stiftung,
Depositum in der Öffentlichen
Kunstsammlung Basel 2001
Im Keller
Tonplastik, ungebrannt/unfired
clay sculpture
31 x 16 x 16 cm
Emanuel Hoffmann-Stiftung,
Depositum in der Öffentlichen
Kunstsammlung Basel 2001
Mick Jagger und Brian Jones
befriedigt auf dem Heimweg,
nachdem sie »I Can't Get
No Satisfaction« komponiert haben
Tonplastik, ungebrannt/unfired
clay sculpture
17,5 x 11 x 11 cm
Emanuel Hoffmann-Stiftung,
Depositum in der Öffentlichen
Kunstsammlung Basel 2000
Abb. S. 144
Milieu (Version II)
Tonplastik, ungebrannt/unfired
clay sculpture
31 x 18,5 x 15 cm
Emanuel Hoffmann-Stiftung,
Depositum in der Öffentlichen
Kunstsammlung Basel 2001
Moderne Siedlung (Version II)
Tonplastik, ungebrannt/unfired
clay sculpture
36 x 26,5 x 9,5 cm
Emanuel Hoffmann-Stiftung,
Depositum in der Öffentlichen
Kunstsammlung Basel 2001
Nüsschen (Spanisch Nüssli)
Tonplastik, ungebrannt/unfired
clay sculpture
Länge/length: 3 cm
Durchmesser/diameter: 10,7 cm
Emanuel Hoffmann-Stiftung,
Depositum in der Öffentlichen
Kunstsammlung Basel 2001

Spock ist etwas traurig, dass er
keine Gefühle haben kann
Tonplastik, ungebrannt/unfired
clay sculpture
12,5 x 11 x 8 cm
Emanuel Hoffmann-Stiftung,
Depositum in der Öffentlichen
Kunstsammlung Basel 2000
Stiller Nachmittag
Tonplastik, ungebrannt/unfired
clay sculpture
21,5 x 11,5 x 7 cm
Emanuel Hoffmann-Stiftung,
Depositum in der Öffentlichen
Kunstsammlung Basel 2000
Vogelnest
Tonplastik, ungebrannt/unfired
clay sculpture
35 x 26 x 8 cm
Emanuel Hoffmann-Stiftung,
Depositum in der Öffentlichen
Kunstsammlung Basel 2001
Nofretete, 1982
Polyurethan, bemalt/polyurethane,
painted
Höhe/height: 50 cm
Sammlung Urs Egger

GÜNTHER FÖRG
(*1952 Füssen, lebt/lives in
Areuse und Freiburg i.B.)
Treppe Villa Malaparte, 1983/2005
C-Print, gerahmt/framed
Auf Wandmalerei/on mural, 2005
Veroneser grün/green und/and
caput mortuum
Bild/image: 240 x 160 cm
Kunstmuseum Basel, Geschenk des
Künstlers 2005 und/and Courtesy
of the artist
Abb. 137

KATHARINA FRITSCH
 (*1956 Essen, lebt/lives in
 Düsseldorf)
Acht Tische mit acht Gegenständen,
 1984
 8 Tische/8 tables: MDF-Platten,
 Stahl/MDF top and steel
 Objekte/objects 1981-1984:
 unterschiedliche Materialien/
 various materials
 Höhe/height: 75 cm
 Durchmesser/diameter: 480 cm
 Emanuel Hoffmann-Stiftung,
 Depositum in der Öffentlichen
 Kunstsammlung Basel 1987
 Abb. S. 120

ROBERT GOBER
 (*1954 Wallingford, Connecticut,
 lebt/lives in New York)
Corner Sink, 1984
 Gips, Holz, Drahtgeflecht, matt
 glänzender Emailanstrich/plaster,
 wood, wire lath, semi-gloss
 enamel paint
 46 x 117 x 91,5 cm
 Daros Collection, Schweiz
 Abb. S. 106
Untitled Sink, 1984
 Gips, Holz, Drahtgeflecht, Stahl,
 Latex, Ölfarbe/plaster, steel,
 wood, wire lath, latex, oil paint
 66 x 168 x 86,5 cm
 Daros Collection, Schweiz

JACK GOLDSTEIN
 (*1945 Montreal, †2003 San
 Bernadino, California)
The Bomber, 1980
 Acryl auf Leinwand/acrylic on
 canvas; 3 Teile/parts
 244 x 457 cm
 B.Z. + Michael Schwartz, New York
 Abb. S. 100
Ring of Fire, 1984
 Acryl auf Leinwand/acrylic on
 canvas
 244 x 101 cm
 B.Z. + Michael Schwartz, New York

GROUP MATERIAL (1979-1996)
 Dokumentation von drei Ausstel-
 lungsprojekten/Documentation from
 three exhibitions:
- The People's Choice, Group
 Material's East 13th Street
 storefront, New York, 1981
- Americana, in the Whitney
 Biennial, The Whitney Museum of
 American Art, New York, 1985
- AIDS Timeline, University Art
 Museum, University of California
 at Berkeley, 1989, and in the
 Whitney Biennial, The Whitney
 Museum of American Art, New York,
 1991; Abb. S. 112
 Courtesy Group Material

PETER HALLEY
 (*1953 New York, lebt/lives in
 New York)
Prisons in Context, 1981
 Acryl und Stuck auf Leinwand/
 acrylic and stucco on canvas;
 3 Teile/parts
 Gesamt/total: 137 x 645 cm
 Privatsammlung
White Cell with Conduit, 1986
 Acryl, Day-Glo-Farbe und Roll-a-
 Tex auf Leinwand/acrylic, Day-
 Glo, and Roll-a-Tex on canvas
 148 x 285 cm
 Privatsammlung
 Abb. S. 122

GEORG HEROLD
 (*1947 Jena, lebt/lives in Köln
 und/and La Palma de Mallorca)
Dürerhase, 1984
 Dachlatten, Kantholz, Holzstamm/
 roof lathing, squared timber, log
 Skulptur/sculpture:
 90 x 190 x 75 cm
 Ständer/base: 160 x 105 x 105 cm
 Privatsammlung Köln
 Abb. S. 145

Genetischer Eingriff in die Erbmasse
 bei Fr. Herold 1945, 1985
 Russischer Eisendraht,
 Dachlatten, Spanplatten,
 Fotokopien/Russian steel wire,
 roof lathing, chip board,
 photocopies
 280 x 52 x 52 cm
 Privatsammlung
saudumm und gehorsam, 1985
 Ziegelsteine auf Leinwand,
 Dispersion/bricks on canvas,
 dispersion; 2 Teile/parts
 Je/each 40 x 50 cm
 Sammlung Speck, Köln
Ohne Titel, 1989
 Kaviar, Acryl, Schellack auf
 Leinwand/caviar, acrylic, shellac
 on canvas
 180 x 130 cm
 Courtesy Galerie Max Hetzler,
 Berlin

JENNY HOLZER
 (*1950 Gallipolis, Ohio, lebt/
 lives in Hoosick Falls, New York)
Inflammatory Essays, 1979-1982
 Set mit 10 Blättern/set of 10
 posters
 Ein Set besteht aus 10 unter-
 schiedlichen Farben/each set has
 10 different colors
 Je/each 43,2 x 43,2 cm
 Galerie Sprüth Magers, Köln
 München
 Abb. S. 146

ILYA KABAKOV
 (*1933 Dnjepropetrowsk, lebt/
 lives in New York)
Gastronom, 1981
 Emailfarbe auf Hartfaserplatte/
 enamel-paint on fiberboard;
 2 Teile/parts
 260 x 380 cm
 Emanuel Hoffmann-Stiftung,
 Depositum in der Öffentlichen
 Kunstsammlung Basel 1986
 Abb. S. 133

MIKE KELLEY
 (*1954 Detroit, lebt/lives in Los
 Angeles)
Glorious Wound, 1986
 Acryl auf Baumwolle, Perücke/
 acrylic on cotton, wig
 203,2 x 119,4 cm
Notebook Drawings, 1986-1991
 49 Zeichnungen/49 Drawings
 Tusche, Bleistift, Farbstift auf
 Papier/ink, pencil, colored
 crayon on paper
 Sammlung Ringier
 Abb. S. 152
Estral Star #3, 1989
 2 zusammengenähte, gestrickte
 Stofftiere/2 knitted soft toy
 animals, sewn together
 66,5 x 25 x 11 cm
 Sammlung Ringier
Untitled, 1989
 Filz, Nylon, gestopft, Knöpfe,
 Nylonstrümpfe auf Stoff/felt,
 nylon, stuffing, button, nylon
 stockings on fabric
 254 x 411,5 cm
Symbiotic Relationships, 1991
 Filzbuchstaben und Stoff/felt
 letters and fabric
 238 x 180 cm
 Sammlung Ringier

MARTIN KIPPENBERGER
 (*1953 Dortmund, †1997 Wien)
Fliegender Tanga, 1983
 Öl auf Leinwand/oil on canvas;
 5 Teile/parts
 Je/each 120 x 100 cm
 Sammlung Grässlin, St. Georgen
Nieder mit der Bourgeoisie, 1983
 Öl auf Leinwand/oil on canvas
 160 x 266 cm
 Sammlung Grässlin, St. Georgen
 Abb. S. 126

JEFF KOONS
(*1955 York, Pennsylvania, lebt/
lives in New York)
New Hoover Convertibles, New Shelton
Wet/Drys 5-Gallon Doubledecker,
1981–1986
3 Hoover-, 2 Shelton-Nass/
Trocken-Sauger, Plexiglas,
Leuchtstoffröhren/3 Hoover
convertibles, 2 Shelton wet/drys,
Plexiglas, fluorescent lights
251,5 x 137,2 x 71,1 cm
Astrup Fearnley Collection, Oslo
Abb. S. 117

LOUISE LAWLER
(*1947 in Bronxville, New York,
lebt/lives in New York)
Why Pictures Now, 1981
Schwarz-Weiss-Fotografie,
Passepartout, gerahmt/black-and-
white photograph, mat, framed;
Ex. 9/10
Bild/image: 8 x 15,6 cm
Gesamt/total: 22 x 32,2 cm
Kunstmuseum Basel, Ankauf 2004
Abb. S. 97
16, 1985
Cibachrome; Ex. 3/5
68,6 x 100,6 cm
Kunstmuseum Basel, Ankauf 2004
Conditions of Sale, 1990
Schwarz-Weiss-Fotografie,
Passepartout mit Text, gerahmt/
black-and-white photograph with
text on mat, framed; Ex. 4/5
Bild/image: 40 x 56 cm
Gesamt/total: 74,2 x 84,4 cm
Kunstmuseum Basel, Ankauf 2004

SHERRIE LEVINE
(*1947 Hazleton, Pennsylvania,
lebt/lives in New York)
After Walker Evans: 1-22, 1981
22 Schwarz-Weiss-Fotografien,
gerahmt/black-and-white
photographs, framed
Je/each 20,3 x 25,4 cm
Und/and 25,4 x 20,3 cm
Kunstmuseum Basel, Ankauf mit
Mitteln der Max Geldner-Stiftung
2005
Abb. S. 102

ROBERT LONGO
(*1953 New York, lebt/lives in
New York)
Untitled (from »Men In The Cities«),
1981
Kohle und Grafit auf Papier/
charcoal and graphite on paper
244 x 152 cm
Collection Metro Pictures
Abb. S. 99

ROBERT MAPPLETHORPE
(*1946 New York, †1989 Boston)
Z-Portfolio, 1979–1981
Mit Selen getönte Abzüge/selenium
toned prints; 13 Teile/parts;
Ex. 10/25
Je/each 19 x 19 cm
Sammlung Thomas Koerfer
Abb. S. 105

ALLAN McCOLLUM
(*1944 Los Angeles, lebt/lives in
New York)
100 Plaster Surrogates, 1982/90
Lackfarbe auf Hydrocal Gipsguss/
enamel on Hydrocal
Dimension variabel/dimensions
variable
Museum van Hedendaagse Kunst
Antwerpen, MuHKA
Abb. S. 114

REINHARD MUCHA
 (*1950 Düsseldorf, lebt/lives in
 Düsseldorf)
Bottrop, 1984
 Holz, Glas, Kunstharzlack, Filz,
 Stahl/wood, glass, enamel paint,
 felt, steel
 85 x 171,7 x 36,5 cm
 Galerie Bärbel Grässlin,
 Frankfurt am Main
 Abb. S. 155
Ohne Titel (»Astron Taurus«,
 Kunsthalle Bielefeld 1981), 1984
 Diptychon/diptych
 Links/left: Holz,
 Kunstharzlackfarbe, Glas, Filz,
 Schwarz-Weiss-Fotografien,
 Aluminium/wood, enamel paint,
 glass, felt, black-and-white
 photographs, aluminum
 Rechts/right: Holz, Linoleum,
 3 Ventilatoren/wood, linoleum,
 3 fans
 Gesamt/total: 180 x 360 x 35 cm
 Collection André Goeminne
Ohne Titel (»Pohlschröder«,
 Ausstellung der Galerie
 Schellmann & Klüser, München
 1982), 1993
 Diptychon/diptych
 Links/left: Glas, Filz, Schwarz-
 Weiss-Fotografien,
 Offsetdruck, Aluminium/glass,
 felt, black-and-white
 photographs, aluminum
 200,1 x 235,8 x 24,3 cm
 Rechts/right: Holz, Filz,
 Kunstharzlackfarbe/wood, felt,
 enamel paint
 131,3 x 111 x 48,8 cm
 Collection Art Gallery
 of Ontario, Toronto.
 Gift of Vivian and
 David Campbell, 2000
 Abb. S. 154

CADY NOLAND
 (*1956 Washington, D.C., lebt/
 lives in New York)
Tanya as a Bandit, 1989
 Siebdruck auf Aluminium/Silk-
 screen printing on aluminum
 180 x 120 x 0,9 cm
 Sammlung Goetz, München
 Abb. S. 153
Untitled, 1989
 Rohre, Flagge, Stühle, Plastik/
 Pipes, flag, chairs, plastic
 ca. 90 x 380 x 205 cm
 Sammlung Goetz, München

ALBERT OEHLEN
 (*1954 Krefeld, lebt/lives in
 La Palma de Mallorca und/and in
 der Schweiz)
Morgenlicht fällt ins
 Führerhauptquartier, 1982
 Öl, Lack und Spiegel auf
 Leinwand/oil, lacquer and mirror
 on canvas
 180 x 280 cm
 Sammlung Grässlin, St. Georgen
 Abb. S. 128
Zimmer mit Ö, 1986
 Öl, Lack auf Leinwand/oil and
 lacquer on canvas
 260 x 180 cm
 Sammlung Grässlin, St. Georgen

RICHARD PRINCE
 (*1949 Panama Canal Zone, lebt/
 lives in New York)
Untitled (hand with cigarette), 1980
 C-Print, gerahmt/framed; Ex. 5/10
 Bild/image: 50,8 x 61 cm
 Gesamt/total: 59 x 78,5 cm
 Kunstmuseum Basel, Ankauf 2002
 Abb. S. 103

Untitled (two women, two men, in
 three-quarter profile), 1980
C-Print, gerahmt/framed; 4 Teile/
parts; Ex. 3/10
Bild/image: je/each 40,8 x 61 cm
Gesamt/total:
je/each 59 x 78,5 cm
Kunstmuseum Basel, Ankauf 2002

CHARLES RAY
 (*1953 Chicago, lebt/lives in Los
 Angeles)
Viral Research, 1986
 Plexiglas, Stahl, Tusche/
 Plexiglas, steel, ink
 93 x 137,5 x 75 cm
 Courtesy Fondazione Sandretto
 Re Rebaudengo, Turin
 Abb. S. 116

TIM ROLLINS + K.O.S.
 (*1955 Pittsfield, Maine, lebt/
 lives in New York)
Absalom! Absalom!, 1983–1985
 Öl und Acryl auf Buchseiten, auf
 Karton, Hanfstrick/oil and
 acrylic on book pages, on
 cardboard, hemp rope
 189 x 511,5 cm
 Emanuel Hoffmann-Stiftung,
 Depositum in der Öffentlichen
 Kunstsammlung Basel 1990
 Abb. S. 110
The Temptation of St. Antony - Other
 Voices, 1989–1990
 Pulveriges Pigment, Tusche,
 Alkohol, Wasserfarbe, Terpentin,
 Wasser, Xerografie, Hadernpapier/
 Powdered pigment, ink, alcohol,
 watercolor, turpentine, water,
 xerography, rag paper, gerahmt/
 framed; 18 Teile/parts
 Gesamt/total: je/each 52 x 39 cm
 Emanuel Hoffmann-Stiftung,
 Depositum in der Öffentlichen
 Kunstsammlung Basel 1990

THOMAS RUFF
 (*1958 Zell am Harmersbach, lebt/
 lives in Düsseldorf)
Interieur 2A (Düsseldorf), 1979
 C-Print, gerahmt/framed;
 Ex. 10/20
 Bild/image: 27,5 x 20,5 cm
 Courtesy Mai 36 Galerie, Zürich
Interieur 5A (Zell am Harmersbach),
 1979
 C-Print, gerahmt/framed; Ex. 9/20
 Bild/image: 27,5 x 20,5 cm
 Kunstmuseum Basel, Schenkung
 »Schule und Elternhaus Schweiz«
 1995
Interieur 1B (Zell am Harmersbach),
 1980
 C-Print, gerahmt/framed; Ex. 8/20
 Bild/image: 27,5 x 20,5 cm
 Courtesy Mai 36 Galerie, Zürich
Interieur 2B (Zell am Harmersbach),
 1980
 C-Print, gerahmt/framed; Ex. 7/20
 Bild/image: 27,5 x 20,5 cm
 Courtesy Mai 36 Galerie, Zürich
Interieur 4B (Zell am Harmersbach),
 1980
 C-Print, gerahmt/framed;
 Ex. 13/20
 Bild/image: 20,5 x 27,5 cm
 Courtesy Mai 36 Galerie, Zürich
Interieur 9B (Zell am Harmersbach),
 1980
 C-Print, gerahmt/framed; Ex. 5/20
 Bild/image: 27,5 x 20,5 cm
 Kunstmuseum Basel, Schenkung
 »Schule und Elternhaus Schweiz«
 1995
Interieur 11B (Zell am Harmersbach),
 1980
 C-Print, gerahmt/framed;
 Ex. 12/20
 Bild/image: 27,5 x 20,5 cm
 Courtesy Mai 36 Galerie, Zürich
Interieur 1C (Zell am Harmersbach),
 1980
 C-Print, gerahmt/framed; Ex. 6/20
 Bild/image: 20,5 x 27,5 cm
 Courtesy Mai 36 Galerie, Zürich

Interieur 2C (Zell am Harmersbach),
 1980
 C-Print, gerahmt/framed;
 Ex. 11/20
 Bild/image: 27,5 x 20,5 cm
 Courtesy Mai 36 Galerie, Zürich
Interieur 4C (Siegen), 1981
 C-Print, gerahmt/framed; Ex. 3/20
 Bild/image: 27,5 x 20,5 cm
 Courtesy Mai 36 Galerie, Zürich
Interieur 3D (Tegernsee), 1982
 C-Print, gerahmt/framed; Ex. 9/20
 Bild/image: 27,5 x 20,5 cm
 Kunstmuseum Basel, Schenkung
 »Schule und Elternhaus Schweiz«
 1995
Interieur 1E (Tegernsee), 1983
 C-Print, gerahmt/framed;
 Ex. 13/20
 Bild/image: 20,5 x 27,5 cm
 Courtesy Mai 36 Galerie, Zürich
Interieur 4E (Tegernsee), 1983
 C-Print, gerahmt/framed; Ex. 8/20
 Bild/image: 20,5 x 27,5 cm
 Courtesy Mai 36 Galerie, Zürich
Interieur 5E (Tegernsee), 1983
 C-Print, gerahmt/framed; Ex. 4/20
 Bild/image: 20,5 x 27,5 cm
 Courtesy Mai 36 Galerie, Zürich
Porträt, 1988
 C-Print hinter Plexiglas,
 gerahmt/C-Print on Plexiglas,
 framed; Ex. 3/3
 210 x 165 cm
 Kunstmuseum Basel, Ankauf 2003
 Abb. S. 125

DAVID SALLE
 (*1952 Norman, Oklahoma, lebt/
 lives in Sagaponack, New York)
Speed, 1981
 Acryl auf Leinwand/acrylic on
 canvas; 2 Teile/parts
 Gesamt/total: 147 x 212 cm
 Emanuel Hoffmann-Stiftung,
 Depositum in der Öffentlichen
 Kunstsammlung Basel 1981
 Abb. S. 119

JEAN-FRÉDÉRIC SCHNYDER
 (*1945 Basel, lebt/lives in Zug)
Station Felsenau, 1983
 Öl auf Leinwand/oil on canvas
 48 x 65,5 cm
 Kunstmuseum Basel, Geschenk von
 Dr. Dieter Koepplin 1987
Wylerholz, 1983
 Öl auf Leinwand/oil on canvas
 48 x 65 cm
 Kunstmuseum Basel, Geschenk von
 Dr. Dieter Koepplin 1987
Wylerholz, 1983
 Öl auf Leinwand/oil on canvas
 48 x 65 cm
 Kunstmuseum Basel, Geschenk von
 Dr. Dieter Koepplin 1987
Sonne, 1983
 Öl auf Leinwand/oil on canvas
 48 x 65,5 cm
 Kunstmuseum Basel, Geschenk von
 Dr. Dieter Koepplin 1987
Madonna mit Kind, 1986
 Öl auf Leinwand/oil on canvas
 200 x 150 cm
 Emanuel Hoffmann-Stiftung,
 Depositum in der Öffentlichen
 Kunstsammlung Basel 1987
 Abb. S. 143

THOMAS SCHÜTTE
 (*1954 Oldenburg, lebt/lives in
 Düsseldorf)
Modell für ein Museum, 1981/82
 2 Zeichnungen auf 2 Staffeleien
 aus Holz, Objekt aus 4 Holz-
 elementen, bemalt, auf Holztisch
 mit Filztuch/2 drawings mounted
 on 2 wooden easels, object made
 of 4 wooden elements, painted,
 on wooden table with felt cloth
 Dimension variabel/variable
 Kunstmuseum Bern, Stiftung
 Kunsthalle Bern
 Abb. S. 156
Museum, 1981
 Lack auf Papier/lacquer on paper
 98,5 x 129 cm
 Friedrich Christian Flick
 Collection

CINDY SHERMAN
 (*1954 Glen Ridge, New Jersey,
 lebt/lives in New York)
Untitled Film Still #5, 1978
 Schwarz-Weiss-Fotografie,
 gerahmt/black-and-white
 photograph, framed; Ex. 8/10
 Bild/image: 20,3 x 25,4 cm
 Emanuel Hoffmann-Stiftung,
 Depositum in der Öffentlichen
 Kunstsammlung Basel 1996
Untitled Film Still #15, 1978
 Schwarz-Weiss-Fotografie,
 gerahmt/black-and-white
 photograph, framed; Ex. 8/10
 Bild/image: 25,4 x 20,3 cm
 Emanuel Hoffmann-Stiftung,
 Depositum in der Öffentlichen
 Kunstsammlung Basel 1996
Untitled Film Still #22, 1978
 Schwarz-Weiss-Fotografie,
 gerahmt/black-and-white
 photograph, framed; Ex. 8/10
 Bild/image: 20,3 x 25,4 cm
 Emanuel Hoffmann-Stiftung,
 Depositum in der Öffentlichen
 Kunstsammlung Basel 1996
Untitled Film Still #30, 1979
 Schwarz-Weiss-Fotografie,
 gerahmt/black-and-white
 photograph, framed; Ex. 8/10
 Bild/image: 20,3 x 25,4 cm
 Emanuel Hoffmann-Stiftung,
 Depositum in der Öffentlichen
 Kunstsammlung Basel 1996
Untitled #91, 1981
 C-Print, gerahmt/framed; Ex.10/10
 60,9 x 121,9 cm
 Emanuel Hoffmann-Stiftung,
 Depositum in der Öffentlichen
 Kunstsammlung Basel 1996
Untitled #123 A, 1983
 C-Print, gerahmt/framed; Ex.17/18
 88,7 x 62,4 cm
 Emanuel Hoffmann-Stiftung,
 Depositum in der Öffentlichen
 Kunstsammlung Basel 1996

Untitled #131 A, 1983
 C-Print, gerahmt/framed; Ex.8/18
 88,3 x 41,9 cm
 Emanuel Hoffmann-Stiftung,
 Depositum in der Öffentlichen
 Kunstsammlung Basel 1996
 Abb. S. 104
Untitled #175, 1985
 C-Print, gerahmt/framed; Ex.6/6
 120,5 x 181,5 cm
 Emanuel Hoffmann-Stiftung,
 Depositum in der Öffentlichen
 Kunstsammlung Basel 1996

HAIM STEINBACH
 (*1944 Rehovot/ISR, lebt/lives in
 New York)
one minute managers IV-2, 1989
 Holzbord, Alutöpfe, Medizinbälle/
 Board, aluminum pots, medicine
 balls
 72,4 x 355,6 x 35,6 cm
 Sammlung Goetz, München
 Abb. S. 118

ROSEMARIE TROCKEL
 (*1952 Schwerte, lebt/lives in
 Köln)
»DEAR LOVELY COLLEGES«, 1986
 Wolle, Plastik/Wool, plastic
 55 x 47 x 7 cm
 Courtesy Galerie Monika Sprüth/
 Philomene Magers, Köln/München
Ohne Titel, 1987
 Wolle schwarz-grau/black and
 grey wool
 250 x 180 cm
 Sammlung Jean Todt
 Abb. S. 124

JEFF WALL
(*1946 Vancouver, lebt/lives in
Vancouver)
A Woman and her Doctor, 1980/81
Grossbilddia in Leuchtkasten/
Transparency in lightbox
100,5 x 155,5 cm
Sammlung Jörg Johnen, Köln
Abb. S. 158

FRANZ WEST
(*1947 Wien, lebt/lives in Wien)
Geile Lippen, 1981
Collage
30 x 20 cm
Sammlung Pakesch
Abb. S. 150
Ohne Titel, 1981
Collage
29 x 22 cm
Sammlung Pakesch
Abb. S. 150
Ohne Titel, 1981
Collage
62,5 x 90 cm
Sammlung Pakesch
Ohne Titel, 1981
Collage
63 x 90 cm
Sammlung Pakesch
Znaimer Rösselsprung (Vulgärfassung),
1981
Collage
24 x 53 cm
Sammlung Pakesch
Abb. S. 150
Im Bade (am Boden), 1982
Collage (Rahmen/Frame Franz West)
30 x 40 cm
Sammlung Pakesch
Abb. S. 151
Das Vermächtnis Lumumbas, 1982
Collage (Rahmen/Frame Franz West)
25 x 32 cm
Sammlung Pakesch

In elysischen Gefilden Nr. 1011, 1983
Collage
43 x 69 cm
Sammlung Pakesch
Hommage an die Herrin Schwarzwälder,
1983
Collage
32 x 74 cm
Sammlung Pakesch
Sphinx Nr. 1027, 1983
Collage
50 x 79 cm
Sammlung Pakesch
»Tarzan auf einem grossen roten
Roller«, 1983
Collage
28 x 93 cm
Sammlung Pakesch
Verschmitzter Calder und fröhliche
Colette, 1983
Collage
32 x 74 cm
Sammlung Pakesch
Venus von Willendorf, 1984
Collage
57 x 151 cm
Sammlung Pakesch
Ohne Titel, 1985
Collage
57 x 89 cm
Sammlung Pakesch
Psyche, 1987
Eisen, Holz, Spiegel, Farbe,
2 Stühle/iron, wood, mirrors,
paint, 2 chairs
139 x 220 x 70 cm
Sammlung Grässlin, St. Georgen

KRZYSZTOF WODICZKO
(*1943 Warszawa, lebt/lives in
Boston und/and New York)
Public Projections 1981-1991, 1992
160 Dias/slides
Collection du Musée d'art
Contemporain de LYON
The Kunstmuseum Basel Projection, 2006
Courtesy of the artist
Abb. S. 148

DANK AN / ACKNOWLEDGMENTS

Marianne Aebersold
Jean-Christophe Ammann
Grete Årbu
Julie Ault
Leen De Backer
Lionel Bovier
Maria Brassel
Jacqueline Burckhardt
Philippe Cabane
Christine Clinckx
Aebhric Coleman
Judith Durrer
Erika & Otto Friedrich
Eva Frosch
Martin Furler-Bassand
Victor Gisler
Bärbel Grässlin
Thomas Grässlin
Lilian Haberer
Simone Haelg
Christoph Heinrich
Tom Heman
Max Hetzler
Rafael Jablonka
Marianne Karabelnik
Elisa Kay
Valérie Knoll
Christoph Kölbl
Jutta Küpper
Ulrich Loock
Carla Mantovani
David Moos
Manuela Mozo
Heidi Naef
Maja Naef
Michaela Neumeister
Justyna Niewiara
Peter Pakesch & Michaela Leutzendorff
Ute Parduhn
Patrick Peternader
Lilian Pfaff
Max Protetch
Meg Rotzel
Beatrix Ruf
Christoph Schenker
Peter Schütte
Thomas Schulte
Rosemarie Schwarzwälder
Monika Sprüth

Gilli & Diego Stampa
Ines Turian
Ralph Ubl
Roost Vischer
Theodora Vischer
Séverine Waelchli
Käthe Walser
Gabriela Walther
Julia Weiss
Rein Wolfs
Marit Woltmann

An dieser Stelle sei ebenso allen
Künstlerinnen und Künstlern wie
auch den Teilnehmern des
Roundtable-Gesprächs für das grosse
Engagement und Vertrauen gedankt.

At this juncture I wish to thank
all of the artists, and the
participants in the roundtable
discussion, for their
great commitment and trust.

Diese Publikation erscheint anlässlich der Ausstellung/
This catalogue is published in conjunction with the exhibition

F L A S H B A C K

Eine Revision der Kunst der 80er Jahre
Revisiting the Art of the 80s

Museum für Gegenwartskunst Basel
30. Oktober 2005 – 12. Februar 2006

Kunstmuseum Basel
Direktor/Director BERNHARD MENDES BÜRGI

Ausstellung/Exhibition
Kurator/Curator PHILIPP KAISER
Wissenschaftliche Mitarbeit/Curatorial assistance
JACQUELINE UHLMANN
Medien, Kommunikation/Press, communication
CHRISTIAN SELZ
Restauratoren/Restorers PETER BERKES, MARCUS JACOB, AMELIE
JENSEN, CAROLINE WYSS
Registrarin/Registrar CHARLOTTE GUTZWILLER
Ausstellungstechnik/Installation STEFANO SCHALLER, CLAUDE
BOSCH, DIETER MARTI, ANDREAS SCHWEIZER

Katalog/Catalogue
Herausgeber/Editor: PHILIPP KAISER
Redaktion/Editing: KATRIN STEFFEN, JACQUELINE UHLMANN
Lektorat/Copyediting: ANGELIKA FRANZ (Deutsch/German),
MARY CHRISTIAN (Englisch/English), KERSTIN STAKEMEIER
Transkription Roundtable-Gespräch/Transcription Roundtable
Discussion: PHILIPP KAISER, MAJA NAEF
Übersetzungen/Translations: BRIAN CURRID mit/with
WILHELM WERTHERN, JOHN W. GABRIEL, CHRISTIAN QUATMANN,
CATHERINE SCHELBERT, KERSTIN STAKEMEIER, LEONHARD UNGLAUB
Gestaltung/Graphic design: EMANUEL TSCHUMI
Reproduktion/Reproduction: PALLINO CROSS MEDIA, Ostfildern-Ruit
Papier/Paper: 100 g/m² Munken Print extra 1,5 f. Volumen,
150 g/m² Luxosamt Offset
Schrift/Typeface: Akkurat-Mono, WWW.LINETO.COM
Gesamtherstellung/Printed by: DR. CANTZ'SCHE DRUCKEREI,
Ostfildern-Ruit
Buchbinderei/Binding: VERLAGSBUCHBINDEREI DIERINGER, Gerlingen

Sponsor
FONDS FÜR KÜNSTLERISCHE AKTIVITÄTEN
IM MUSEUM FÜR GEGENWARTSKUNST DER EMANUEL HOFFMANN-STIFTUNG
UND DER CHRISTOPH MERIAN STIFTUNG

Kunstmuseum Basel, Museum für Gegenwartskunst
mit Emanuel Hoffmann-Stiftung
St. Alban-Rheinweg 60
4010 Basel
Schweiz/Switzerland
www.kunstmuseumbasel.ch

Erschienen im/Published by
Hatje Cantz Verlag
Senefelderstraße 12
73760 Ostfildern-Ruit Deutschland/Germany
Tel. +49 711 4405-0 - Fax +49 711 4405-220
www.hatjecantz.com

Buchhandelsausgabe/Trade edition: ISBN 3-7757-1631-9
Museumsausgabe/Museum edition: ISBN 3-7204-0161-8
Printed in Germany

Hatje Cantz books are available internationally at selected
bookstores and from the following distribution partners:
USA/North America – D.A.P., DISTRIBUTED ART PUBLISHERS,
New York, www.artbook.com
UK – ART BOOKS INTERNATIONAL, London, sales@art-bks.com
Australia – TOWER BOOKS, Frenchs Forest (Sydney),
towerbks@zipworld.com.au
France – INTERART, Paris, commercial@interart.fr
Belgium – EXHIBITIONS INTERNATIONAL, Leuven,
www.exhibitionsinternational.be
Switzerland – SCHEIDEGGER, Affoltern am Albis,
scheidegger@ava.ch

For Asia, Japan, South America, and Africa, as well as for
general questions, please contact Hatje Cantz directly at
sales@hatjecantz.de, or visit our homepage www.hatjecantz.com
for further information.

OS132 Dawsons £24.99 —